Ernie Clausen
2013

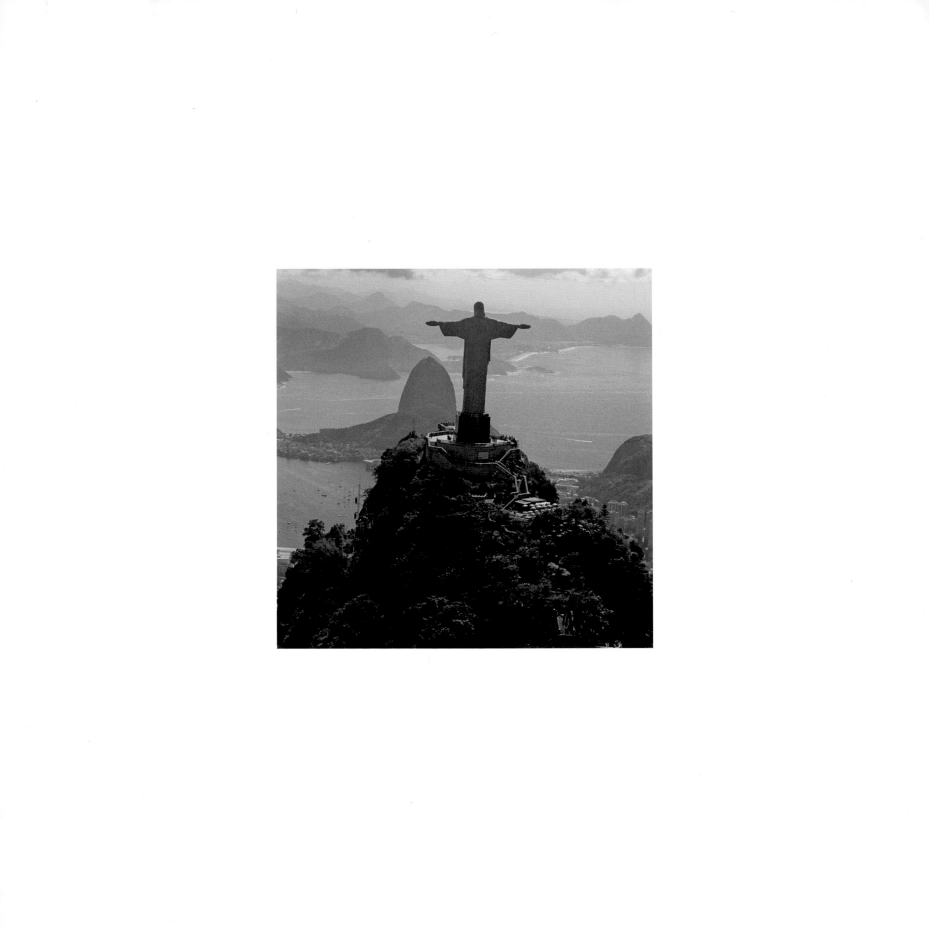

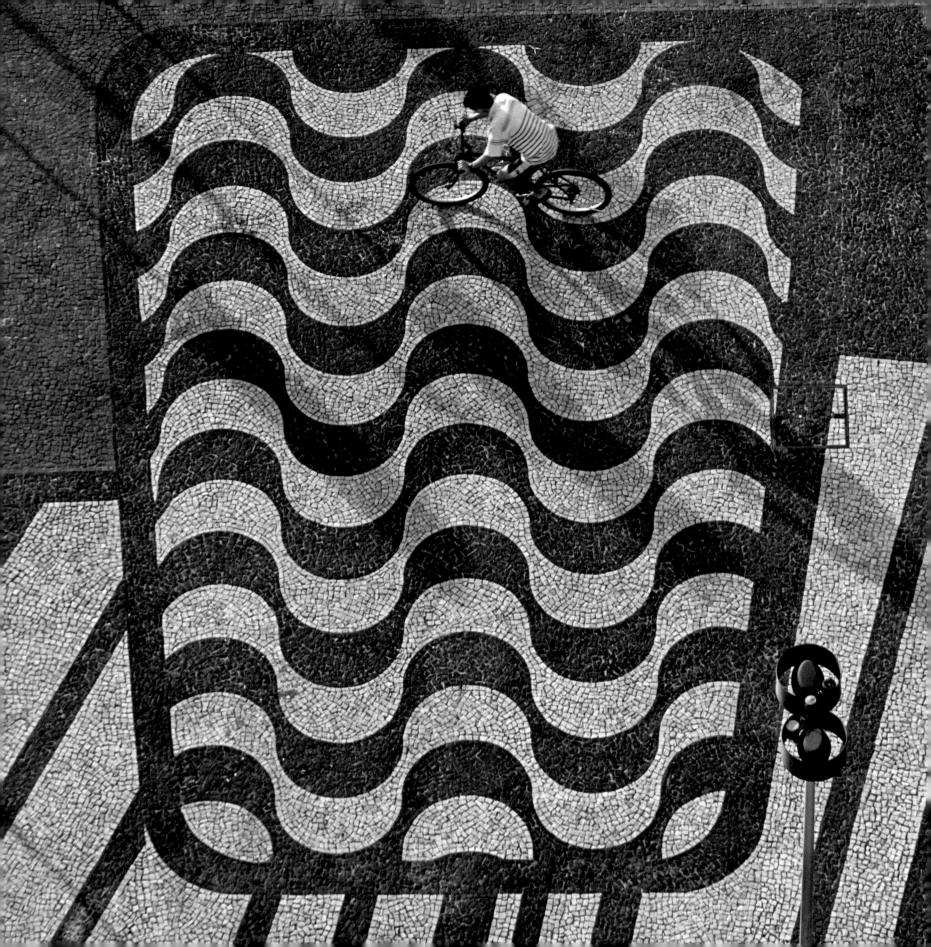

At Home
in Rio

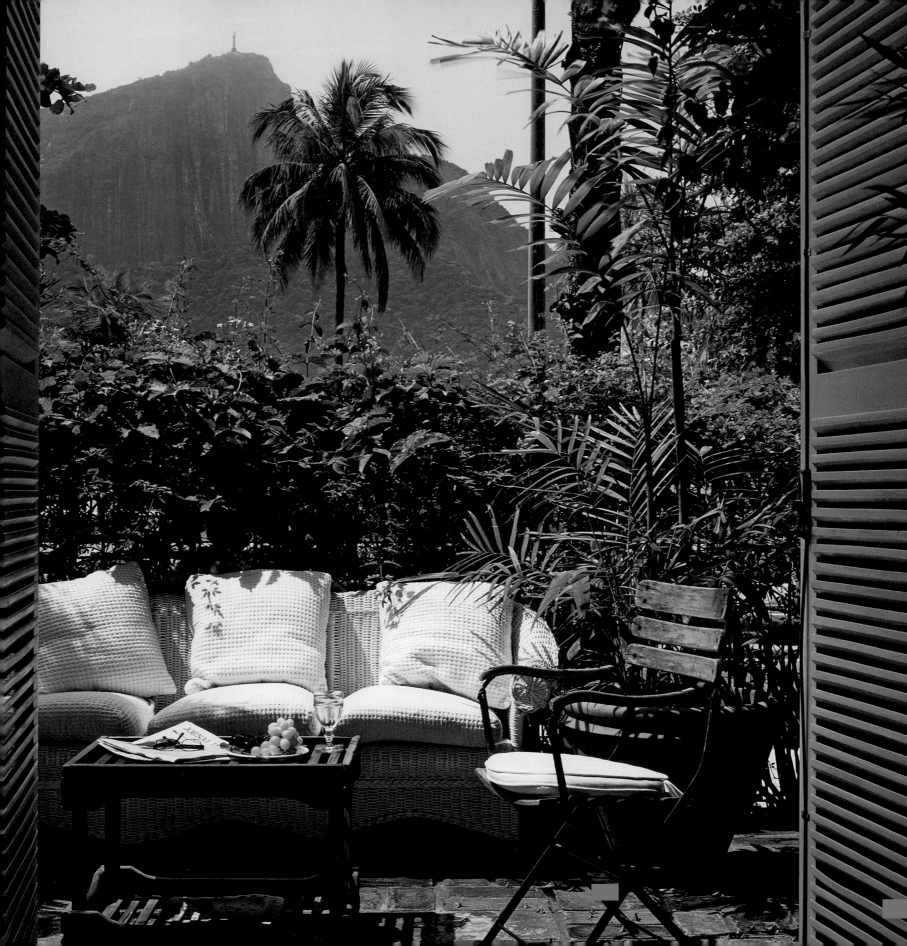

At Home
in Rio

PAULO THIAGO DE MELLO

PHOTOGRAPHS BY RETO GUNTLI & AGI SIMOES

THE VENDOME PRESS

NEW YORK

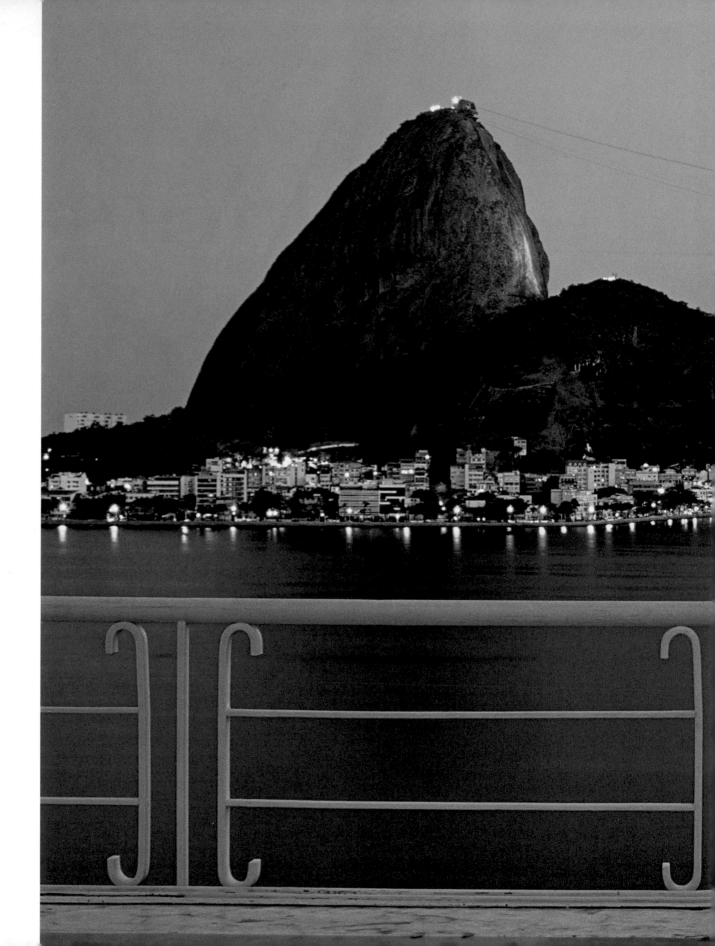

Page 2:
Decorated with Portuguese stones, this sidewalk along Copacabana Beach, the calçadão, is one of the picture-postcard scenes typical of this neighbourhood in Rio.

Page 4:
A view of the Corcovado from Lenny Ortiz Niemeyer's terrace in Lagoa. Lenny is a well-known designer of beachwear.

Right:
Botafogo Bay, with the silhouette of the Morro da Urca and Pão de Açúcar (Sugarloaf Mountain), is one of the best-known images of Rio de Janeiro.

Overleaf:
The home of Frances Marinho has a privileged view of the city.

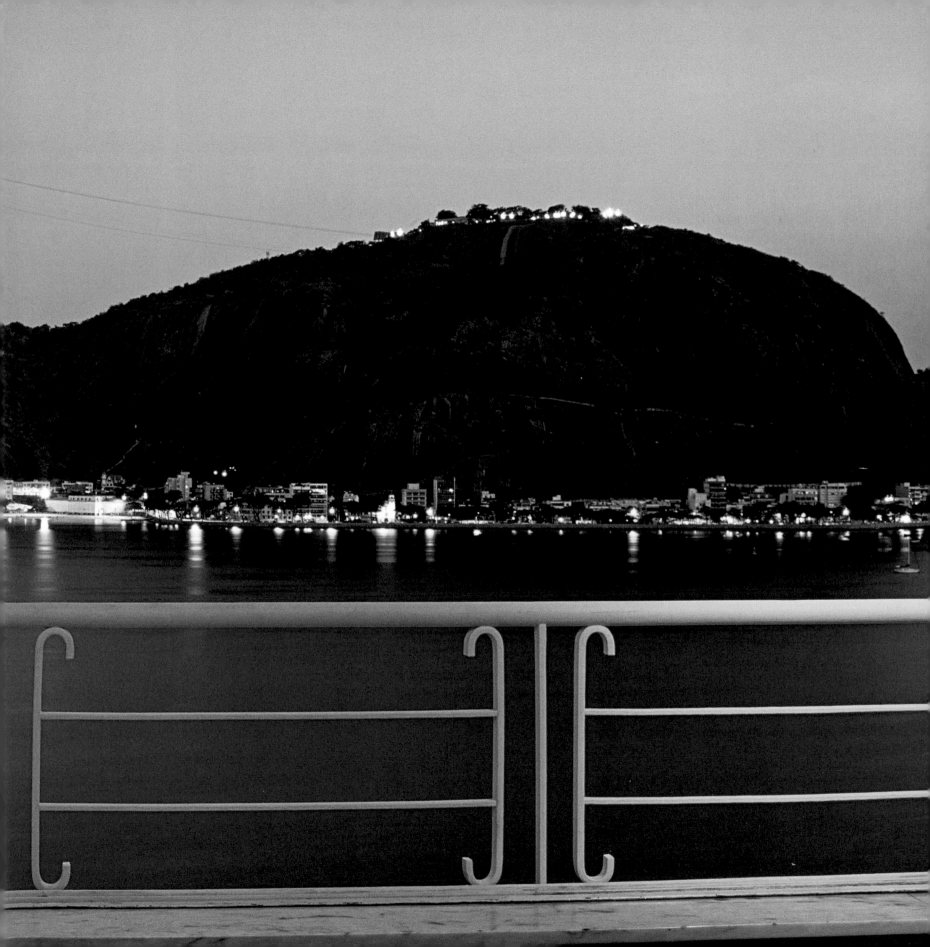

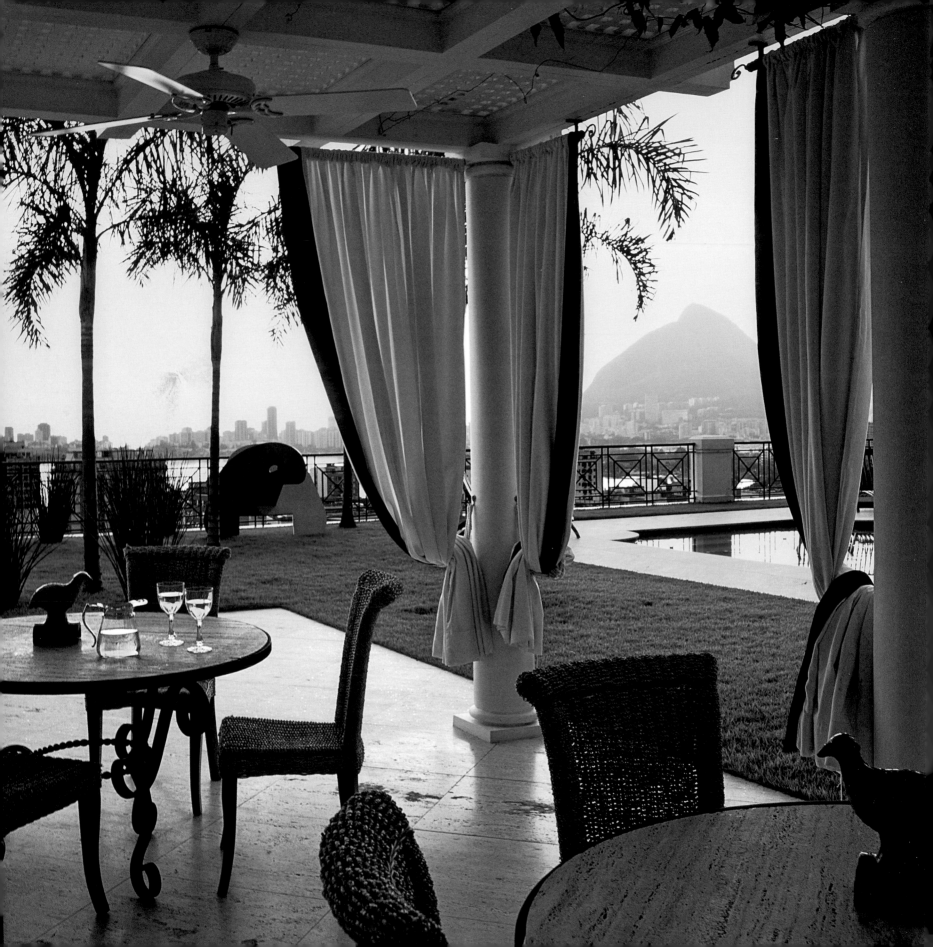

Contents

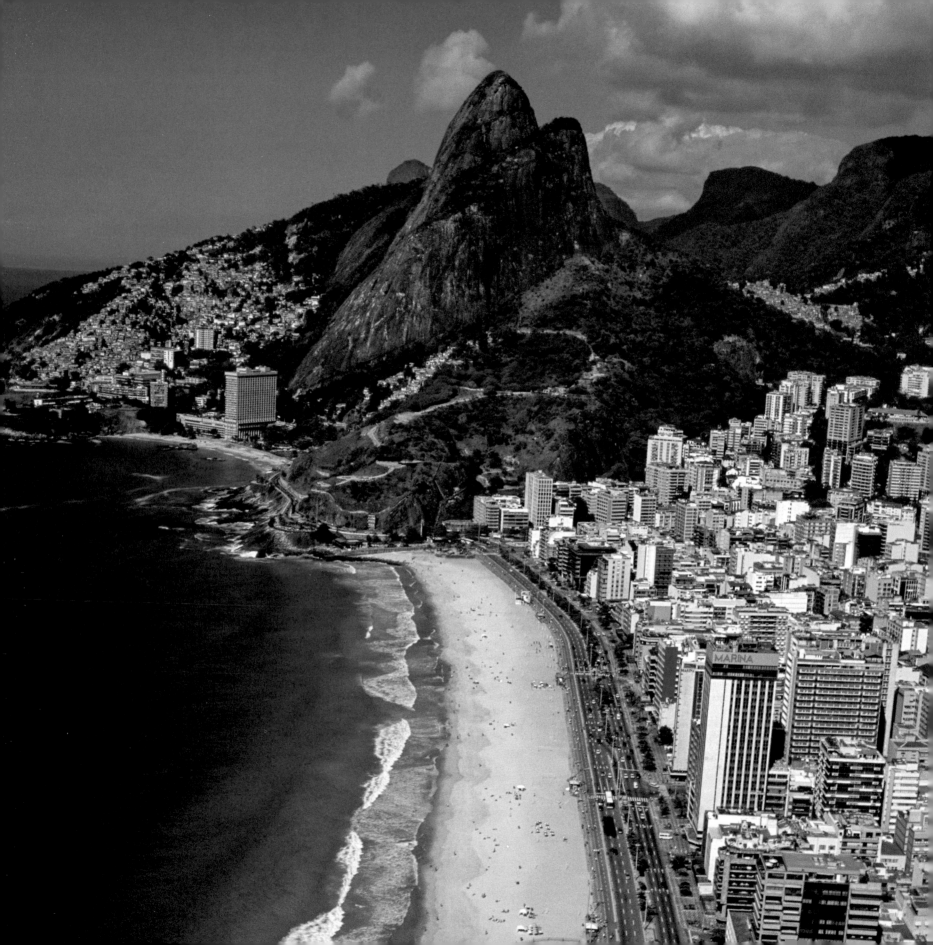

Introduction

Morro Dois Irmãos
(Two Brothers Mountain)
overlooks Leblon, Rocinha
and São Conrado, in the
South zone of the city.

The extraordinary geography of Rio de Janeiro, characterized by its great beauty, may give the city its body, but it is the people of Rio that give it its unique soul. No matter which area they live in or what their social background may be, the *Cariocas* (the nickname for anyone from Rio) are famous for their friendliness and good humour, qualities that are rare in the major cities of the world today, where hectic lifestyles take their toll. In Rio, however, city life is integrated with nature in such a way that the negative effects of modernity are mitigated, and the friendly nature of the people flourishes. Body and soul come together in a tightly-knit union, difficult to describe or classify in words, that gives the light-hearted spirit of Rio's inhabitants a distinctive flavour.

Any big city faces challenges and problems. Urban violence, pockets of poverty, lack of safety, competition, selfishness – the characteristics of any large metropolis of the West today – often seem to be part of the process of globalization. Nevertheless, Rio's natural setting favours relaxation, tranquillity and peace of mind. Whether it be the beaches, mountains or forests, the culture, or just a simple stroll along the city's streets: everything seems to encourage the Cariocas – and anyone who visits their city – to leave behind – or at least think less about – their everyday worries.

This local personality existed even before the Portuguese and the French began to fight over this land. The Tamoio and Tupinambá Indians passed on their original love of pleasure and the good life, demonstrating that they knew the value of play as well as work. This inheritance was so great that, even when times were tough, the Cariocas never lost their *joie de vivre*. This attitude led foreigners to apply stereotypes like laziness, arrogance, extravagance and fickleness to the local people. These characteristics, however, instead of offending or annoying the Cariocas, made them proud to be able to exhibit this profound love of life with such intimacy and spontaneity.

There is no doubt that nature lent a helping hand. What problems do not dissolve, for example, when walking on a sandy beach at sunrise or sunset? Taking a dip in the sea before going to work, or going on a trip to the forest on weekends, sipping a cold beer at sundown, or enjoying an

The home of Ricardo Cravo Albin, connoisseur of the popular music of Brazil, in Urca.

12

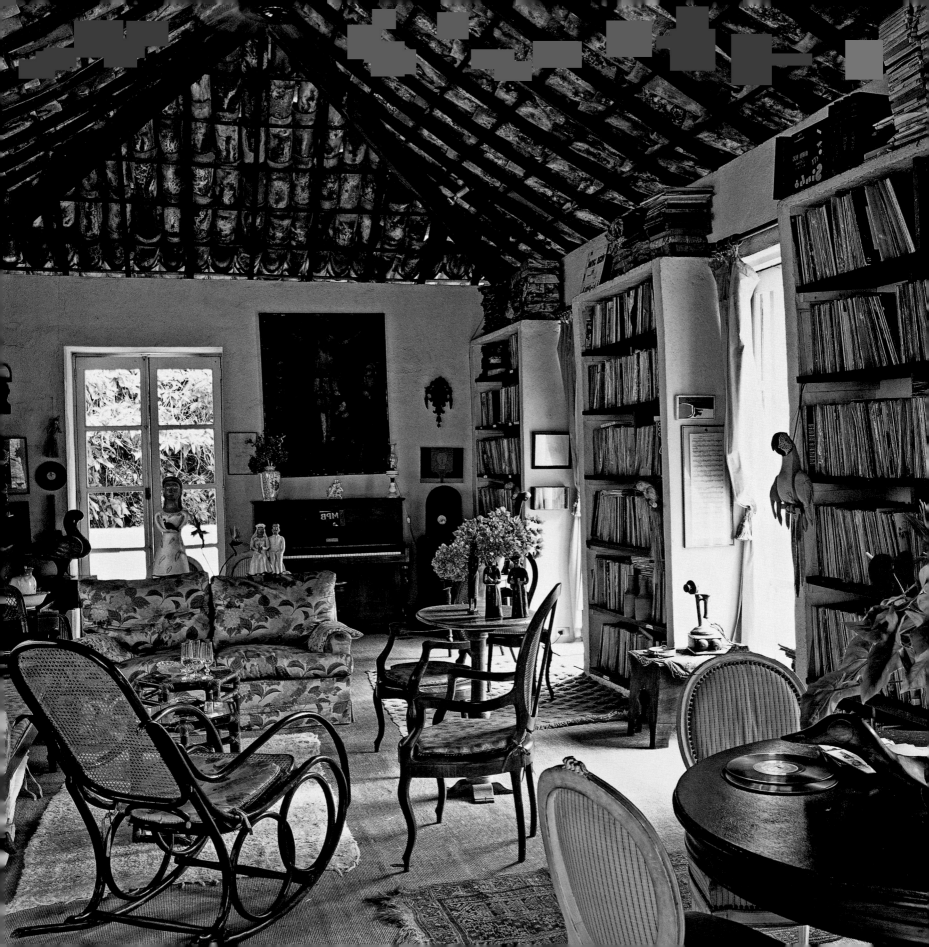

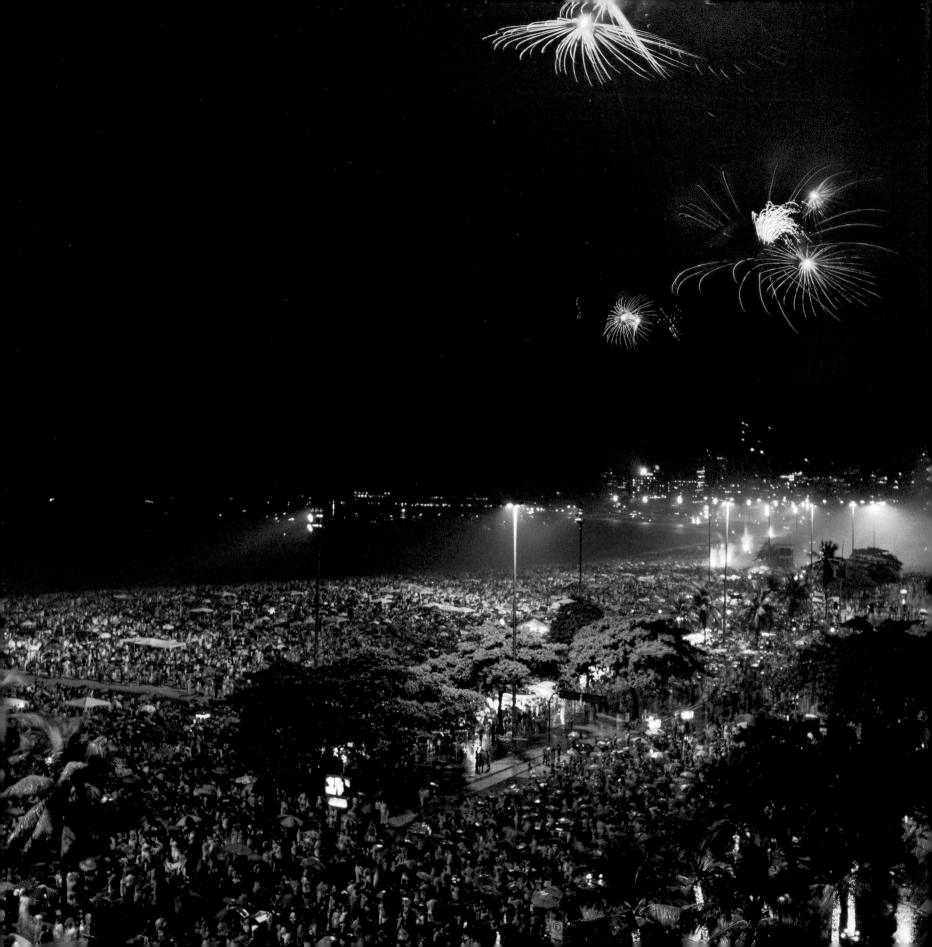

ice-cream cone from a street-corner stand? There is little room for bad moods in this setting.

In spite of this, Rio de Janeiro faces formidable challenges that, while not undermining the good humour of the locals, do weigh on their minds. Rio is the destination of the majority of the people who flee Brazil's northeast, escaping the droughts of the Sertão, a barren, scarcely populated, desert-like region, as well as migrants from the country's other less prosperous areas. The city's population has boomed in the last four decades, causing a series of crippling consequences, such as a lack of housing, a precarious public health system, increasing urban violence, more and larger *favelas* (the hillside shanty towns), poor sanitation in marginal areas, and an inadequate public transport network, among others.

These misfortunes place the city's inhabitants in the contradictory position of living in one of the best urban habitats in the world while confronting on a daily basis the problems caused by neglect of their environment, brought about by ineffectual social policies and a concept of town planning still based on outdated values, which no longer match the complexity of life in the globalized world of the 21st century.

Optimists, however, could take these contradictions and turn them into something positive: to explicitly outline the pleasures and pains of living in Rio de Janeiro is merely to describe the steps that sensitive developers should take to give this unique city the quality of life that it deserves.

New Year's Eve celebrations attract more than three million people to the two-and-a-half-mile-long beach in Copacabana, where Brazil's top entertainers perform on different beach-front stages.

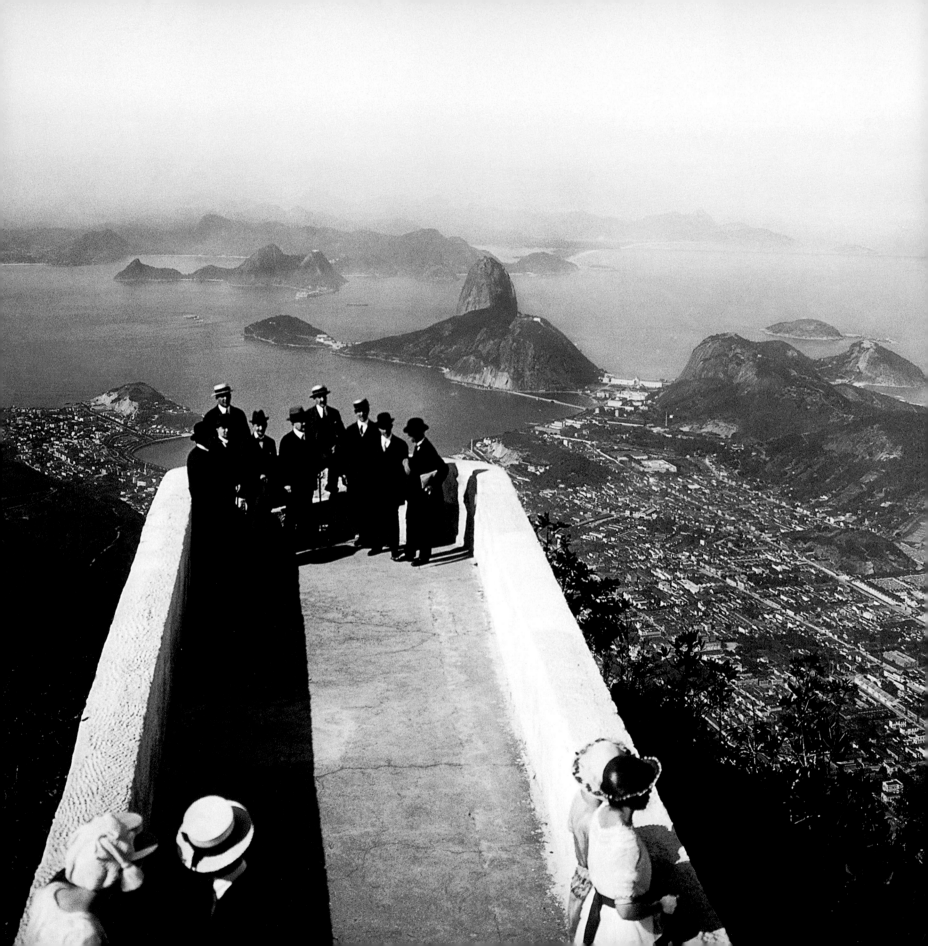

The History of Rio

The bewilderment of Portuguese sailors on reaching the Brazilian coast could not have been greater than at the moment they sailed into Guanabara Bay on 1 January 1502. Astonished by the exuberance of its unusual geography – composed of beaches, densely wooded valleys and mountains – they thought that they were navigating the mouth of a large river and decided to name the site São Sebastião do Rio de Janeiro (St Sebastian of the January River), in a double homage to both the saint and the Portuguese king. Their geographical error, however, was soon clarified, and the Portuguese discovered that the bay was really the Atlantic Ocean, and the territory, originally inhabited by Tamoio and Tupinambá Indians, had already been occupied by French invaders.

Their mistake was corrected, but the name, nonetheless, stuck and in that very first year, the Portuguese navigators began to build where Praia do Flamengo (Flamingo Beach) is today. The natives called these first constructions 'cariocas': the houses of the white man. The name caught on and, in a short time, the inhabitants of the city were being called Cariocas, as they still are today. The river that emptied into the ocean at that point in Guanabara Bay was baptized Carioca River.

The war to expel the French from the bay lasted years and cost many lives, with victories and defeats on both sides. Nevertheless, with the Portuguese's eventual conquest of the area under the command of Mem de Sá and later his nephew, Estácio de Sá, the moment came for the official founding of the city of São Sebastião do Rio de Janeiro on 1 March 1565. Unsurprisingly, given the maritime spirit of the site, the ceremony took place on a beach located between Pão de Açúcar (Sugarloaf Mountain) and Morro Cara de Cão (Dog's Head Mountain), two of the city's landmarks,

The statue of Cristo Redentor (Christ the Redeemer), on the Morro do Corcovado, has long been surrounded by intrigue. The work, attributed to French sculptor Paul Landowski (1875–1961), was officially inaugurated on 12 October 1931. Currently, however, there is a legal dispute over who was its true creator.

more than sixty years after the first Portuguese sailing vessel crossed the sand bar at the mouth of Guanabara Bay. But, in spite of its formal foundation, it still took a number of years to expel the French, who were determined to establish the colony of 'France Antarctique' here.

With its many beaches, defending the city required the construction of forts and watchtowers to fend off pirates and invaders, but more than this, it encouraged the colonization of the region. The Portuguese established the first seat of their government at Morro do Castelo, where they built a fortress and a Jesuit school. The city's centre and the heart of the community sprung up here, stimulating further urban growth. Little by little, other Catholic orders settled nearby; with them came soldiers, merchants and adventurers (most of whom were poor Portuguese immigrants or exiles from Europe) and the city grew even further, following a typical medieval pattern of streets and buildings.

At the end of the 16th and the beginning of the 17th century, the original settlement spread. The swamps and marshlands, so common to the area, were drained and filled. At the beginning of the colonial period, Portuguese authorities granted settlers permission to move further inland and build their homes as best suited them, exempt of all taxes. The objective of the Portuguese Crown was to occupy as much land as possible and thus guarantee and consolidate Portuguese rule over the region.

This painting, from the collection of banker and economist Paulino Basto, shows the Morro do Corcovado as seen from the Botanical Gardens. It was painted before the construction of the statue of Christ the Redeemer.

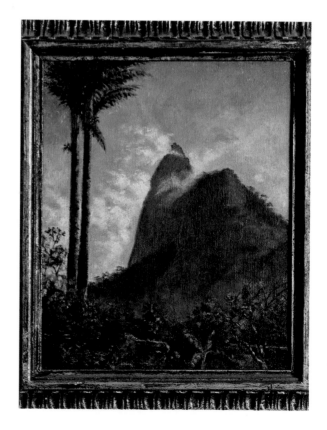

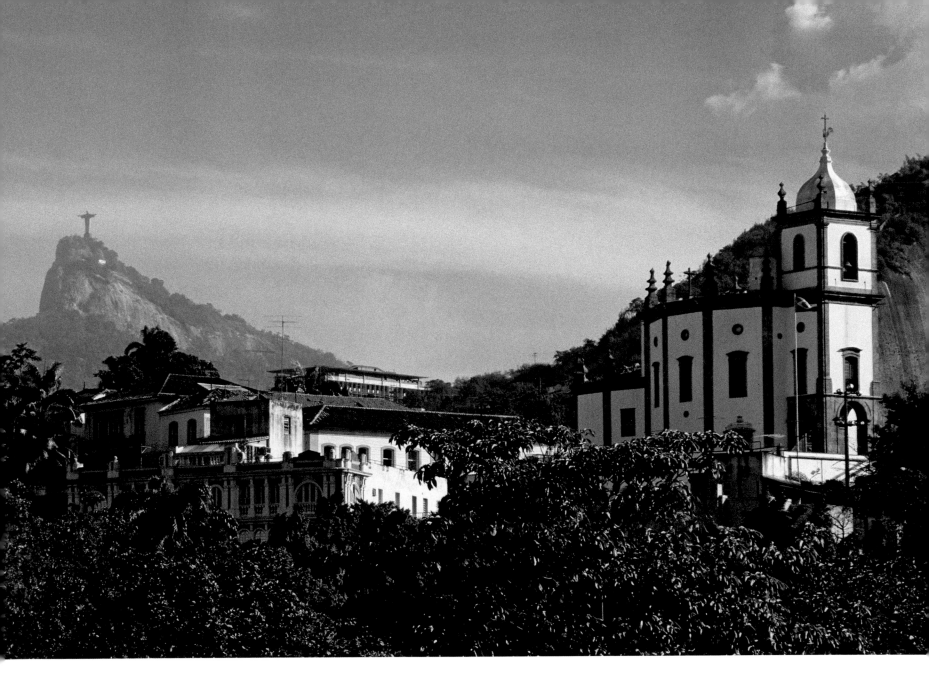

In Flamengo, under the open arms
of Christ the Redeemer, the colonial
features of Rio's centuries-old
churches bring back memories of the
city's past, one that is also marked by
the overwhelming presence of nature.

The territory was also coveted by other nations, particularly by the French, as well as by the local indigenous people, who had been expelled from the lands of their ancestors.

One of the main thoroughfares at that time was called Rua Direita (Straight Street); the road joined Morro do Castelo with São Bento. Midway between these two points, the Carmelite Brothers built the chapel of Nossa Senhora do O. The Order's chapel led to the creation of the first of the city's squares, known as *largos* or *praças*. It was originally called the Largo do Carmo, then the Largo do Paço, and today it is known as Praça XV, a large port area where gems and spices from the interior were traded. The discovery of gold in Minas Gerais turned Rio into a major trading centre, through which the precious metal was exported from Brazil exclusively to Portugal.

Through the administrative abilities of the Jesuits and the Crown's land concession policy, the north and west of the city were gradually settled in a more organized manner. This process coincided with the construction of the first *engenhos* or sugar refineries. Many places still derive their names from this industry: Engenho Novo, Engenho Velho, Engenho de Dentro, Realengo (an abbreviation for Real Engenho), Engenho da Rainha and Engenho de Santa Cruz are all examples.

Moving toward the South zone of the city, the main highway borders the Carioca River, hence its name, the Caminho Carioca. It runs along the Glória and Flamengo beaches. In colonial times, the

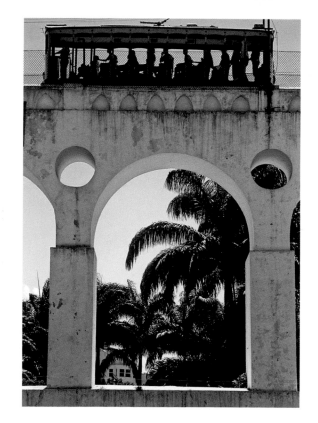

Right:
The arches of Lapa were built in 1744 to support an aqueduct that carried water as far as Santa Teresa. They now carry a tram line that connects the centre of the city with the Santa Teresa neighbourhood.

Far right and opposite:
The Candelária, one of the city's richest churches, was built in the 17th century. Located in the heart of the Centro, at the intersection of Avenidas Rio Branco and Presidente Vargas, the building has been witness to many important historical events.

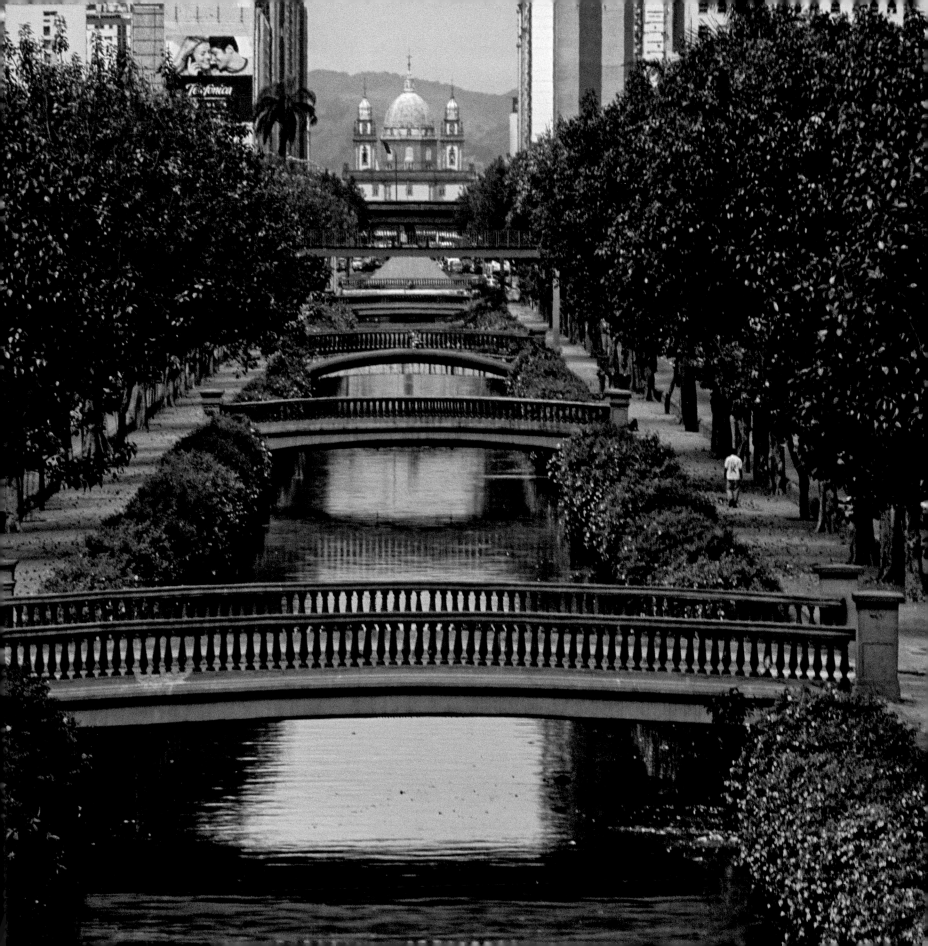

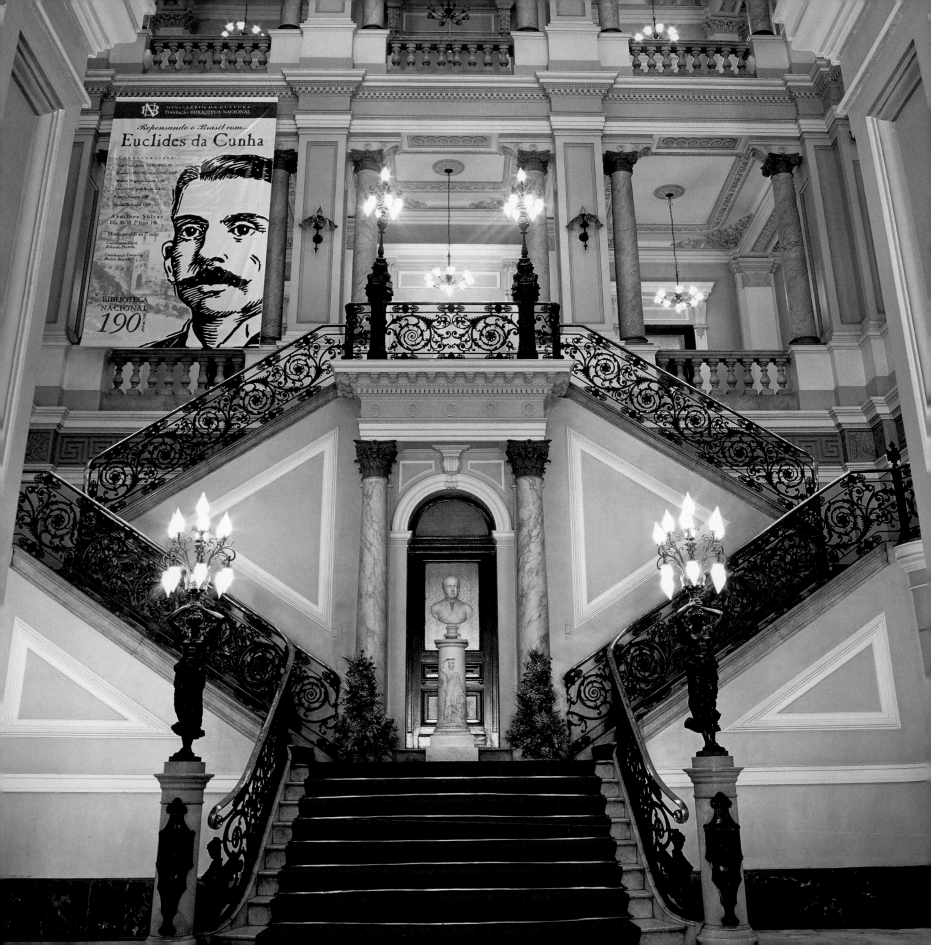

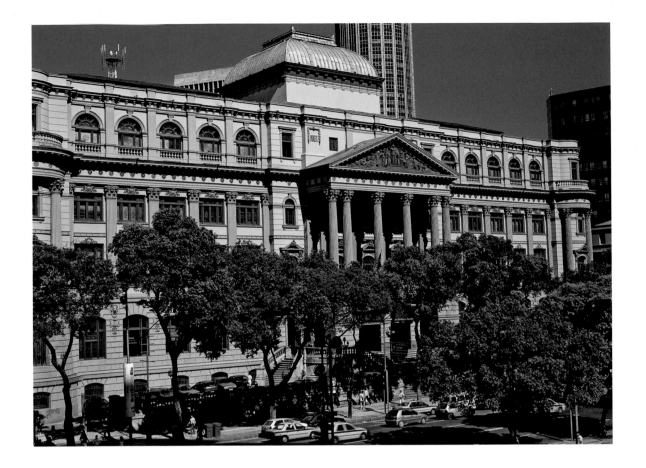

Left and opposite:
The National Library
conserves the largest archive of
books and documents in Latin
America. Built between 1905
and 1910, the foundation stone
was set in 1908, when the
prince regent Dom João VI
donated the material his
family brought from Portugal.
The building was designed by
Marcelino de Souza Aguiar
in an eclectic style, with
many neoclassical and art
nouveau elements.

city's southernmost border was Botafogo, but there were very few houses then. In addition, the Carioca ran into natural barriers: the chain of hills that isolate Copacabana, Ipanema, Gávea and Leblon, as well as the large Lagoa de Sacopenapã (now called Rodrigo de Freitas). The original name in Tupí-Guaraní means 'Lake of the *socós*', a typical bird of the region. With the exception of a few farms, these areas were practically deserted. Winding paths and dangerous roads made access difficult.

Throughout the 18th century, the French continued a policy of sporadic invasions, all of which were repelled by the Portuguese. In spite of the periodic disturbances, the determination to settle the city gradually produced results. Progress brought pavement to the main streets in the centre, the channelization of the Carioca River, and in 1723, the construction of the Carioca Aqueduct (now the Arcos da Lapa), which brought fresh water from the source of the Carioca River to a fountain built in the Campo de Santo Antonio, first christened the Chafariz da Carioca, later the Campo da Carioca, and nowadays known as the Largo da Carioca, a square that is a landmark of central Rio. The aqueduct was the city's first major public work.

Inspired by Garnier's Opera in Paris, the Municipal Theatre building was opened in 1909 and is one of the largest and most luxurious theatres in Rio de Janeiro. The principal hall has a capacity of 2,357 people.

The discovery of gold and precious stones in Minas Gerais turned Brazil into Portugal's wealthiest colony and Rio de Janeiro into the Empire's principal overseas port. In 1808, the Portuguese royal family, including the king and prince regent Dom João VI, arrived at Guanabara Bay, accompanied by many members of the court, fleeing from Napoleon Bonaparte's expansion throughout Europe.

The presence of the King of Portugal, in what appeared to be self-imposed exile, stimulated the growth of the city. Rio began to take on a cosmopolitan and European social atmosphere. One of the monarch's first steps was to name Rio de Janeiro the capital of the United Kingdom of Portugal, Brazil and Algarve (1815), which meant a transfer of royal power from Lisbon to Rio. In addition, the Portuguese Crown decided to open the ports of Brazil, integrating both the country and above all the Imperial capital with the rest of the world. Following this decision, the first groups of immigrants,

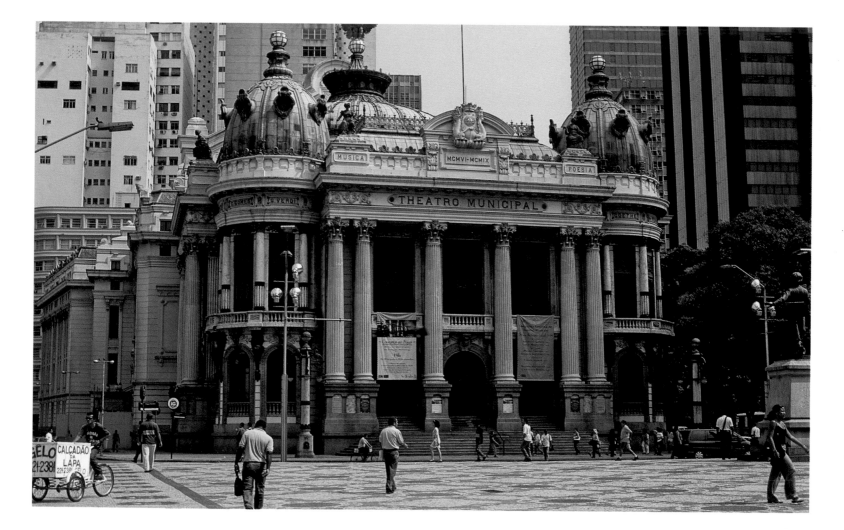

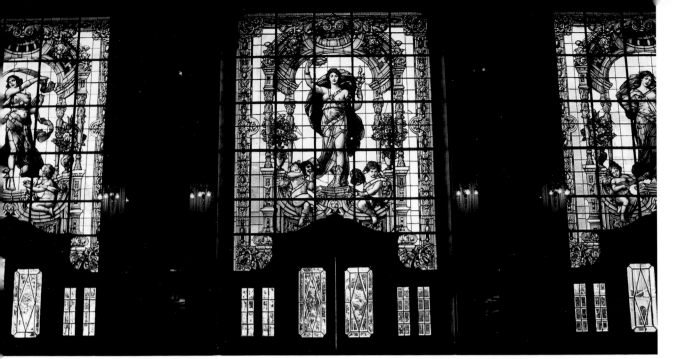

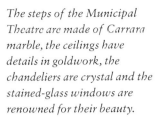

The steps of the Municipal Theatre are made of Carrara marble, the ceilings have details in goldwork, the chandeliers are crystal and the stained-glass windows are renowned for their beauty.

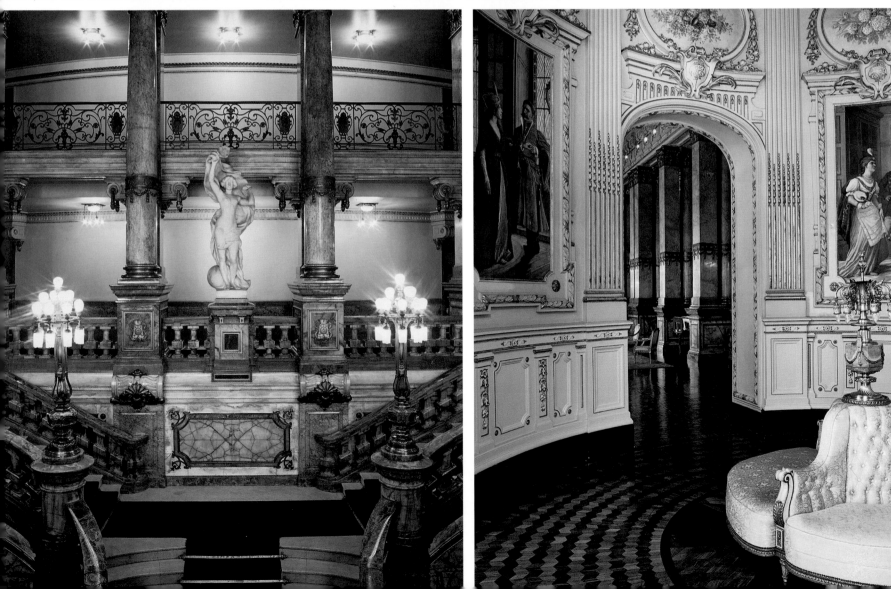

particularly from England, began to arrive, and the name of Rio de Janeiro was finally etched onto the map of the world.

Dom João VI installed his entourage in the Largo do Carmo (Praça XV), which became the royal palace. In the thirteen years he remained in power, the king promoted the rapid expansion of the city. There was also progress in the realm of culture, with the opening of the Botanical Gardens, libraries and theatres. In 1822, Brazil declared its independence from Portugal, and Rio de Janeiro went from being capital of the Kingdom to becoming the capital of the Empire of Brazil, with Dom Pedro I as its first Emperor.

During this period, the public transport network expanded, and a new network of streetcars pulled by donkeys brought a further wave of expansion to the city's more remote corners. The building of the Dom Pedro II Railway, today known as the Central do Brasil, was a major turning point, which allowed the capital to be connected with the interior of the State of Rio de Janeiro and other more distant regions, principally the industrial centres of São Paulo and Minas Gerais.

During the period between the mid-19th century and the end of the Brazilian monarchy in 1889, Rio's authorities developed a system of gas-powered public streetlights, channelized the Maracanã River, and set up infrastructure for public utilities, such as the installation of telegraph

Right and opposite:
Founded in 1950 at Praia
Vermelha, the Institute of Fine
Arts was moved to Parque
Lage in 1966. The house where
the school now operates was
built by its original owner,
Henrique Lage, as a gift for an
Italian singer with whom he
had fallen in love.

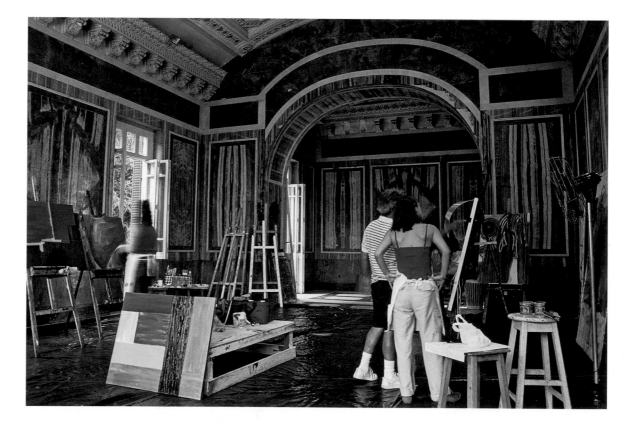

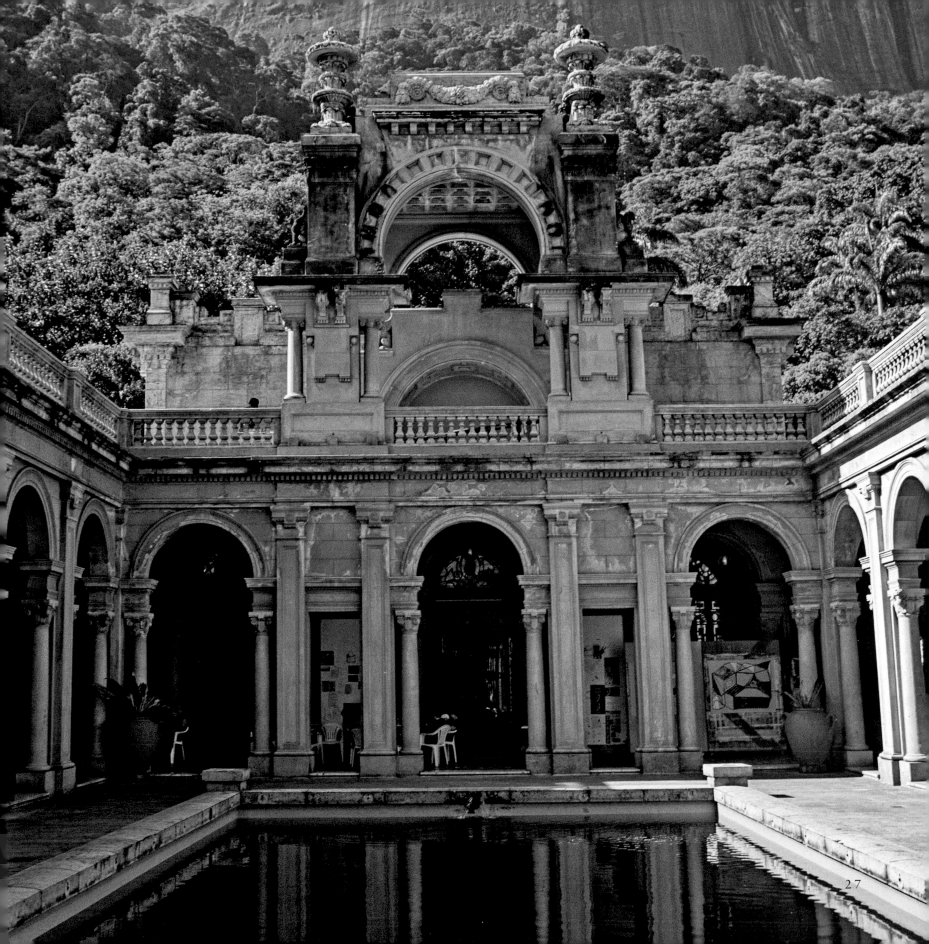

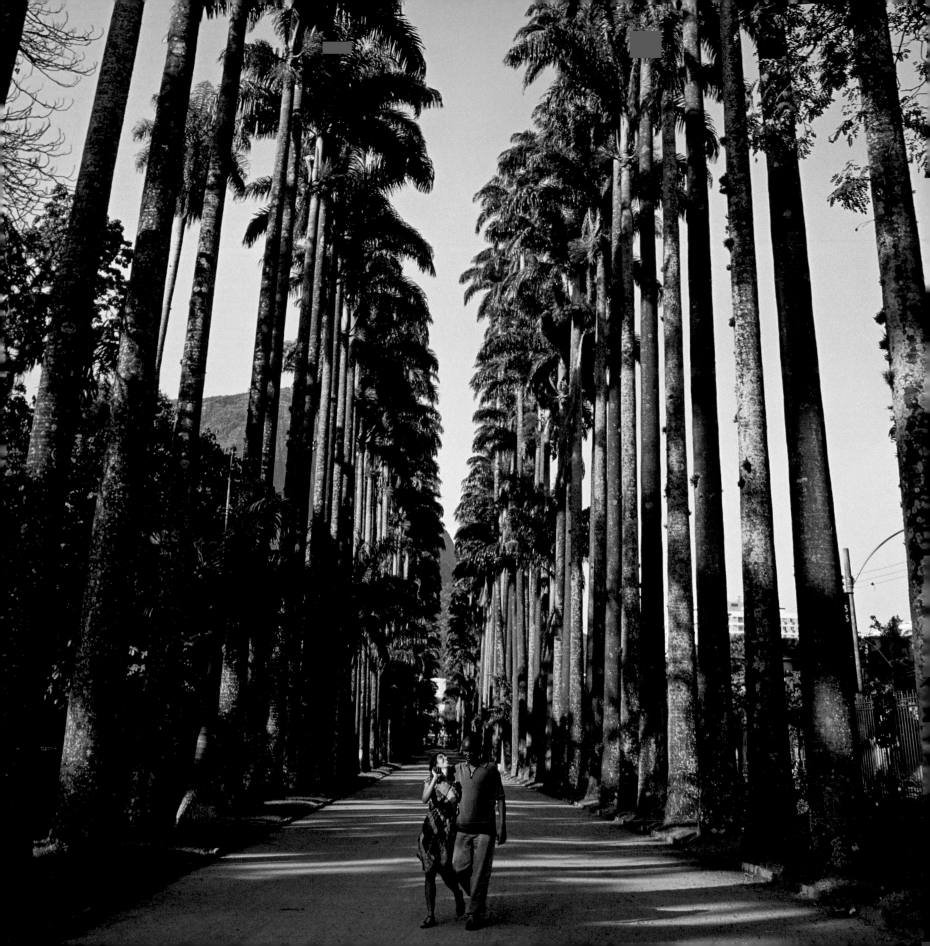

The prince regent Dom João VI created the Jardim Botânico (Botanical Gardens) in 1808 to house the plants brought from the East Indies by an expedition commissioned by the royal family, who had moved the court of Portugal to Brazil, when faced by the threat of Napoleon's troops. The rows of palm trees (Roystonea oleracea) that form a striking entrance to the Botanical Gardens were planted on the orders of the Prince himself and have earned the illustrious name of royal or imperial palms.

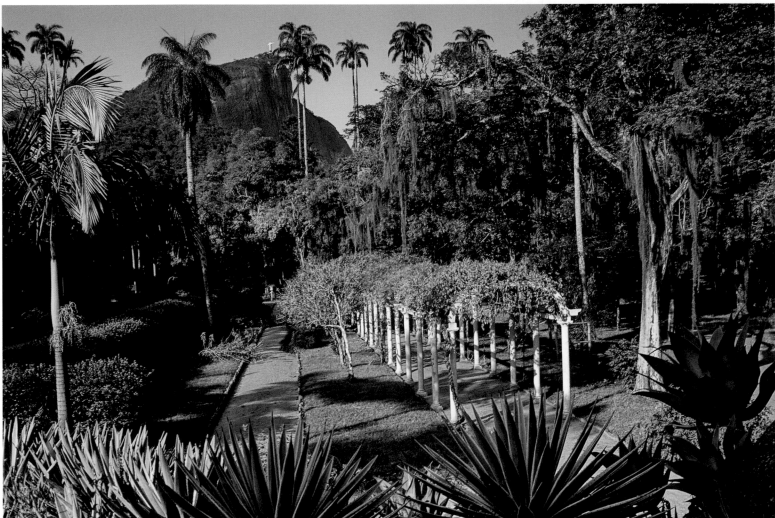

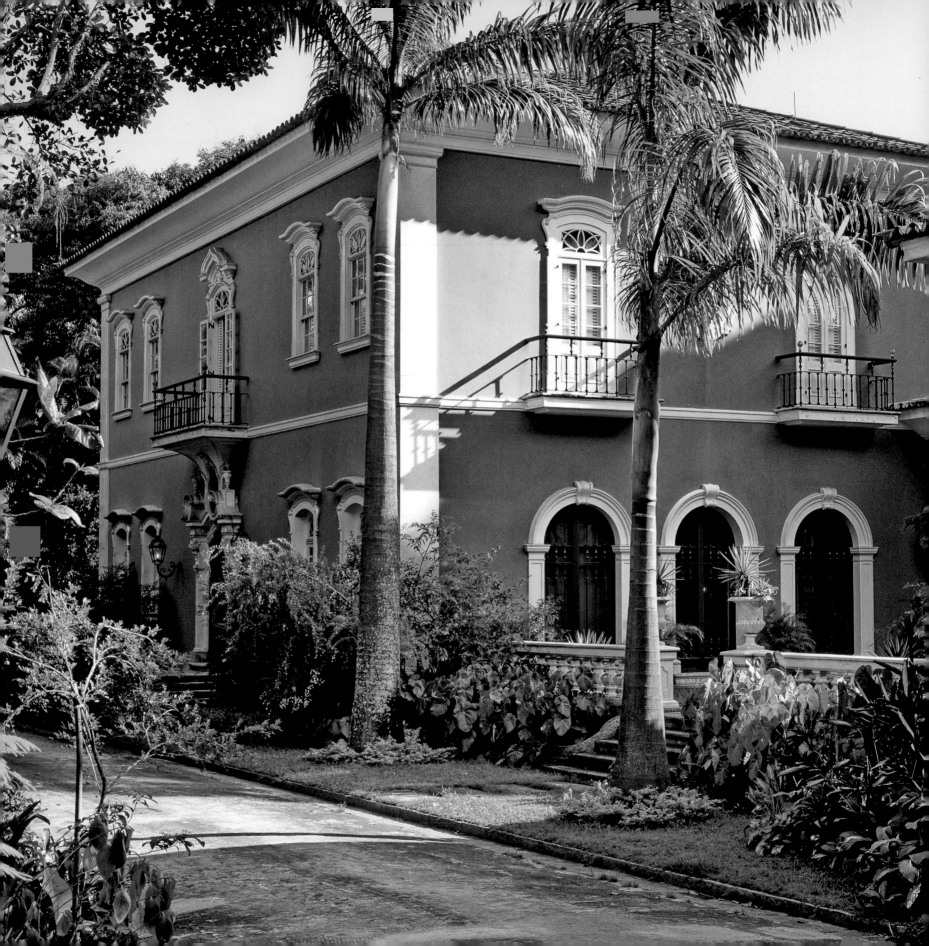

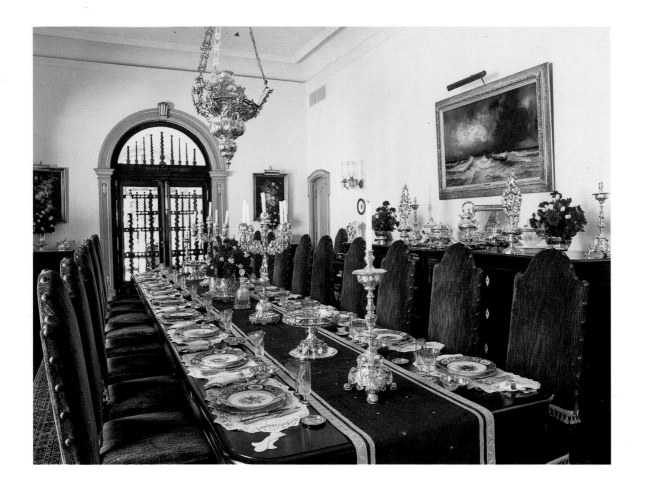

offices, and the creation of public sanitation and sewer systems. These changes were accompanied by the setting up of other new institutions, such as law courts and a municipal fire department.

It was a period of rapid urban growth, sparked by construction projects initiated by the private sector. Buildings, churches, convents and stores sprung up all over the city. Streetlights were now powered by electricity instead of gas and a telegraph service was inaugurated. The Floresta da Tijuca was reforested, the results of which have converted Rio into one of the few cities in the world with a forest within its urban centre. The Túnel Real Grandeza (now the Túnel Velho) was built in 1892. It linked Botafogo with Copacabana by tram and so accelerated the development of a neighbourhood which, since the 1940s, has become a showcase of Carioca modernity and bohemian society.

The final decades of the 19th century are considered to be the period of the greatest urban transformation in Rio de Janeiro. These changes were stimulated by an economic, political and social revolution that altered the city's appearance forever, giving Rio a more cosmopolitan appearance. In 1889, the monarchy ended, and the Republic of Brazil was proclaimed. Rio de Janeiro, which had

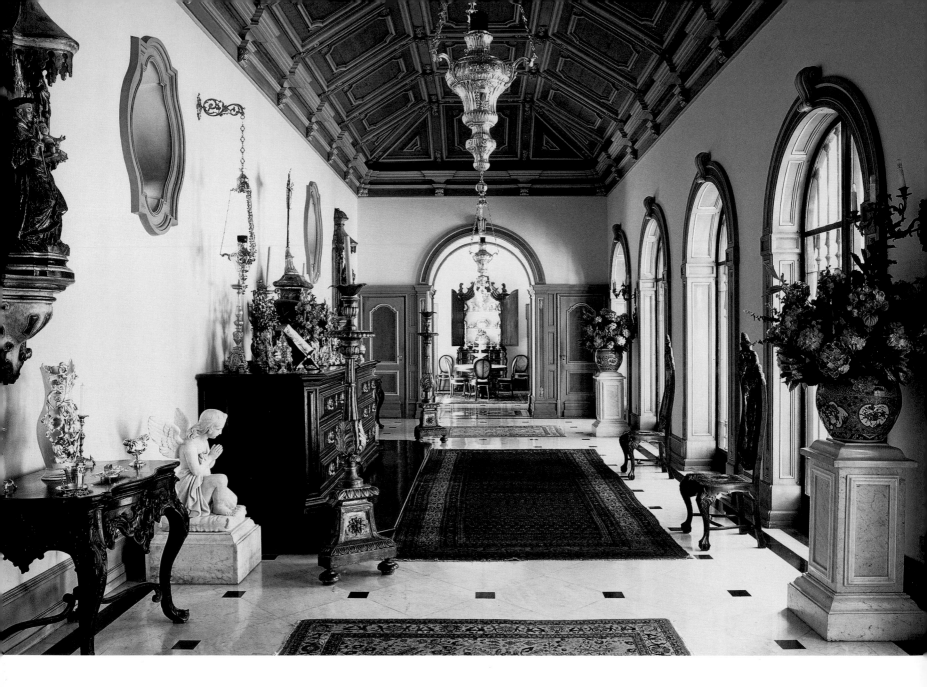

been the capital of the Portuguese colony, the kingdom, and the empire, now became the central city in a new political system. It was a time of great institutional pride for Rio, the new republic's political and cultural centre. This prestige would endure, if in a less obvious manner, even after the transferral of the nation's capital to Brasilia in 1960.

With the arrival of the 20th century, the process of change intensified, with revolutionary urban development projects promoted by mayors who wanted to model the city on Paris. Mayor Francisco

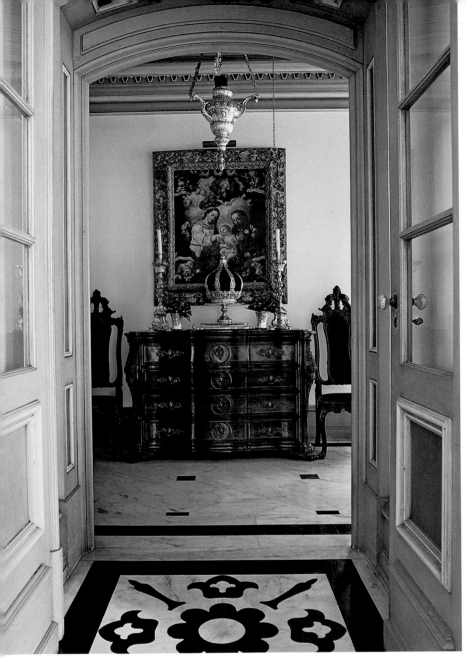

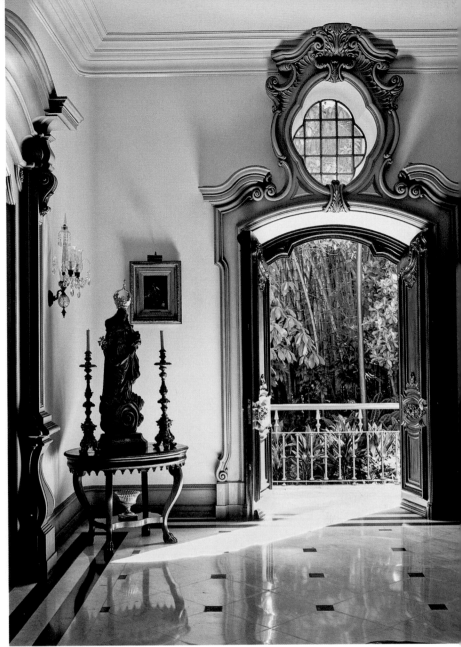

Shortly before his death, Brando Barbosa transformed the Mansão do Jardim Botânico into an art institute. From the flooring to the ornamental details, the house is characterized by its architectural elegance. This sumptuousness is also reflected in the decoration and the works of art, especially paintings, sculptures and silverware. The mansion is now the home of Luma de Oliveira and her two sons, Thor and Olin.

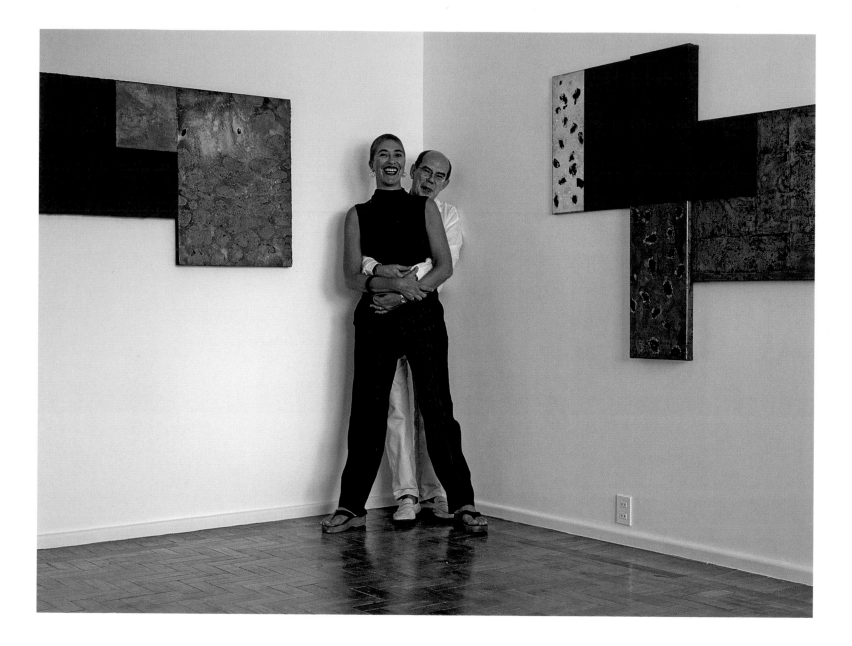

Pereira Passos, in the first decade of the new century, initiated a brisk process of urban renewal, tearing down large areas of buildings that dated back to colonial times. The basic motive for this redevelopment was to eradicate the epidemics and diseases that originated in these neighbourhoods, but it was also part of a grander, more ambitious scheme, based on Enlightenment ideas. The Parisian model of broad avenues and boulevards, multi-family buildings, and a clear and rational vision of urban planning inspired the Mayor to envision a modern, cosmopolitan and republican city.

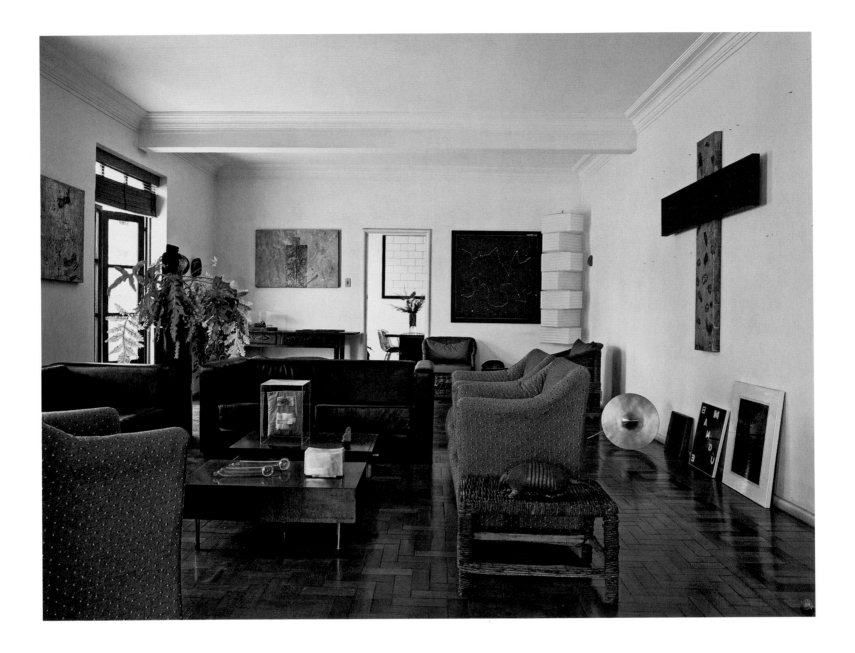

Above and opposite:
Painter Antonio Dias, one
of the most important
contemporary Brazilian artists,
together with singer Lica
Ceccato. Dias participated
in the landmark exhibition

Opinião 65 *at the Museum of*
Modern Art, which marked
the beginning of his career.
Considered a rebel and a
nonconformist, his art
challenges convention.

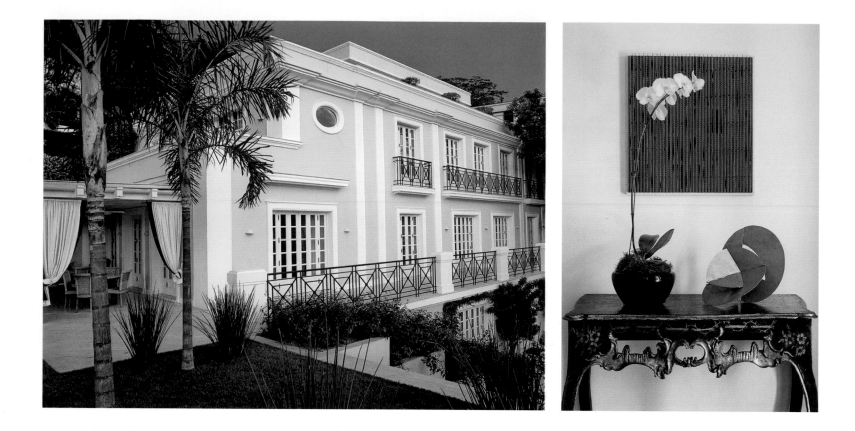

Pereira Passos was also responsible for the opening of the Túnel do Leme (today the Túnel Novo) in 1906, providing a second route to Copacabana, as well as the construction, that same year, of Avenida Princesa Isabel and Avenida Atlantida, which led to the growth of Copacabana. The largest contribution to the urban landscape during his administration was, without a doubt, the opening of Avenida Central (today called Avenida Rio Branco), which connected the city's new docks with the Passeio Público. During the thoroughfare's construction, 650 humble dwellings were demolished, earning the mayor the nickname of *Bota-Abaixo* (Tear-It-Down). To achieve their goals, the local authorities imposed their will arbitrarily, removing residents by force, if necessary, from their homes.

In addition to the Avenida Central and the opening of the Túnel Novo, Pereira Passos also built other major avenues: Beira Mar, Rui Barbosa, Niemeyer and Praia de Botafogo. With Avenida Atlantica in Copacabana, the Mayor connected the centre of Rio to the South zone with a coastal road, taking advantage of the best that Rio has to offer: the landscape. Inspired by the boulevards of Paris, the mayor also widened the old streets in the downtown area, broadening several avenues, for example: Passos, Mem de Sá, Uruguaiana, Assembléia and Carioca. The sumptuous Municipal Theatre (1909), a National Library and School of Fine Arts, all examples of the eclectic style of architecture, were further additions to this revitalized urban landscape.

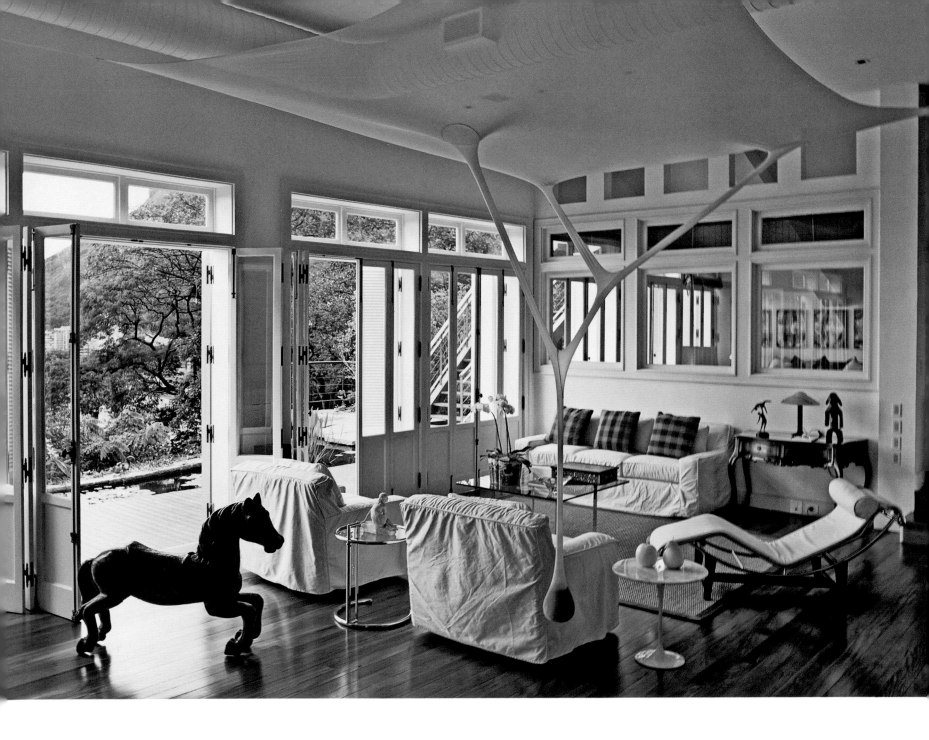

Frances Marinho's living room includes major works by Ernesto Neto and Le Corbusier, and is an example of dynamic harmony in interior decoration. The fine wooden floor and white furniture allow the landscape outside to play the dominant role in creating an atmosphere.

If, on the one hand, this was a Rio created by the plans of Mayor Tear-It-Down, it was also the Rio of the Belle Époque. The price of progress was the destruction not only of old buildings, but also of a way of thinking and acting that no longer matched the norms of community life and social interaction in a Republican society. The revolution that was characterized by these great public works was accompanied by a change of mentality and a different global outlook. But the implementation of these changes, imposed in a harsh and authoritarian way, provoked protests and resistance from those who had been displaced by the demands of 'progress'.

With the abolition of slavery in 1888, the waves of European immigrants (mostly Portuguese, Italian, German and Spanish), in addition to migrants from the north and northeast of Brazil, provided the labour needed by emerging industries. Meanwhile, white-collar workers were now required to fill posts in the bureaucratic and civil services, and to work for the government's legislative, judicial and executive bodies. This resulted in the establishment of both a working class and a middle class. The Rio of the Belle Époque was, ultimately, a modern and cosmopolitan city.

Cildo Meireles is an artist from the generation of 1970, known for his controversial art. His work often has strong political overtones, such as his cruzeiro *banknotes stamped with the question 'Who killed Herzog?', in reference to a journalist who was assassinated in prison during the military regime. At the age of 52, Meireles was given a retrospective exhibition at the Museum of Modern Art in São Paulo in March 2006. After some time spent in New York, the artist now lives in Rio de Janeiro once more.*

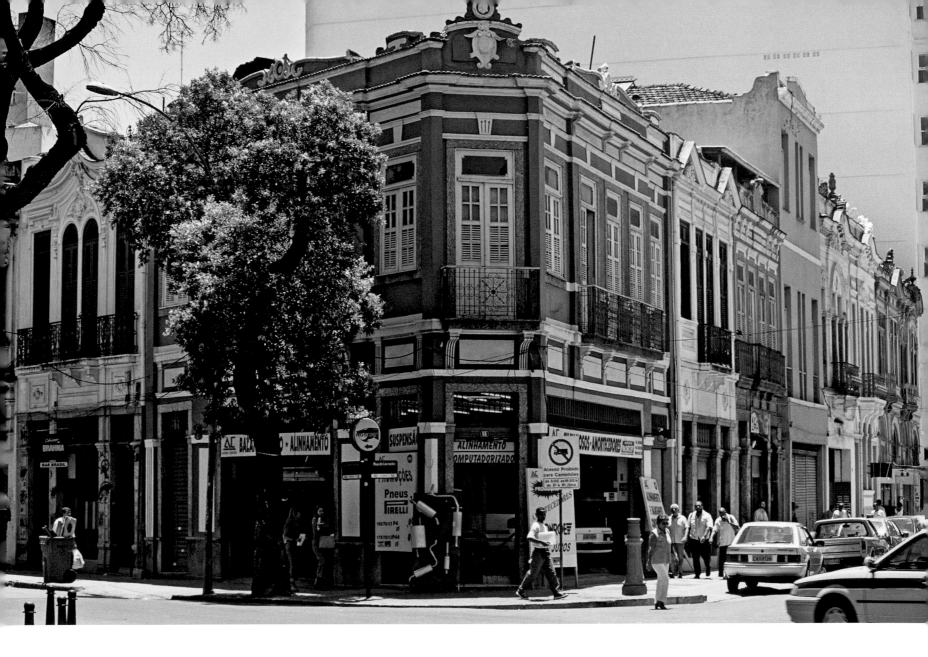

The population, once restricted to their homes, now began to spend more time on the avenues and boulevards. The figure of the *flâneur* or city wanderer appeared, and Cariocas discovered the street as a meeting place, an opportunity to socialize. Cafés and bars sprung up, where politicians, journalists, intellectuals, artists and other bohemians could spend their free time. At the same time, however, vagrancy and alcohol abuse among the working classes was vigorously repressed, with a prison term of up to six years given to those caught in bars without proof of employment.

During the 1920s and 1930s, the process of change continued to get faster. The Week of Modern Art festival in São Paulo in 1922 influenced the artistic life of Rio. That same year, a major

The houses on the corner of Rua Mem de Sá and Rua do Lavradio in Lapa are typical of Rio architecture from the late 19th-century.

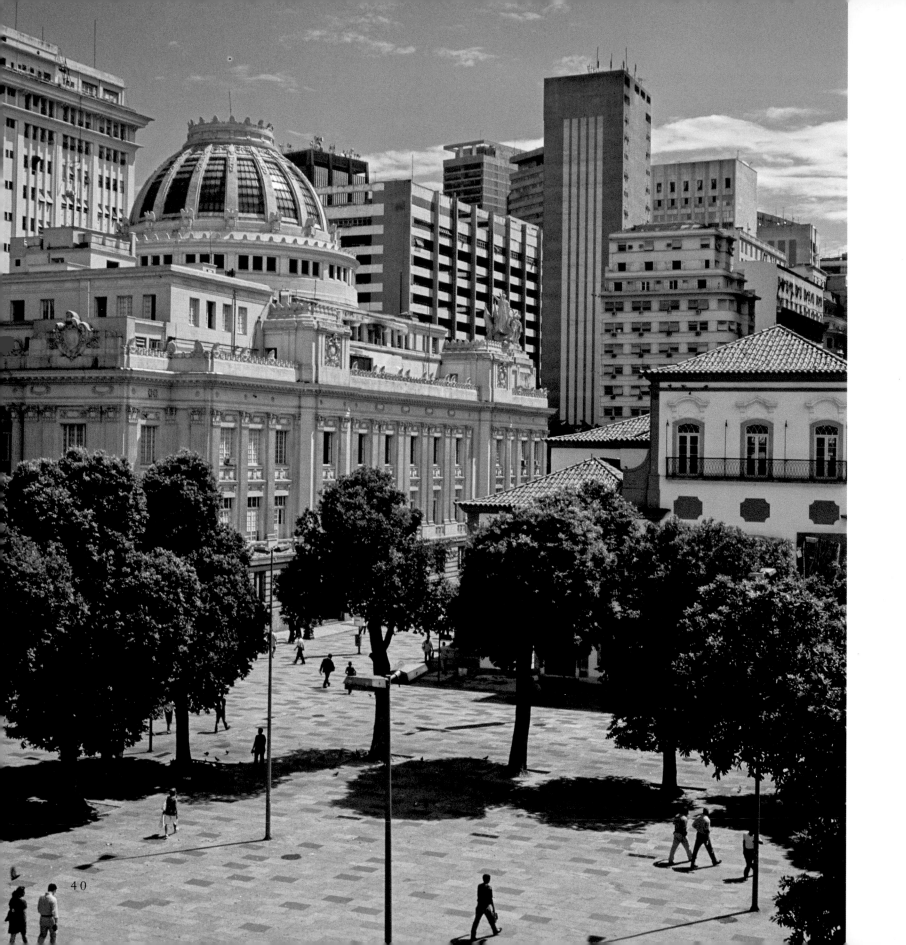

Opposite:
The Palácio Tiradentes, built in 1926,
is the home of Rio's Legislative
Assembly. Set on Praça XV, it stands
in front of the Imperial Palace, built
in 1743, which was formerly the
residence of the colonial governors.

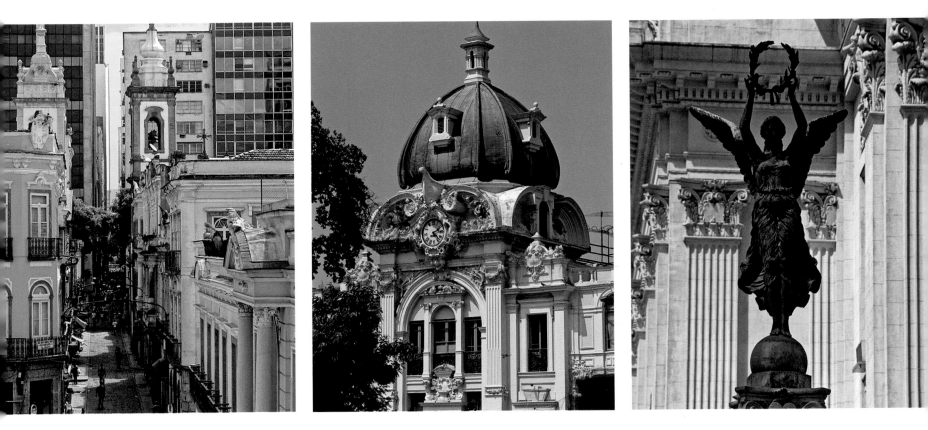

Above:
Hidden between the skyscrapers of
the cosmopolitan Centro district are
many architectural and historical
treasures: colonial churches with their
sumptuous towers, the domes of
grand houses in the Moorish style and
statues from the Republican period.

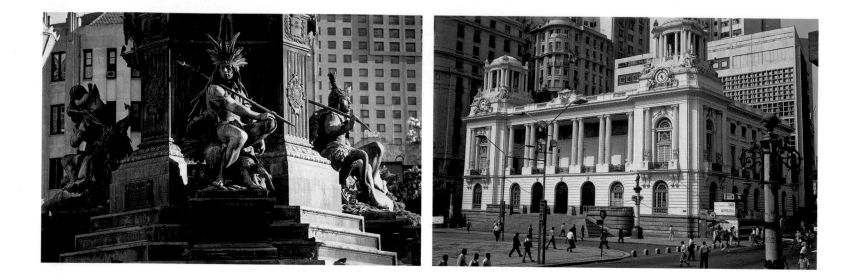

festival was organized in Rio: the International Exhibition of the Centenary of Independence. The Revolution of 1930, which brought Getúlio Vargas to power, signalled an era of institutional change and innovation that clashed with the traditional values of colonial times. The city grew at a dizzying pace, and the architectural styles that predominated were eclectic, art nouveau and neoclassical. The modernist style, however, quickly came into vogue, turning Oscar Niemeyer and Lúcio Costa into the stars of a new national architecture.

Morro do Castelo, that first urban centre founded by Portuguese settlers, began to be demolished in 1922. New buildings included the Hotel Glória and the Museum of Image and Sound. In 1923, the neoclassical Palácio Pedro Ernesto was inaugurated. The Copacabana Palace Hotel, designed in the Louis XVI style by French architect Joseph Gire, was built that same year. Art deco arrived in Rio in 1930, and many new buildings bore its hallmarks, especially in Copacabana. The Casa Cavé, a café that rivalled the famous Confeitaria Colombo, boasted a stylish art deco design.

In the 1920s, Rio's Carnival, in all its many and varied forms, began to flourish. The ever-growing nature of the event turned the annual festivities in one of the highlights of Brazil's cultural tradition. The anarchy and the disorder of the *blocos*, the impromptu Carnival gatherings, and the *cordões de rua*, groups of street performers, are what give the celebration its enduring appeal.

The first recorded samba, a form of music in 2/4 or 4/4 time with a syncopated rhythm, was *Pelo Tefefone* ('By Telephone'), composed in 1917. By 1926, the coming together of intellectuals such as Gilberto Freyre, Sérgio Buarque de Holanda and Prudente de Morais with samba composers and musicians like Pixinguinha, Donga and Patricio Teixeira guaranteed the success of this new form of musical expression. The Portela samba school began life as a *bloco* in 1923 and the Mangueira school followed in 1928. The term that is so familiar to us today, *escola de samba*, appeared a year later.

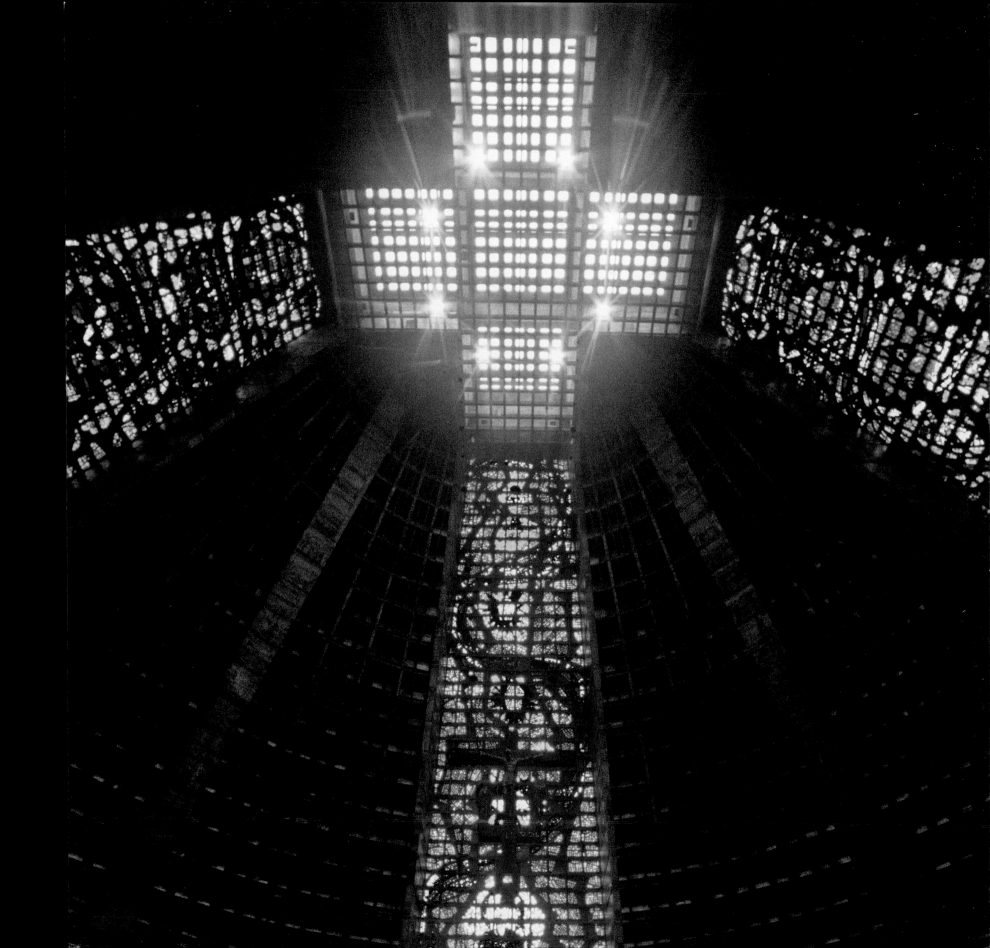

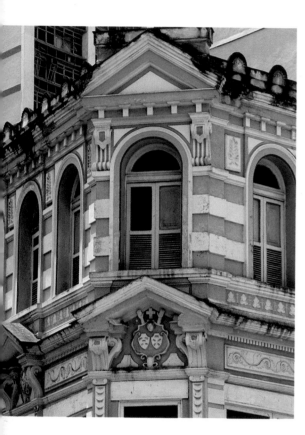

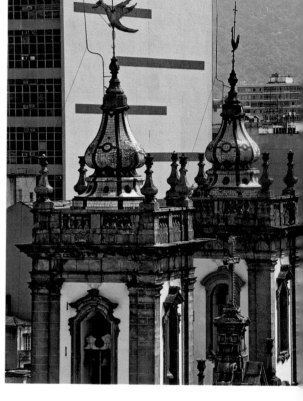

Known as a popular shopping thoroughfare, Rua Buenos Aires marks the border of the Saara market, a centre for shopkeepers of Syrian, Lebanese and Sephardic Jewish origin, who all share the space in harmony. At the beginning of the

20th century, most of the buildings were two-storey houses, known as sobrados, *with the shop on the ground floor and living space for the shopkeeper's family on the floor above. Today, both floors are filled with shops or offices.*

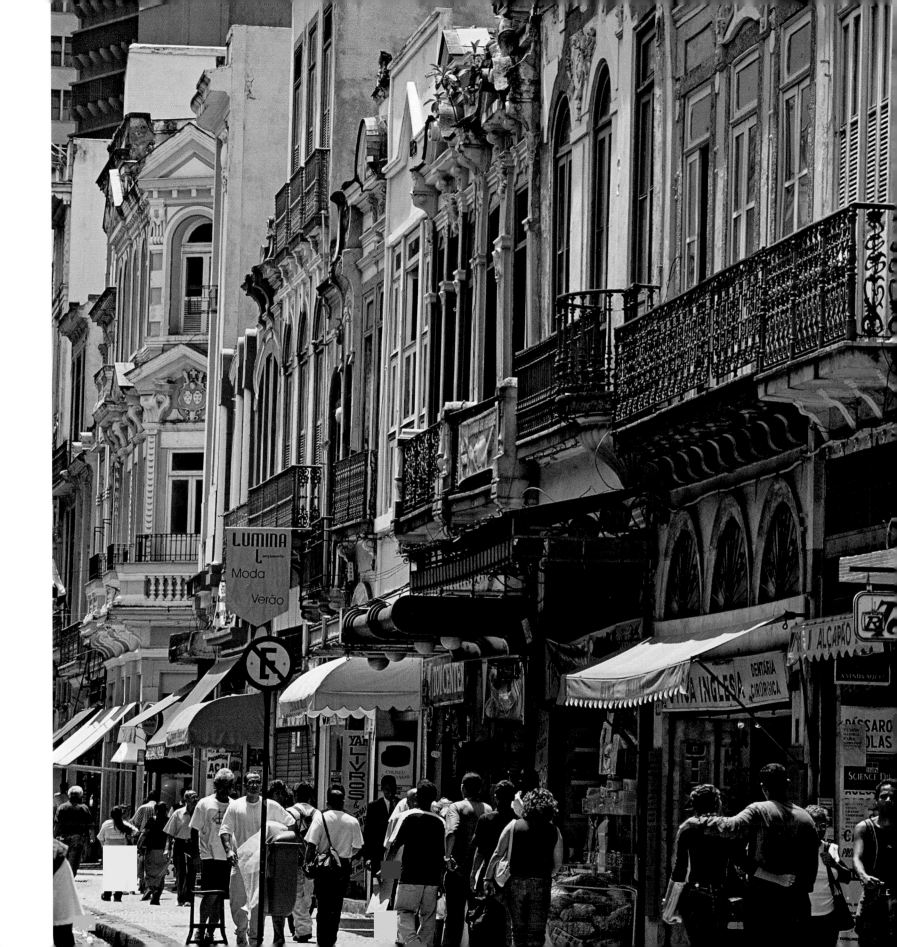

The Real Gabinete Português de Leitura is one of the most fascinating libraries in Rio. Inspired by the façade of the Monastery of the Jerônimos in Lisbon, the library is decorated in the manuelino *style (after Portuguese king Manuel I). With 350,000 volumes, its collection is only surpassed by that of the National Library. The building, which was started in 1880, was designed by Portuguese architect Rafael da Silva y Castro. It is considered to possess the greatest collection of work by Portuguese authors outside of Portugal itself.*

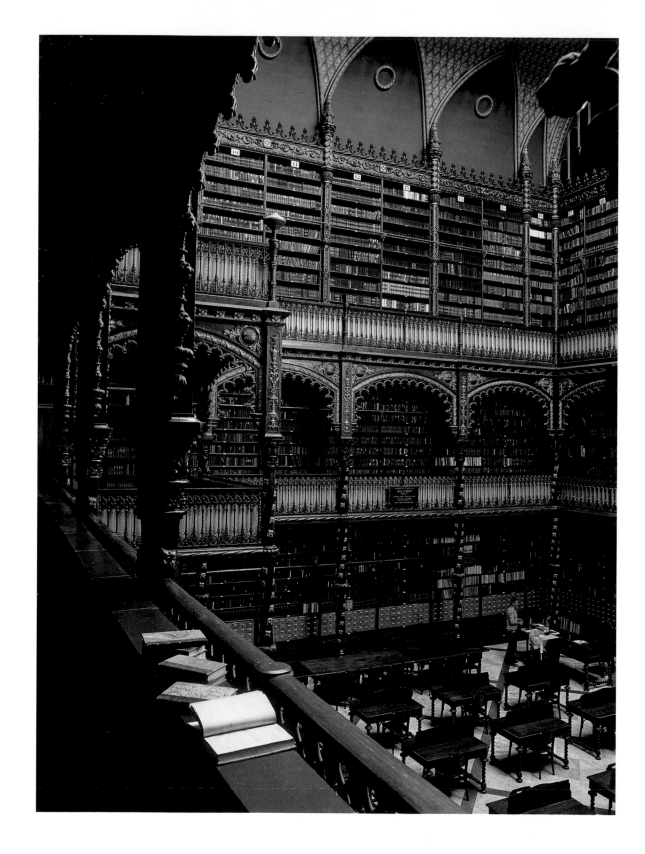

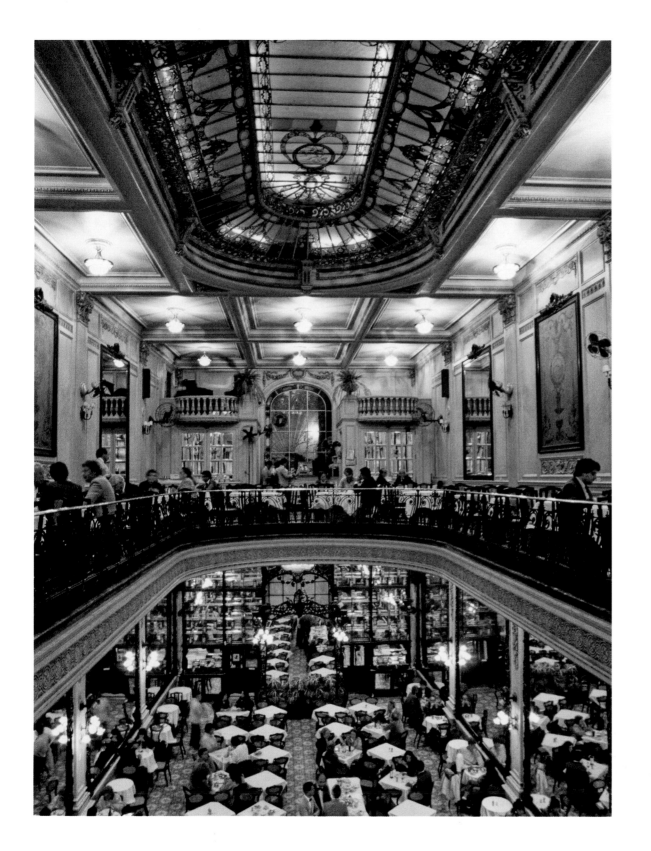

One of Rio's most beautiful examples of belle époque architecture, the Confeitaria Colombo, founded in 1894, is also one of the most elegant places to dine in the city. It was remodelled in 1914, when the art nouveau details were added, and then enlarged in 1920, when a tea room was opened. The stained-glass windows in Louis XVI style, the gigantic Belgian mirrors and furniture in jacaranda wood are the Colombo's most impressive features.

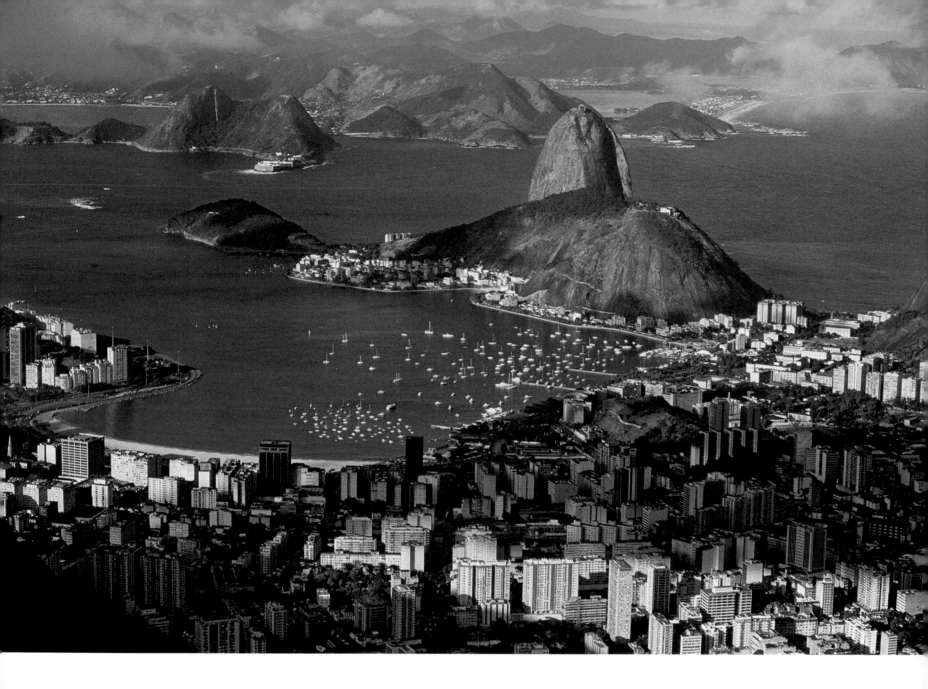

The samba and other Brazilian cultural forms first found acceptance in Rio and gave the city its unique cultural identity, recognized not only nationally but all over the world.

The time was ripe for institutional change in a country that until that point had been dominated by rural oligarchies. Getúlio Vargas came to power in 1930 and committed himself to building an urban and industrialized Brazil, which he planned to base in two cities: Rio de Janeiro, the political and administrative centre, and São Paulo, the economic centre. Vargas also stimulated the

Left and below:
Among the large buildings
along Rua São Clemente
in Botafogo and Humaitá,
this elegant mansion in
neoclassical style houses the
Portuguese Consulate. It is
renowned for scrollwork and
pinnacles, and the garden is
also famously beautiful.

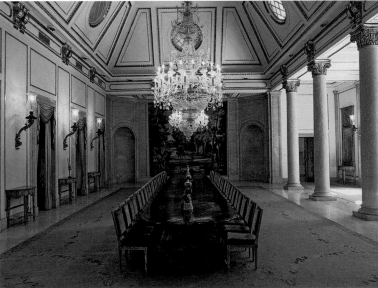

Opposite:
An aerial view of Botafogo
beach and the entrance to
Guanabara Bay with Pão de
Açúcar (Sugarloaf Mountain).
This is one of the most
symbolic images of the city,
and confirms Rio de Janeiro's
unsurpassed natural beauty.

workforce, creating labour laws that attracted rural workers to the cities. During this period,
there was a massive population shift from Brazil's poorer regions to the country's cities, and a
corresponding shift in the balance of power. Brazil was no longer a rural society and the old
oligarchies lost their dominance: the so-called Vargas Era changed the political nature of the nation.

With the increasing arrival of settlers from the countryside, as well as the new waves of
European immigrants, the city grew in every direction. The *morros*, or low hills so typical of the Rio

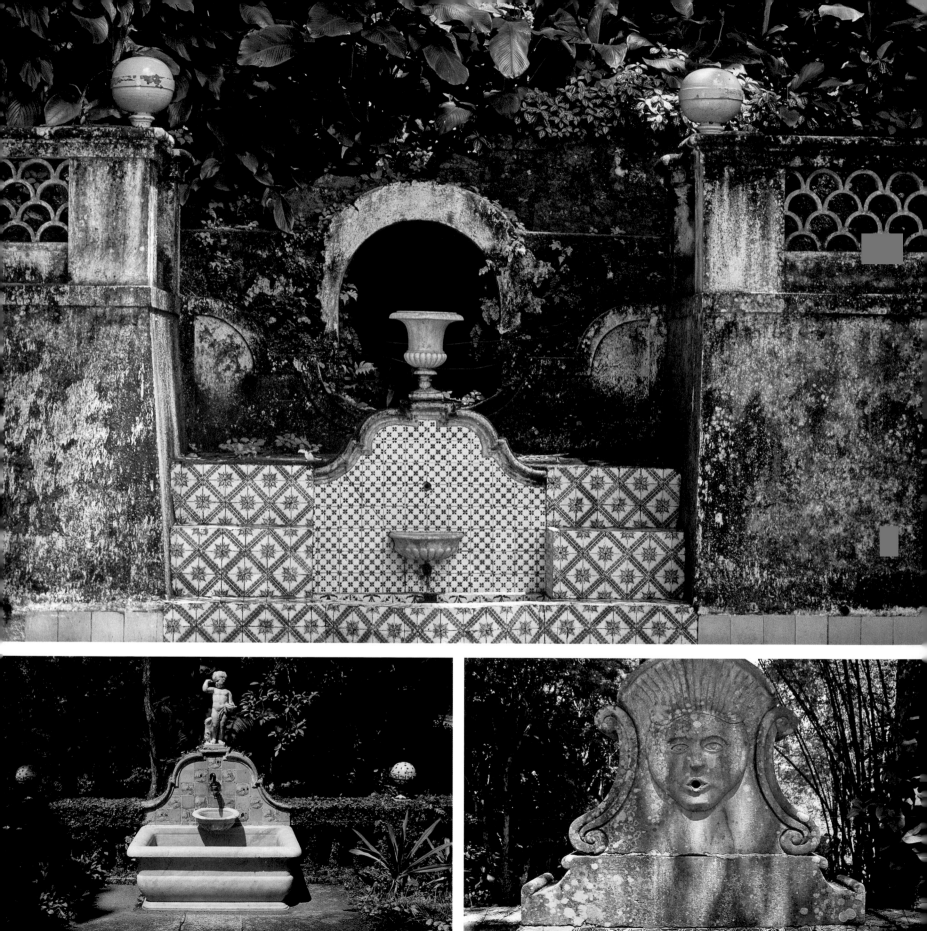

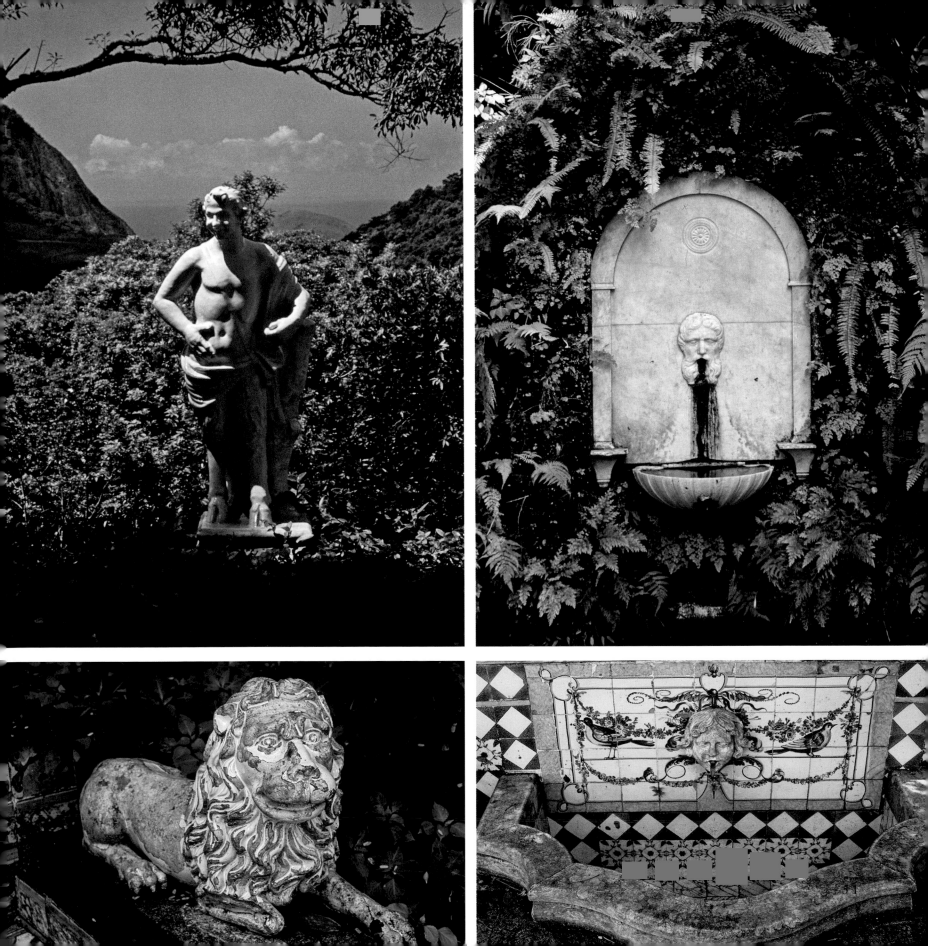

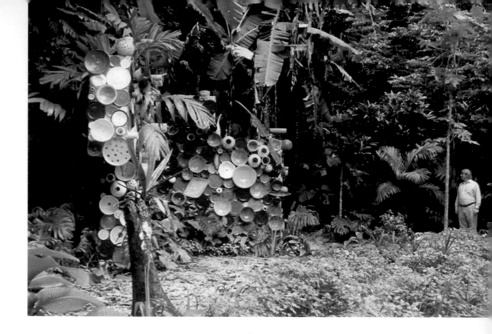

landscape, began to attract the poorest segments of the population, most of whom had been forced to leave their homes elsewhere because of poverty or the harshness of the political regime known as *coronelismo*, a system of power characteristic of the Old Republic (1889–1930), in which large landholders, ranchers and sugar-mill owners held political sway. This new kind of immigration, by people in search of a better life in the city, created the infamous *favelas*. Without any basic hygiene or sewage facilities, the life of the people of the *favelas* is still plagued by all kinds of hardships, in spite of continuous efforts to include them in the wider urban fabric. The residents are stigmatized and the areas are dominated by heavily armed gangs of criminals which, while still in the minority, impose a power parallel to that of the state, and reinforce the reputation of the *favelas* as violent, marginal places. The majority of the *favela* population, however, is made up of workers with few professional qualifications and a low level of education.

At the same time, the Centro has also undergone profound transformations. No longer residential, it has become a 'downtown' area reminiscent of New York or Chicago. Growing skyscrapers provide the headquarters for large domestic and international corporations, banks, financial operations, and office space for all kinds of businesses, as well as government agencies, ministries and law courts.

Vargas's government also tried to impose a new mentality on the country, based on the value of work and family, on order and progress. This mentality was heavily promoted during the period known as the *Estado Novo* (New State), starting in 1937. In truth, the regime was a State dictatorship, with the suspension of civil rights and harsh repression by Vargas's police.

After World War II, political pressure to put an end to the Vargas dictatorship increased, and a period of greater political freedom commenced. The election of Juscelino Kubitschek as president in the 1950s initiated a period of greater economic prosperity and the expansion of Brazil's industrial

base. During this period, Rio de Janeiro experienced a new age of glory as the cultural capital of the country. Styles and fashions emanated from the capital, spreading across the rest of the country. The Cariocas were considered to be cosmopolitan and able to compete with the latest and best that the world's largest metropolises had to offer.

In 1960, with the inauguration of the city of Brasilia, Kubitschek's dream that was given life by architect Oscar Niemeyer and urban planner Lúcio Costa, the political and administrative functions of the capital were transferred from Rio to this brand new city located at the heart of the nation. Rio watched her political power vanish, but the city remained the nation's cultural centre, continuing to set trends for the rest of Brazil.

The Museu do Açude, in the Tijuca Nacional Park, was once a residence of art patron Raymundo Ottoni de Castro Maya. The museum's aim is to integrate its cultural heritage with the natural richness of the National Park.

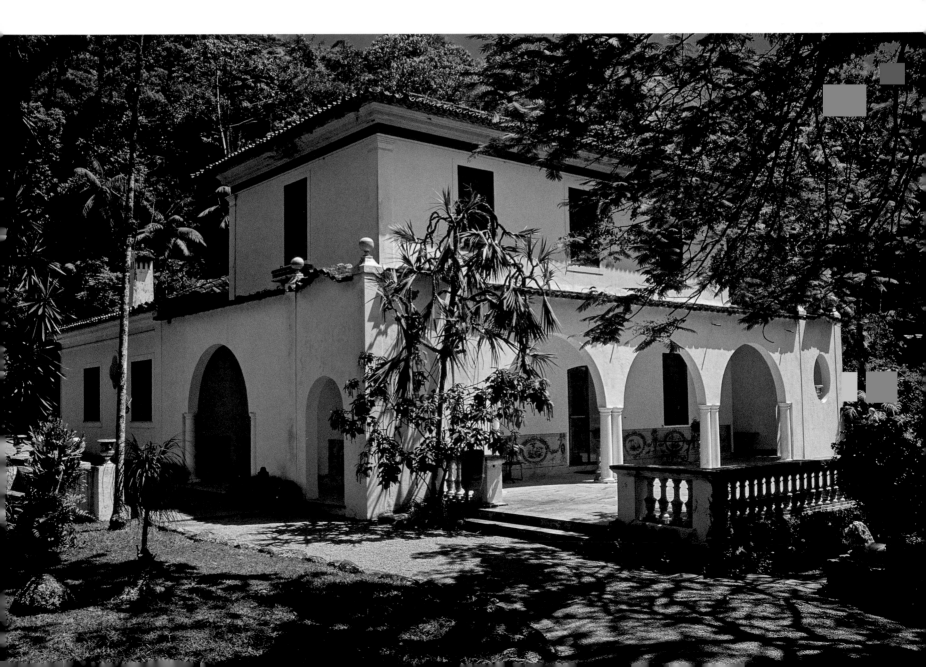

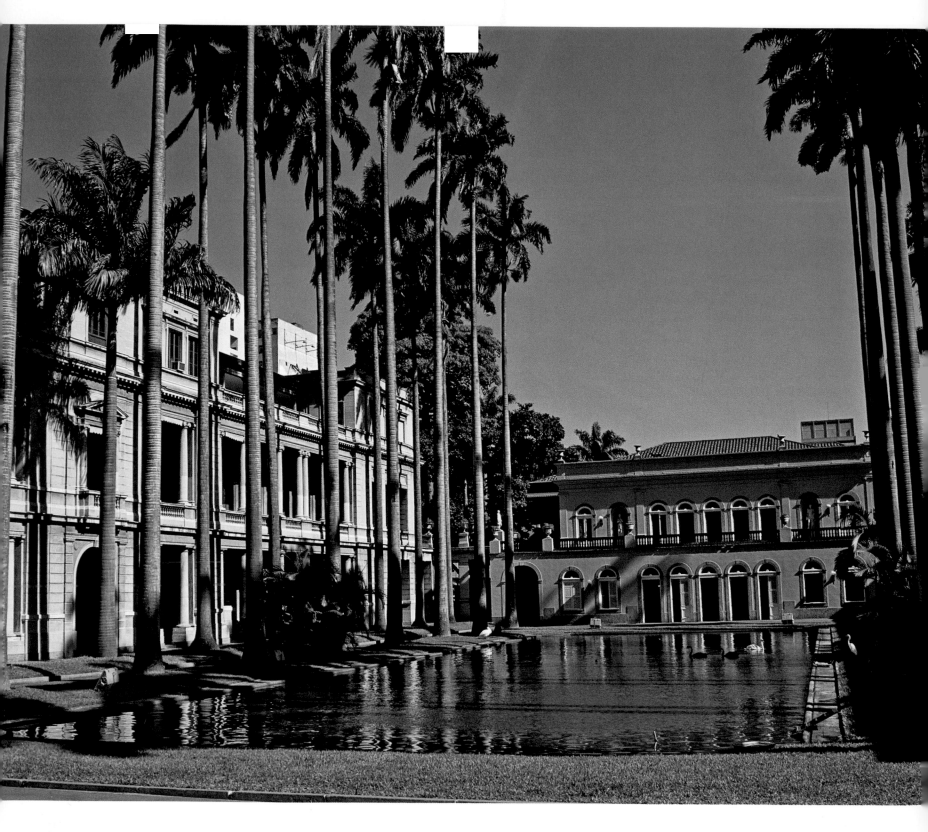

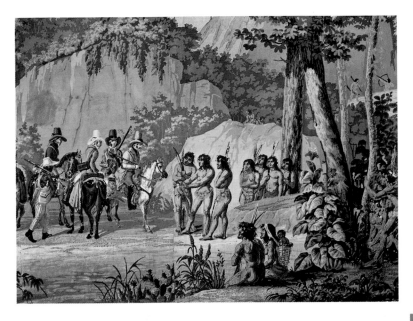

The building now serves as an office for the Ministry of Foreign Relations and is the home of the Historical and Diplomatic Museum, created in 1955. The dining room is decorated with panoramic painted wallpaper made by Jean Zuber et Cie in France in 1830 (left and below).

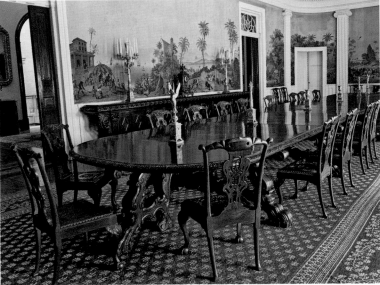

Opposite:
The Palácio Itamaraty was the seat of the government of the First Republic and then of the Brazilian Ministry of Foreign Relations. Built in the mid-19th century, this neoclassical building originally belonged to the Baron of Itamaraty. A row of palm trees set in the courtyard garden frames the entrance to the building.

The decade of the 1960s was also a period of intense ideological disputes, set in the context of a world divided by the Cold War, especially after Fidel Castro established the West's first Communist regime in Cuba in 1959. The peak of these conflicts occurred during the presidency of João Goulart, and revealed a Brazil that was torn between capitalist and socialist values.

The growing wave of violence provoked a military coup in 1964. Military rule began and civil rights were subordinated to the authority of the Armed Forces for a period of twenty years. There were accusations of torture and summary convictions of anyone suspected of leftist activism. It was a time of great institutional and cultural regression. During the early years, nevertheless, the country's financial situation improved. Many multinational companies opened branches in Brazil, and the military regime built many important public works. Increased economic activity brought prosperity to the wealthiest classes of Brazil. Rio, once again, played a twin role, as both a centre for the elite and a gathering place for opposition to the military regime.

As the years passed, however, the boom was no longer sustainable, and the country slipped into a deep economic crisis. Full recovery has still not been achieved. This period brought decadence to Rio de Janeiro, as well as social conflict, crime, and the relocation of industry to other regions of Brazil, particularly to São Paulo.

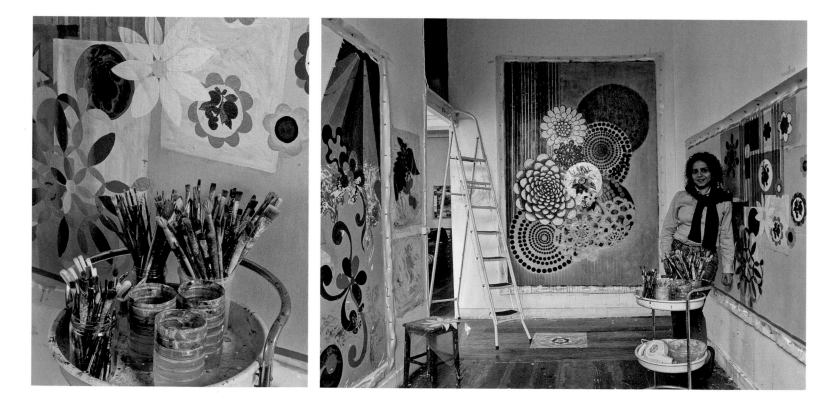

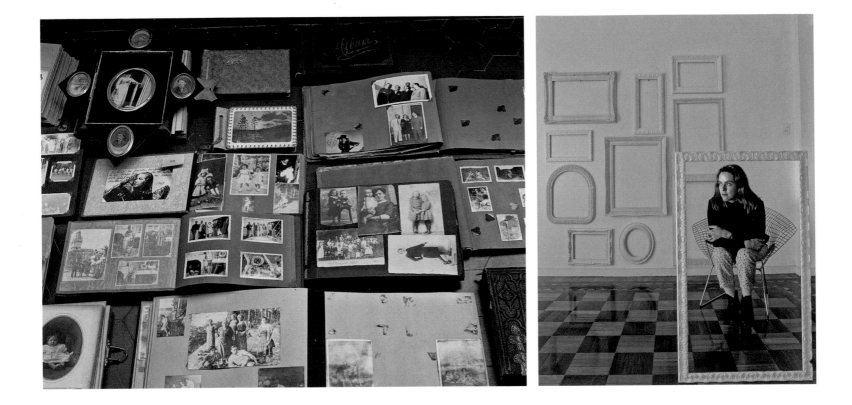

Today, the country's main cultural centre is confronting many dilemmas of its own. It is, however, a great opportunity for Rio's potential, talents and history to come to the rescue – not only those of town planners and public administrators, but those of all the residents of Rio de Janeiro, which remains one of the world's outstanding cities.

57

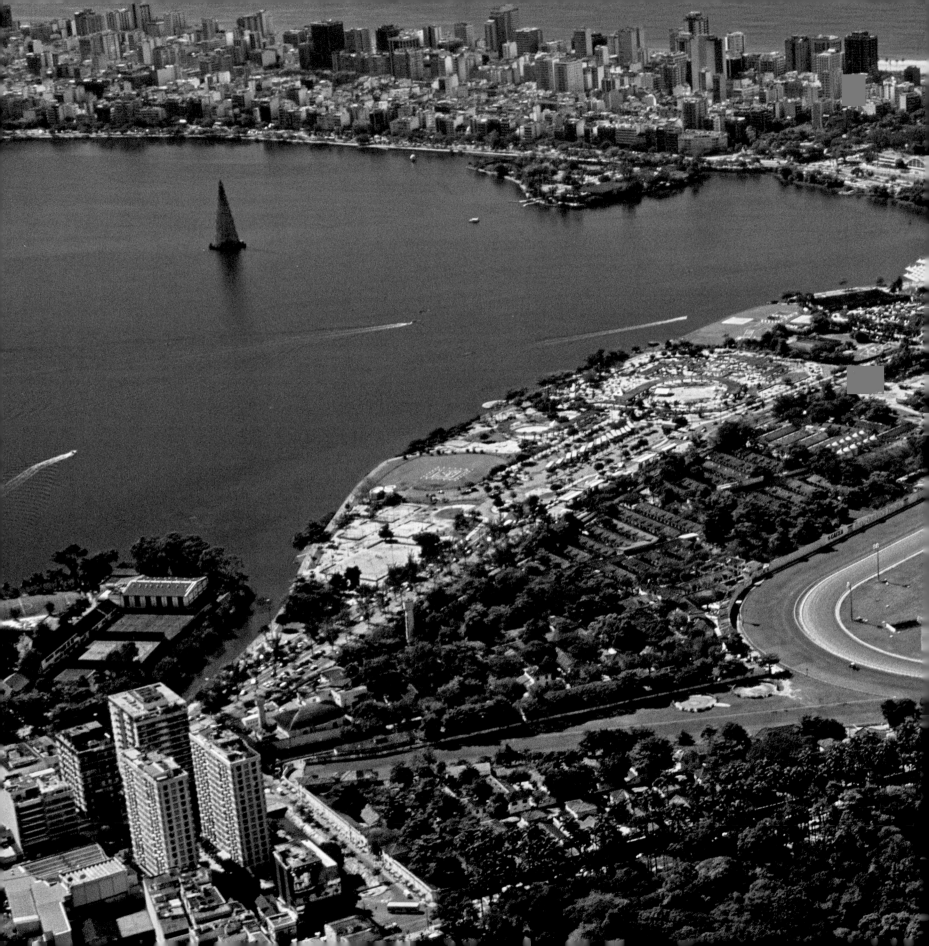

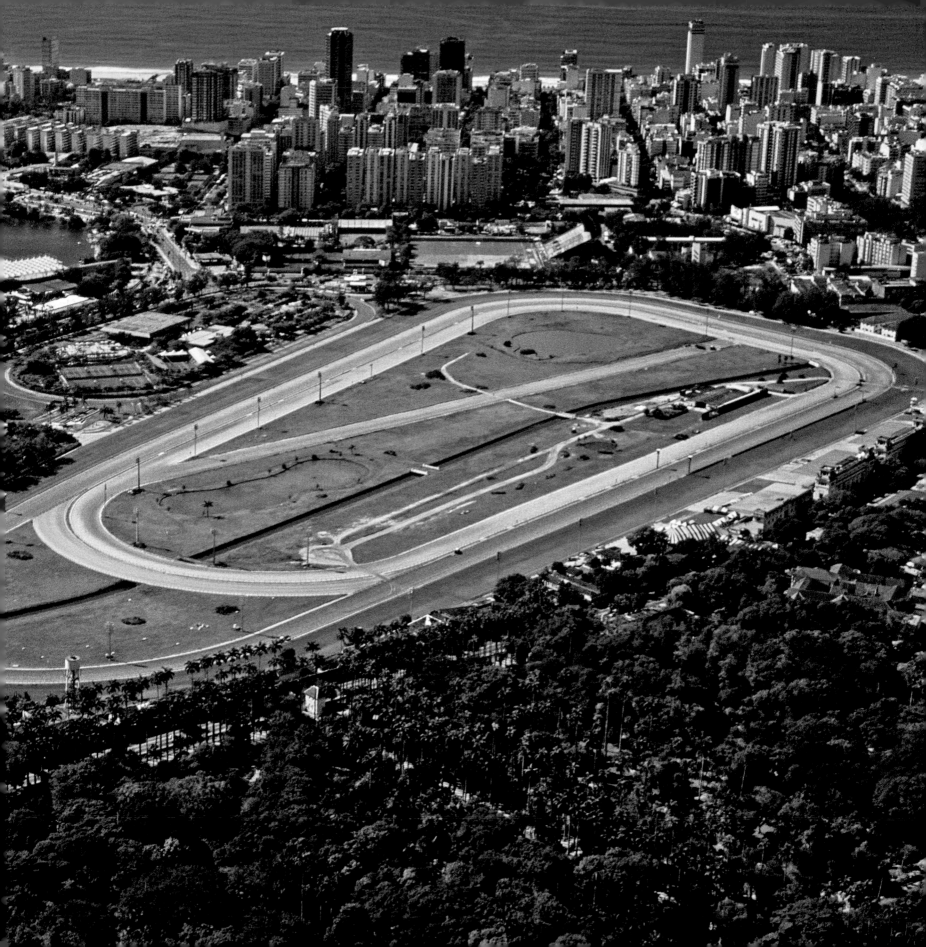

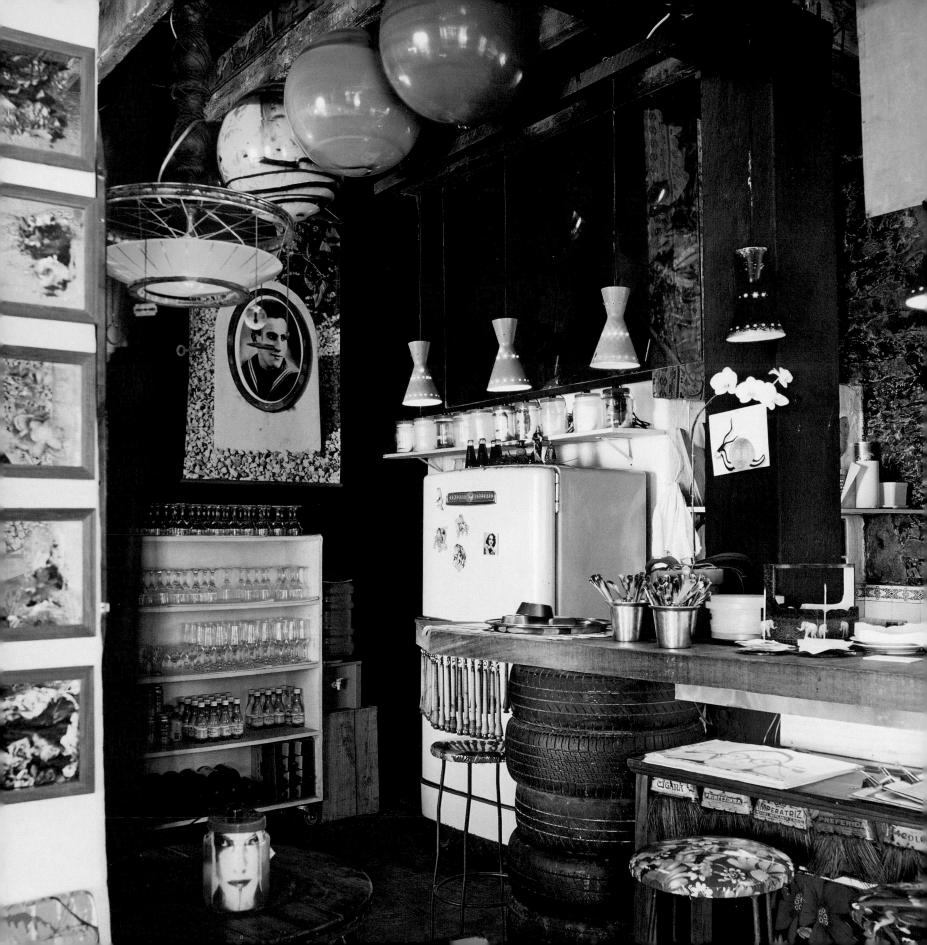

The Social Life of Rio

In a city with so many attractions, both physical and cultural, the social life of the Cariocas is extremely lively and particularly focused around public spaces. It is more usual for people to spend their leisure time going out with friends to explore the entertainment options of the city's many neighbourhoods, rather than inviting friends to their homes. The activities that do take place at home, such as lunches or dinners, can also be social and communal but generally require a greater degree of intimacy among the people taking part and tend to occur only on special occasions. Celebrations such as holidays, birthdays, baptisms and musical evenings mean the preparation of food and getting together at someone's home, and involve the etiquette of being a host or a guest.

Because of the hot and tropical climate, Rio's streets are an enticing option. As most young Cariocas live with their parents and only leave home when they marry, there has long been a culture of spending leisure time in public places, in place of smaller-scale gatherings at home. Now, these customs are changing; as economic conditions improve and children marry later in life, many young people are deciding to live alone. This has boosted the use of the home as a centre for entertaining. Nevertheless, the majority of Cariocas still prefer the street as the best place to mingle and have fun.

There is no doubt that the growth of urban violence, as a consequence of various economic, institutional and political problems, and the increasing population density in the largest Brazilian cities, especially since the 1960s, has had a profound impact on customs and community life. The use of urban spaces has been affected and the culture of leisure has become less dominant. Rio de Janeiro has been no exception, and in fact the city has been one of the worst affected by these issues.

The studio of Zemog, a leading artist, has become a meeting place for the cultural world in Rio. Located in the Santa Teresa district, Zemog's studio is filled with his work, some of which is kitsch, some more rustic in style. On Friday evenings, however, the artist turns his space into a bistro.

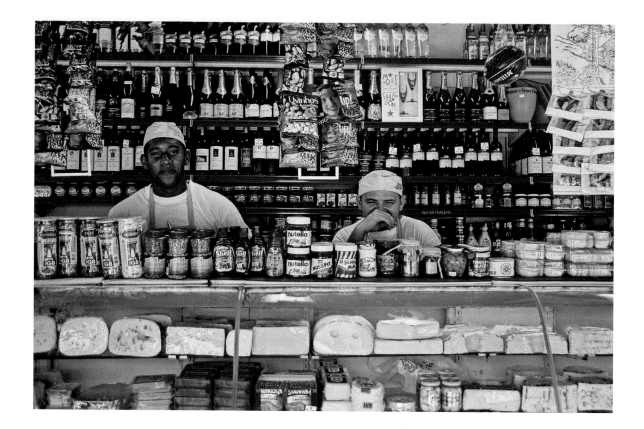

Above and opposite: There are many old and traditional bars and botequins *in the Centro district of Rio de Janeiro. Originating in colonial times as general stores, the* botequins *are a mixture of mini-market and bar. During happy hour in the Centro, especially on Friday evenings, the pavements may be covered with tables.*

Residential buildings, for example, began to adopt security measures that were previously unheard of, resulting in empty streets and a population segrated by social class. Beginning in the 1970s, the creation of large condominium complexes in areas where land was still available, such as the Barra da Tijuca, produced a new approach to urban planning, but isolated the different sectors of society even more. The middle classes moved into the new apartment complexes, while the poorer classes moved to the edges of the city, into shoddily built apartment blocks with poor infrastructure.

Nevertheless, in the traditional neighbourhoods of the city, pavement life continued much as before, especially on the busiest commercial streets. In the newer neighbourhoods, built during and since the 1970s, the use of public space is very different, confined to closed areas such as shopping centres, nightclubs, bars, hypermarkets, and residential communities. The beach, however, continues to be the best place for democratic interaction, where people from every social level come together to share the sea and the sunshine.

Getting together in communal spaces, whether public or private, is still the commonest way to spend leisure time in Rio, but the options vary enormously, depending on the neighbourhood and the time of day. There are cultural venues, like museums, theatres, literary workshops, cultural centres, cinemas and art galleries. There are places for eating or drinking, including restaurants, cafés and

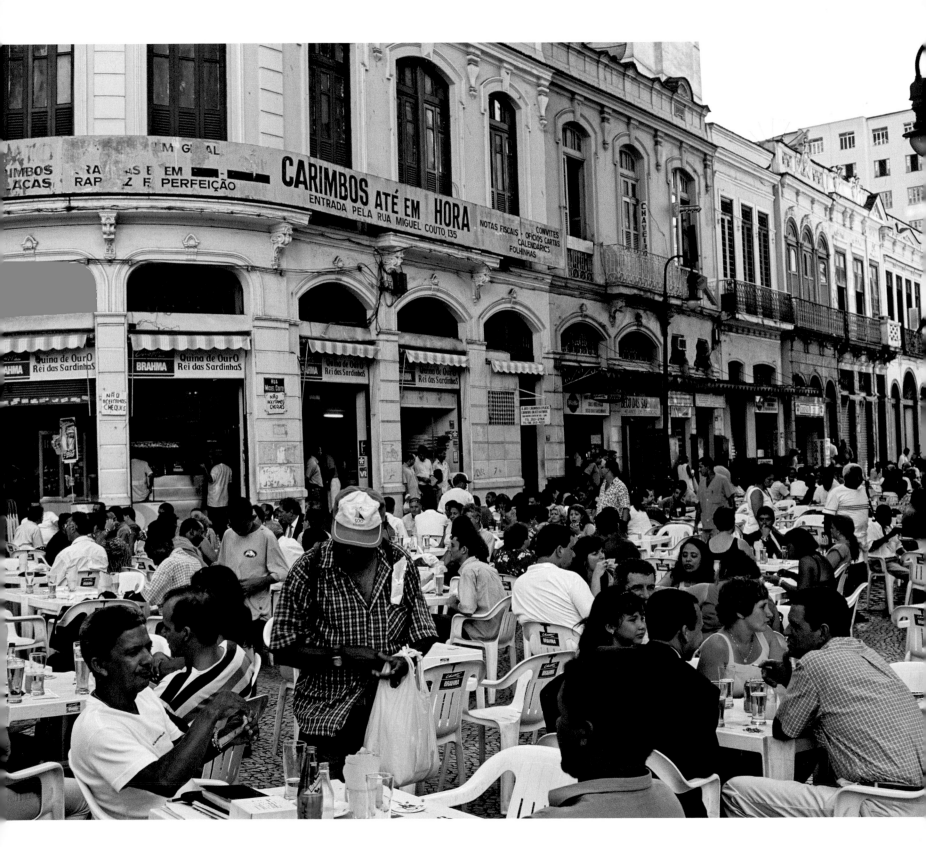

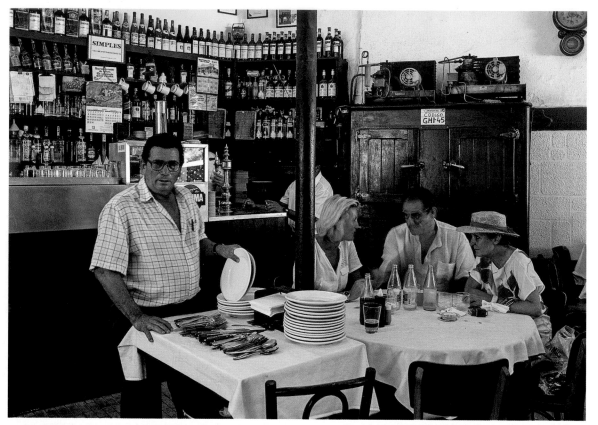

José Otero (holding plates) is the owner of one of the most traditional botequins in the city, the Bar Brasil, founded in 1908. Located in the heart of the bohemian neighbourhood of Lapa, the establishment is famous for the quality of its chope (beer on tap), which has a special creaminess.

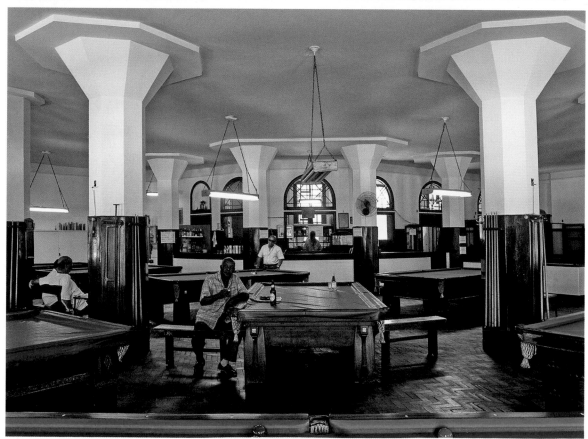

Located in a building that dates from 1927, the Bilhares Guanabara is a combination of a bar and a pool hall. The large space, whose bar counter looks onto Praça Tiradentes, contains fifteen professional pool tables distributed geometrically so that none gets in the way of the others.

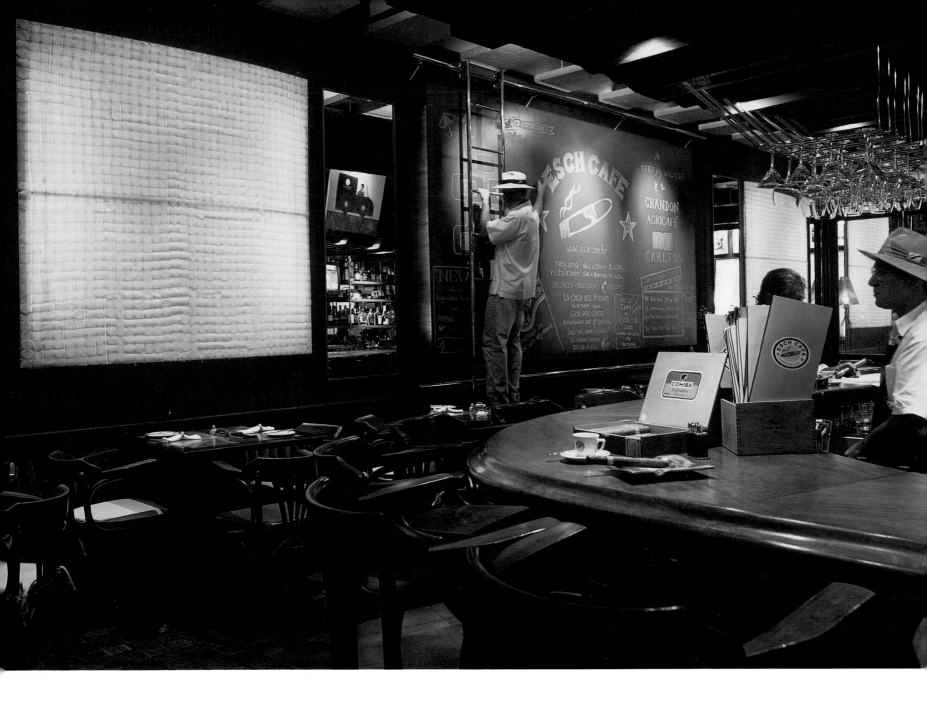

One of the most sophisticated cafés
in Rio de Janeiro is the Esch Café in
Leblon. It is primarily a tobacco shop
whose top-quality products come
from Havana, thanks to a commercial
agreement with La Casa del Habano.

bars of many kinds. There are also a variety of places for dancing or listening to music, ranging from small clubs and concert halls to bars, nightclubs, musical cafés, and the traditional *botequins* with their *rodas de samba* (samba sessions). The public squares, beaches and parks are also available for anyone who wants to enjoy the open air.

The *botequim*

Among the establishments that serve alcohol, the *botequim* (plural: *botequins*) is surely one of the landmarks in the everyday life of a typical Carioca. *Botequins* vary in style, from the most basic, known as *pé-sujo* (dirty-foot), to the most sophisticated, which are generally located in well-to-do neighbourhoods. For both rich and poor, however, the *botequim* competes with the beach as the most democratic recreational spot in town.

Much of Rio's cultural history can be told through its cafés, bars and *botequins*; they have long been meeting places for intellectuals, poets, professionals, politicians, and of course of the common people, who turn their favourite *botequim* into a second home. Regulars visit their *botequim* on a daily basis, and get together with their peers to drink and talk about all kinds of topics, ideas and

The Farmacia Simões is one of the few surviving traditional pharmacies, in which the pharmacist makes up medicines according to the doctor's prescriptions.

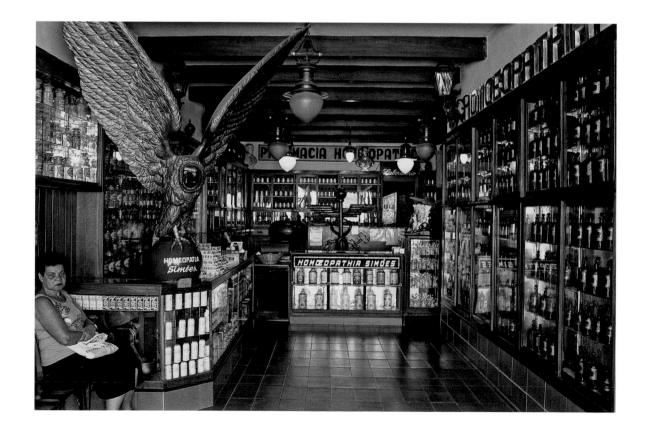

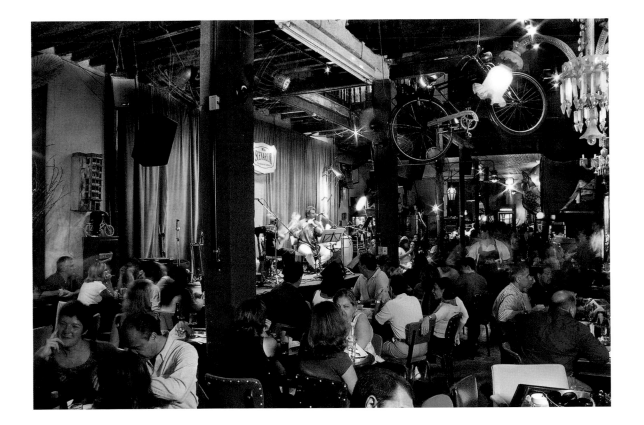

projects. *Botequins* are so much a part of local life that they characterize the cultural core of the city. To be a regular at a *botequim* is a form of exercising one's right to be a citizen of Rio: 'I go to my *botequim*, therefore I am a Carioca.'

The *botequim* plays a substantial role in maintaining the social fabric of a neighbourhood; it makes the street more lively and reinforces people's sense of belonging to part of the city. *Botequins* have often been a stage for important cultural and political events, such as the organization of student protests during the military dictatorship. They have also provided a suitable atmosphere for the development of successful artistic and musical movements such as samba, bossa nova and Tropicalismo. The *botequim* is to Rio de Janeiro what cafés are to Paris, and beer halls to Munich, They are a kind of meeting place adapted to demands of the local culture.

Today, more than ever, the *botequins* stand at the heart of Rio's bohemian and intellectual life. Figures from Carioca folklore, such as the *malandro* (conman), the sensuous beauty, the labourer, the poet, among other stereotypes of city life, find both their stage and their audience at the *botequins*. The link between the Cariocas and the *botequins* is so strong that it would be impossible to grasp the subtleties of the city's soul without visiting these spots. These arc not only places to drink and eat but spaces where the Cariocas affirm, question and reaffirm their identity.

This is an identity forged by resistance and marginality. When the first *botequins* appeared in the city, at the beginning of the growth and industrialization of Rio, they were targets for repression by the authorities and treated in official speeches (by the State, the clergy, the medical profession) as dens of iniquity, anarchy and alcoholism – places that could lead a man of virtue to vice, disease and even death. At a time in which the city needed to provide employment for masses of potential workers (European immigrants, freed slaves, and migrants from other states), the *botequim* was a serious threat. During the first decade of the 20th century, a vagrant could get a six-year prison sentence and alcohol abuse could be punished by internment in an asylum.

Even so, the *botequim* represented a place in which men could feel free, a neutral spot between home and the factory for workers. There, for a moment, they felt safe from the bureaucracy that ruled at the workplace, where they were subjected to the will of foremen, managers and directors. At the same time, they could relax from moral obligations and their social responsibilities as providers for their families. They could express themselves without any fear in the *botequins*. It should be pointed

Lica Ceccato is a singer and entertainer on the Rio nightlife scene. Married to the artist Antonio Dias, she shares her life with him between Rio, Cologne and Milan.

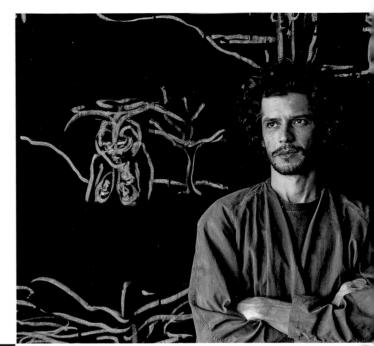

Right and below:
Singer and visual artist Cabelo (Rodrigo Saad) burst onto the Carioca cultural scene in the 1990s as a member of the group Boato. As a musician, he took part in the CEP 20.000 club nights, where an entire generation of artists were discovered. In the visual arts, his work has been exhibited in many international shows, including the prestigious Documenta *in Kassel, Germany.*

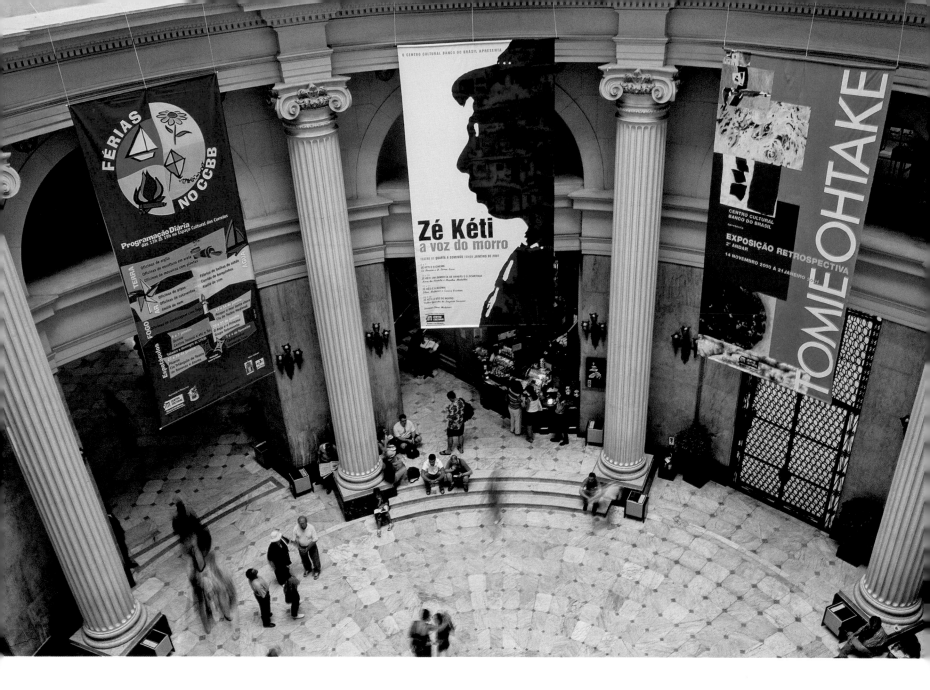

Located in a neoclassical-style building constructed between 1880 and 1906, the Bank of Brazil Cultural Centre opened in 1989 and since then has provoked a cultural revolution in the city, even during a period of economic recession. The centre has two theatres, a cinema, a video room and video booths, and eight exhibition spaces.

out, however, that relationships within these establishments were governed by strict codes of behaviour, which, when not observed, could lead to outbreaks of violence. These were, however, relationships between peers, between relatively equal individuals.

In this way, as the city grew, the *botequins* were considered both a stimulant for antisocial behaviour and an arena for free expression, and this contradictory role still characterizes this unique institution to this day. Although women are accepted as customers today, the clientele is still predominantly male. Above all, the *botequim* remains a lasting symbol that gives Rio a special flavour and provides a prime setting for Cariocas to enjoy their love of social life outside the home. Whatever people's social plans for the evening, a visit to *botequim* is bound to feature at some point.

Music and culture

The *botequim* has traditionally been the launchpad for Brazil's major artistic movements and forms of cultural expression. Samba, bossa nova and Tropicalismo are just three examples. In the case of the samba, the *botequim* was not only a meeting place for poets, musicians and the other many creators of this rich musical world, but also the birthplace of the songs themselves. Many of these

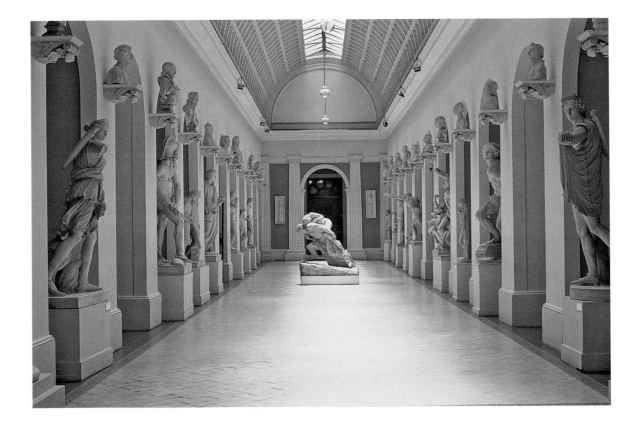

When he arrived in Brazil in 1816, the then director of the French Artistic Mission, Joachim Lebreton (1760–1819), could not have imagined that the paintings that he brought with him would form the nucleus of the collection at the National Museum of Fine Arts. The Museum was not opened until 1938, in the building that had previously functioned as the National School of Fine Arts.

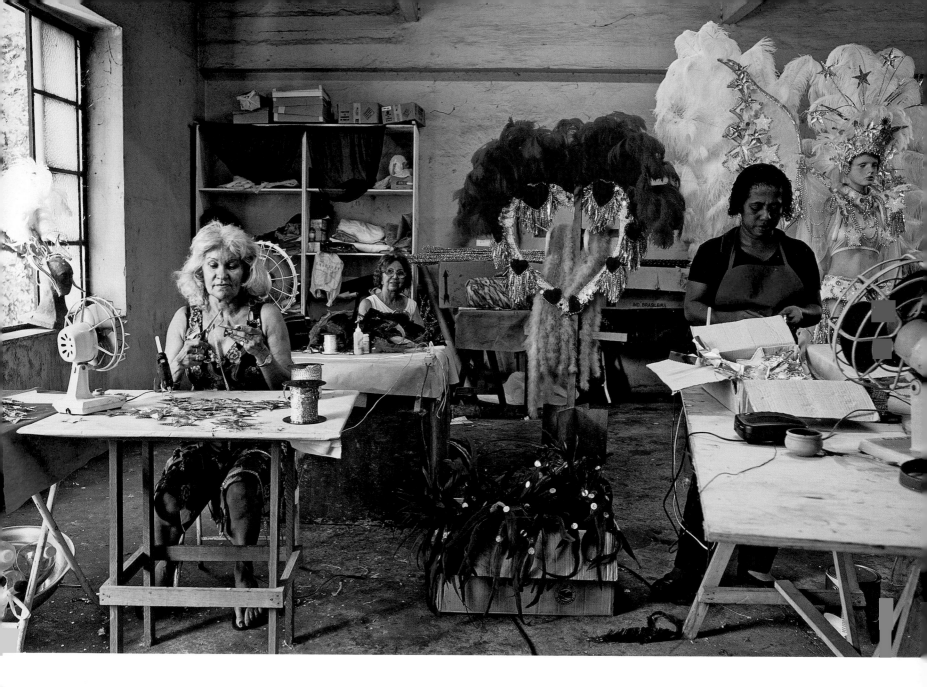

compositions are now considered national treasures. During the period when the police persecuted the clientele of the *botequins*, samba players often had to hide their instruments behind the bar, counting on the complicity of the owner to help them avoid arrest.

The most important step in the development of bossa nova was the collaboration of musician Antonio Carlos Jobim and poet Vinícius de Moraes in the 1950s, which often occurred at the Villarino, a traditional *botequim* in the Centro district. The two artists met there and, according to

Opposite:
Preparations for the principal event of the city's holiday calendar demand arduous work and dedication. The fanciful and symbolic costumes worn by the members of the escolas de samba *that thrill the world during Carnival are sewn one by one at a tireless pace.*

Right:
Passistas *(the star dancers) from the Beija-Flor samba school rehearse with the costumes they will wear in the parade at the Sambódromo. Some of these outfits are extremely heavy and demanding for the dancers to wear.*

Below:
Known for his modern concepts, carnival producer Chiquinho Spinoza ceaselessly supervises each element of the Caprichosos de Pilares *as they get ready for the parade. From the gigantic dolls to the smallest details, everything is crucial in the struggle to win the competition.*

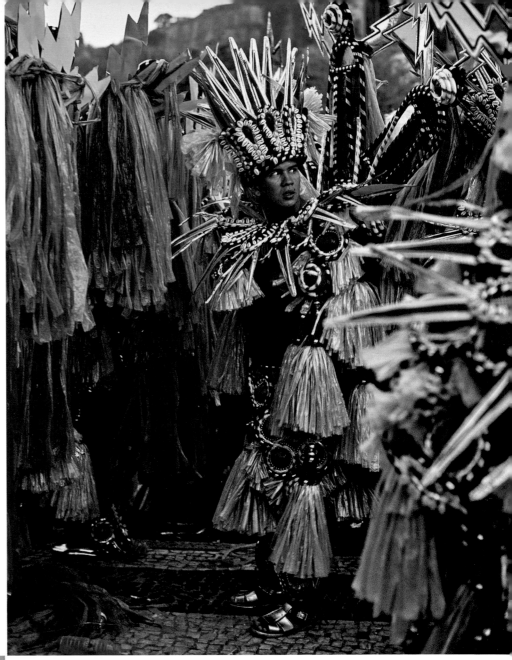

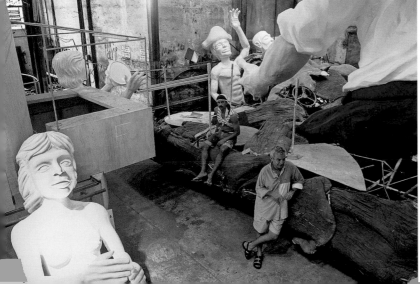

Overleaf:
At the Rio Carnival, the real fun happens in the blocos de rua, *the groups that come together spontaneously all over the city. Many of them pay homage to great figures* *from the history of samba. Here, the drag queens of the* Banda de Ipanema *pay tribute to Carmen Miranda, the Brazilian star who brought the samba to Hollywood.*

73

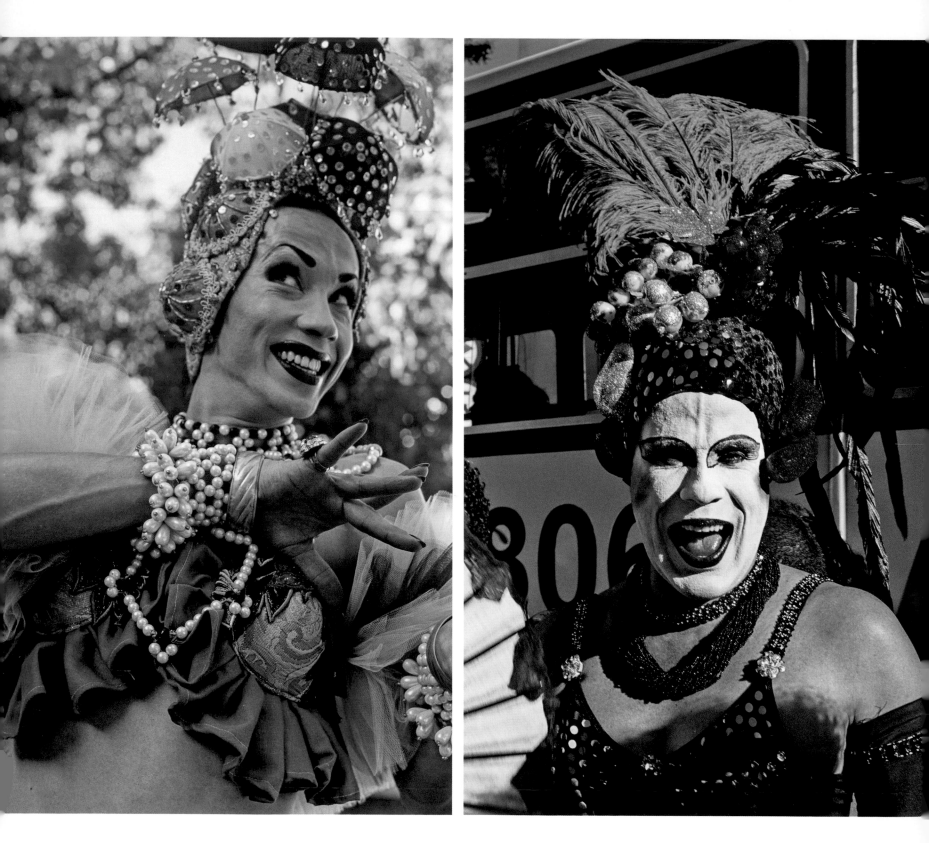

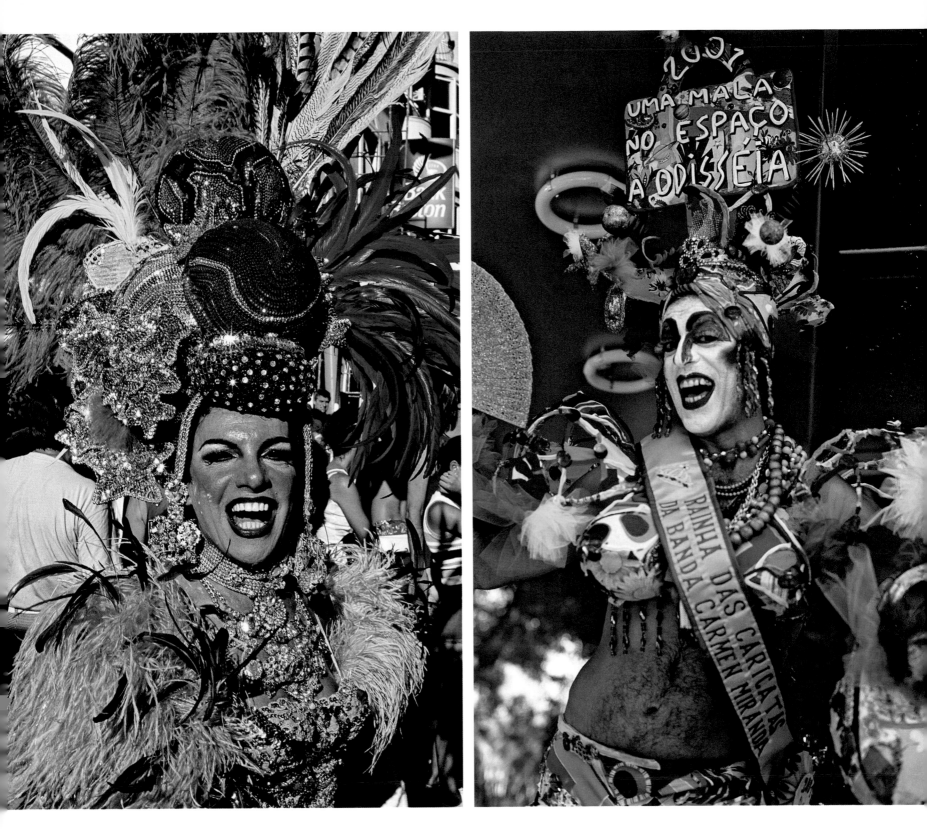

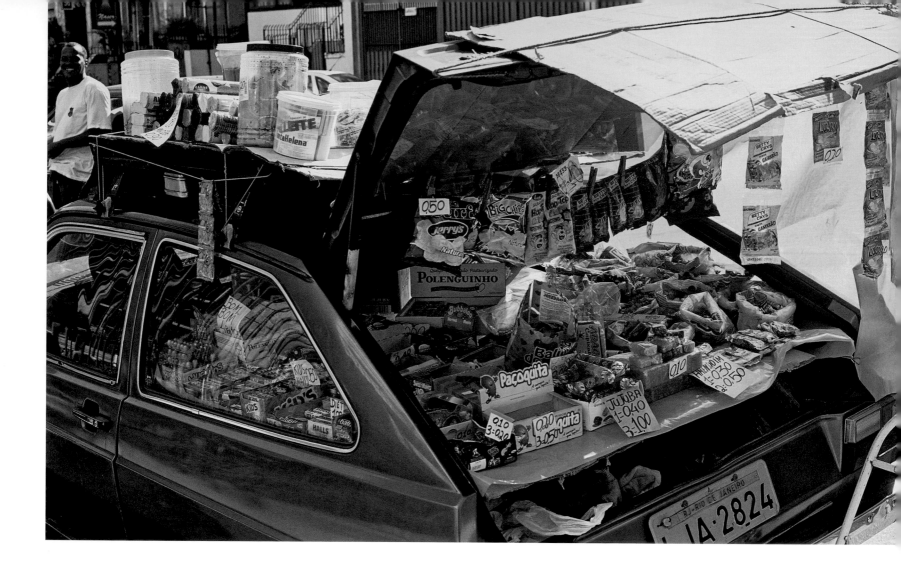

witnesses, began to create their music on the spot. To the lyricism of the samba and the bolero, the pair added the harmony of jazz and the *batida*, the rhythmic beating on guitar strings, in a kind of syncopated samba, together with a soft, cool singing voice – and bossa nova was born. The new style conquered the world and become, even more than the samba itself, the music that everyone everywhere identified with Brazil.

The movement known as Tropicalismo or Tropicália came later, in the 1960s. The style evolved out of a mixture of poetry, the pop vernacular of that decade, and rock and roll, and it quickly expanded beyond the field of music into the visual arts, literature, film and poetry. Tropicalismo came at a time when the country was in political upheaval, with a military regime that limited human rights on one side and increasingly radical leftwing politics on the other. The pressures were great, and cultural movements were taking on a tone of protest and defiance. A certain sense of urgency permeated everything in Rio in that period.

These pages:
The result of years of economic crisis and unemployment, street vendors have spread all over the city and become part of the urban landscape. Selling fruit and many manufactured goods, the thousands of people involved are technically breaking the law but are tolerated in most parts of the city. As well as the street vendors who sell their merchandise to survive, there is also an organized mafia dealing in counterfeit and even stolen goods. The creative ways that vendors display their goods adds a colourful touch.

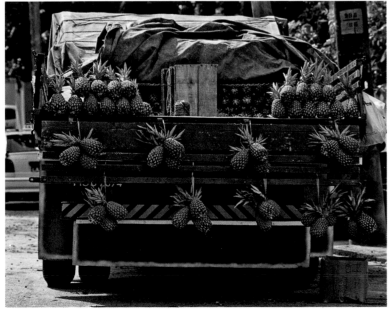

Overleaf:
One of the world's largest soccer stadiums, the Estádio do Maracanã was opened on 16 June 1950, just before the World Cup. It was designed by architects Rafael Galvão, Pedro Paulo Bernardes Bastos, Orlando Azecedo and Antonio Dias Carneiro. The official name of the stadium, Mario Filho, is in honour of the late journalist who dedicated his career to giving his home city a monumental stadium. Maracanã has a capacity of 122,268 spectators, but the record attendance was 183,341 for a game between Brazil and Paraguay in 1969. Brazil won 1–0, after a goal by Pelé.

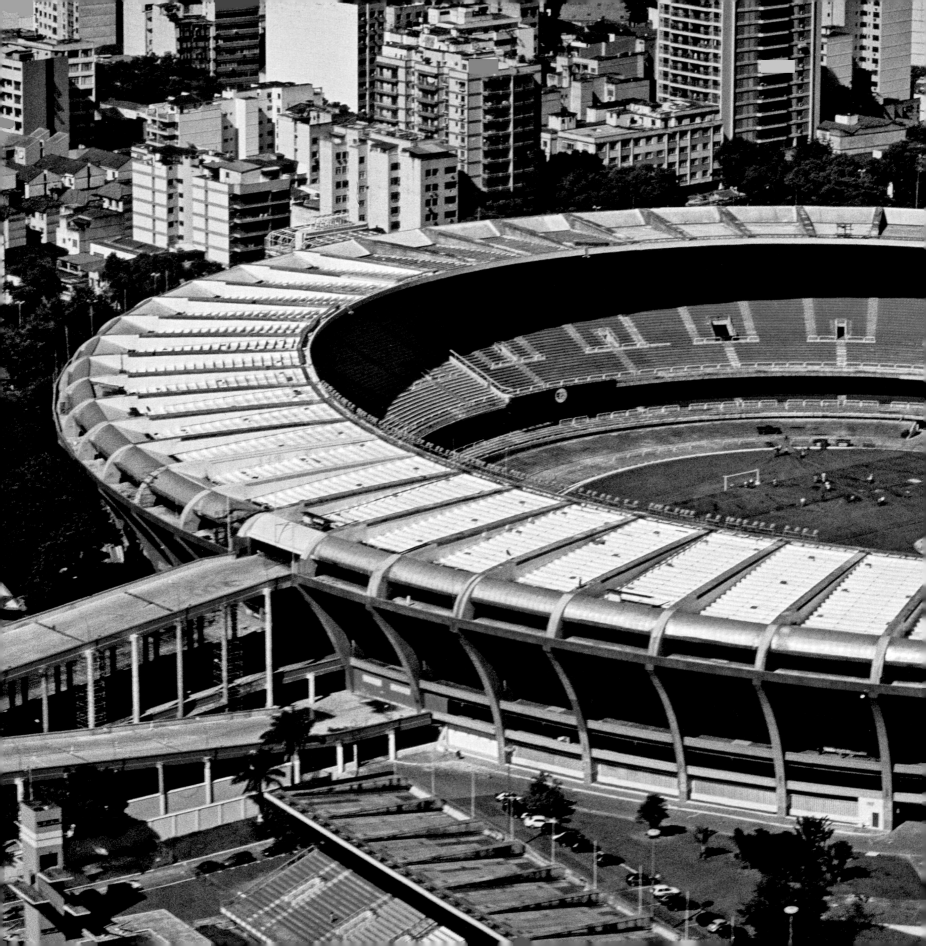

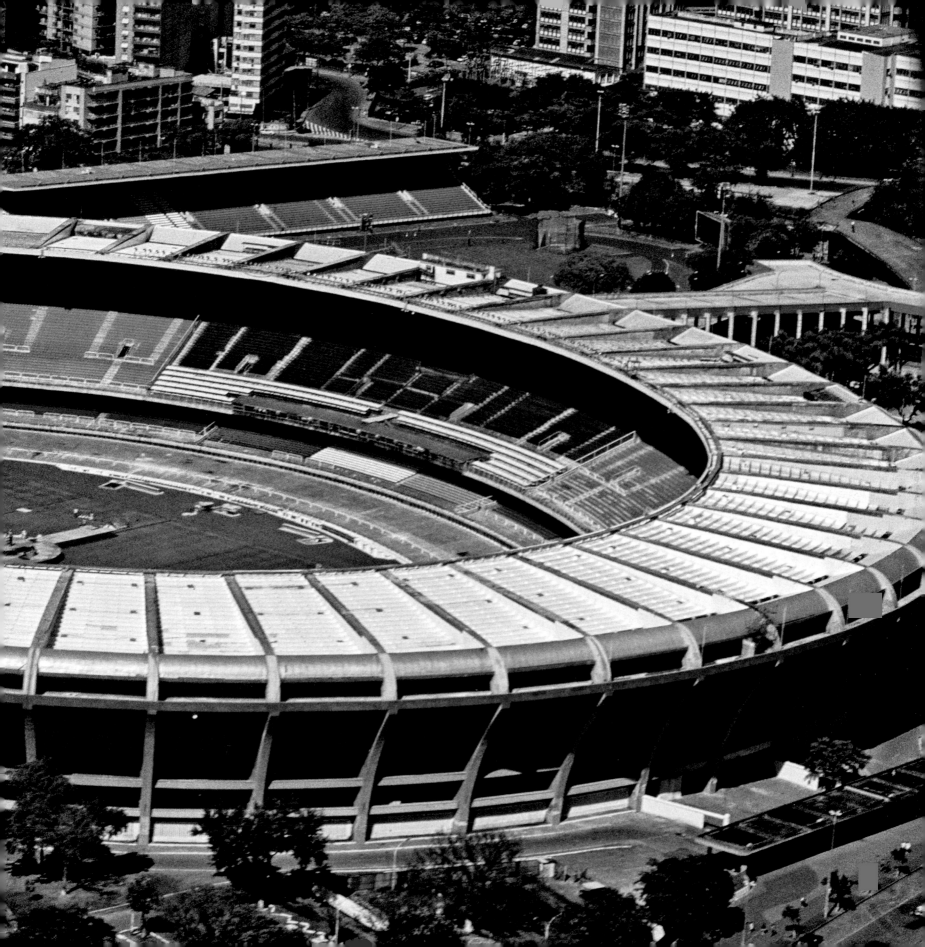

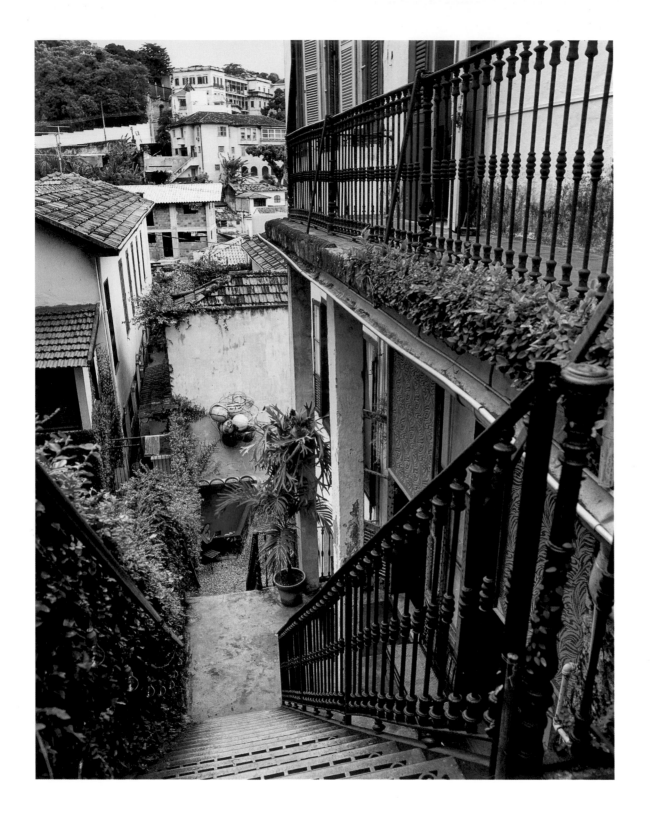

*Left and opposite:
Mixing art and cuisine,
Zemog's studio, accessible
down these stairs, turns into a
small restaurant with a home-
like atmosphere on Fridays.*

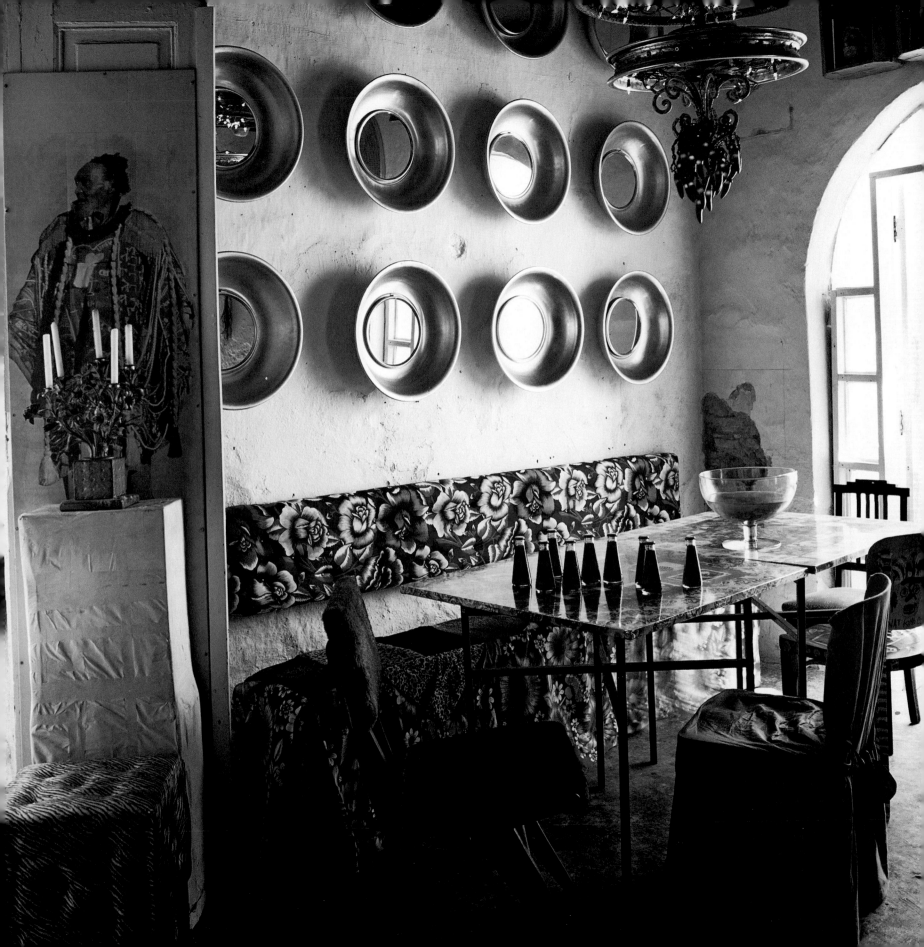

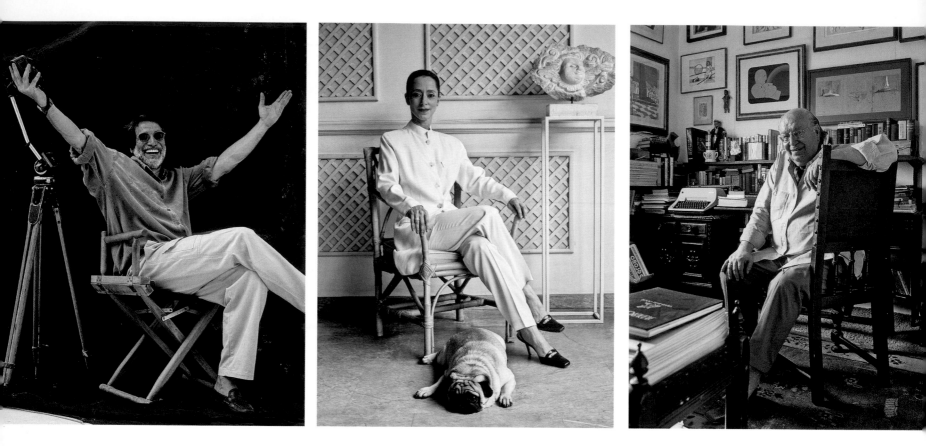

Above left:
Luiz Garrido abandoned his
economics degree to become a
photojournalist in the mid-
1960s. Later, he began to
specialize in advertising
photography.

Above centre:
Ana Maria Baiana is known
as one of Brazil's greatest
ballerinas and also one of the
most popular. Her name is
forever associated with the
Municipal Theatre, where she
was principal dancer for more
than two decades.

All these movements were centred in Rio. Although cultural activity in São Paulo, Minas Gerais, Pernambuco, Rio Grande do Sul and Bahia was intense, it was exposure in Rio de Janeiro which gave them legitimacy in the opinion of the press and the public. This frame of reference has changed in recent times, and the importance of Rio has diminished, with cultural centres elsewhere in Brazil now able to achieve a greater degree of autonomy in their means of self-expression, allowing them to differentiate themselves from Rio.

Carnival: the heart of Rio

One crucial event that influences the leisure time of the Cariocas is directly related to the samba: Carnival. Although the celebration itself is limited to a few days in February, Carnival is the motor of the city's culture throughout the entire year. It has become an industry based on tourism and entertainment, a festive super-production of international renown. At the same time, however, it also conserves its traditional origins, which are grounded in the poorer communities of the city. The preparations for the parades of the *escolas de samba* at Oscar Niemeyer's Sambódromo, conducted

with great pomp and expense, contrast with the gatherings of spontaneous, irreverent groups on the city's streets, considered by many to be the core of the true Carnival.

Musicians, poets and composers spend the entire year composing sambas for the many different events – dances, parades, *blocos*, *cordões* – and the lyrics are often based around everyday happenings and newspaper headlines. Rehearsals at the principal *escolas de samba* and discussions in *botequins*, backyards and gardens are carried on enthusiastically at all times. As can be seen, Carnival itself is just the tip of a cultural iceberg that is fundamental to the city's spirit and lasts for a whole twelve months.

Of all the city's festivals, Carnival is the one that gets the majority of the population involved and is also the one that is most connected with a sense of belonging to the city. As was the case with the *botequins*, Carnival was also originally persecuted and stigmatized by the authorities. The motives were similar: to combat the idleness and recreation of the working classes. In addition, the celebration was also thought encourage licentiousness; the festival of King Momo, as it is known, has always had strong sexual connotations. It is remarkable and at the same time quite typical that the fame of Carnival has now spread around the world, and become one of the symbols most identified with the city of Rio.

During the days of the *folia* (revelry or merrymaking), as the Cariocas call the Carnival period, the *blocos* are the most spontaneous and accessible way for anyone to participate, whether they are locals or visiting tourists. The *blocos* are mainly organized by neighbourhoods, although several are organized by different professional groups, like that of the journalists, called *Imprensa que eu Gamo*

Opposite, right:
Sergio Viotti is a writer, theatre critic and actor. He began his career in radio, before moving on to theatre and television, where he performed in soap operas and miniseries.

Below:
Carlinhos de Jesus is one of the people responsible for the rebirth of ballroom dancing in Brazil. Today, his name is synonymous with this kind of dancing, which features several national styles, including samba, chorinho, *and* maxixe.

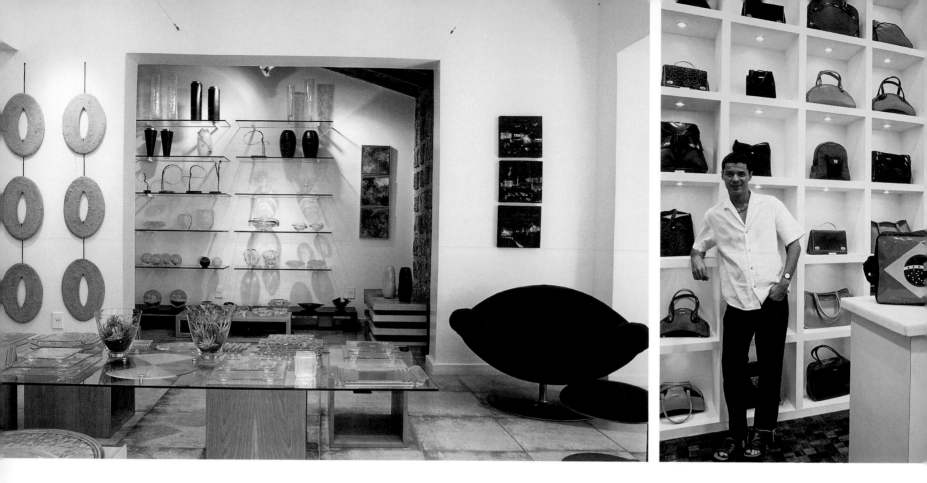

Above left:
Designer furniture and
decorative objects are
becoming increasingly popular
among the Rio middle classes.
Specialist stores are springing
up everywhere, such as this
shop, Kraho, in Casa
Shopping, which sells locally-
made products.

Above right:
Designer Gilson Martins,
in his store at the Rio Sul
Shopping Centre, has created a
prize-winning series of items,
using the Brazilian flag as the
central element.

('I love it when you press'). The names of the *blocos* are generally tongue-in-cheek, often a spontaneous combination of puns, satire and critique, while the themes and the titles of the *sambas* usually refer to the topical news stories, especially those related directly to Rio de Janeiro itself. The *bloco* 'Compatibility Is Almost Love' represents Ipanema; 'The *Bloco* of the Carmelites' is from the Santa Teresa neighbourhood; 'The Armpit of Christ' come from the Jardim Botânico area; and 'Black Ball' represents from the Centro. The Banda de Ipanema, meanwhile, is a combination of a *bloco* and a *banda* (band); as well as Ipanema locals, it also attracts Rio's gay and lesbian community.

The cosmopolitan soul of the Cariocas

With the return of rapid economic growth at the beginning of the 21st century, the cultural scene in Rio is once again experiencing a boom. In the field of music, for example, there is funk, black Brazilian music, and hip-hop in the suburbs, mixing and mingling with traditional *samba* bands, *pagode*, a slow version of the samba, and *chorinho*, the first typically Brazilian urban music, dating from the 1880s. The samba has lost its association with poverty and slavery and is rediscovering its own history, incorporating traditional music forms such as the *jongo* (a dance of Bantu origin) and

shedding new light on the cultural roots of Rio de Janeiro and its African, European and indigenous heritage.

Film, theatre and the visual arts are forms of expression that have been traditionally linked to the middle classes because of their higher production costs, but they are now becoming accessible to a broader cross-section of the population through programmes of cultural promotion, resulting in richly imaginative art exhibitions, performances and films that can be seen all over the city. This flowering of creativity has raised the self-esteem of the Cariocas and has helped them to revise their social roles, as well as their identities as inhabitants of Rio. Areas that are marginalized by the presence of *favelas* and by high levels of crime and violence are now finding new expression through art, and this form of cultural interaction has made middle-class youth more aware and understanding of the social issues faced by their fellow citizens.

Lapa, the bohemian heart of Rio in the early 20th century, has become a meeting place for different groups of Cariocas once again, a circumstance that would have been unimaginable just a few years ago in Lapa, or in any other part of the city. This renaissance is the most conclusive proof that the Cariocas are rethinking their identity, and finding common ground despite their differences.

The characters of traditional Carioca folklore – the *malandro*, the bon-vivant, the idler, and the seducer – have all fallen victim to the influences of cultural interaction, and new prototypes are now

Rua do Lavradio in Lapa is famous for its antique shops that specialize in all kinds of treasures, especially furniture. When a group of musicians initiated a movement to revive the samba in this old bohemian neighbourhood, several of the shops, such as Emporio 100, began to open at night as bars that offer live samba and chorinho *music.*

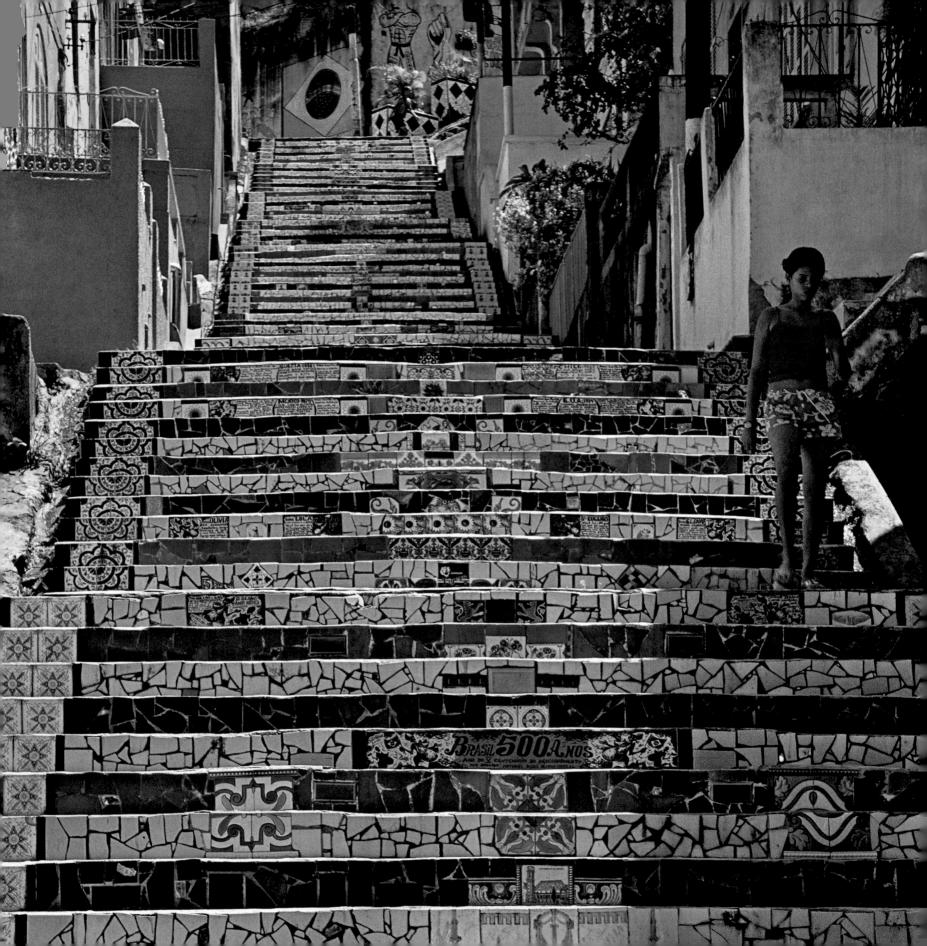

found in the global press. This new outlook has now been popularized, and these new forms of expression have spread to the city's districts and communities. The Cariocas are reinventing themselves, joining in the new global order by affirming their fundamental differences, taking on new roles and rejecting others, as they learn to occupy the new geographic and creative space of their city. As they discover their own patterns of difference, they are also discovering what makes them so unique in today's world.

On the other hand, the shock that the Portuguese and the French first felt when they saw the indigenous inhabitants of the region naked on the beaches seems to be reflected in the expressions of tourists and visitors that arrive in Rio in the early 21st century and find the semi-naked locals parading in the sun. The idea of sexual freedom, embodied not only by beach life but also by the Carnival, is one of Rio's most famous modern stereotypes. Although the Cariocas are certainly no puritans, the truth is that their sexual liberty has been exaggerated.

Guided by strong Roman Catholic influences, the inhabitants of Rio de Janeiro live by their beliefs, just like citizens in any large Western city. The characteristic friendliness of the Cariocas, however, is often taken for permissiveness, which can generate confusion and cause misunderstandings. Those who live in Rio are generally open with their feelings, and often exhibit

Opposite:
Lapa is home to many artists, such as Chilean painter Selarón whose painted tiles decorate the staircase on Rua Joaquim Silva.

Above left:
Artist José Jaime, nicknamed Geléia da Rocinha (the Rocinha Jelly), sells his work all over the city and internationally.

Above right:
Dona Zica, recently deceased, was considered the first lady of the Mangueira samba school for her marriage to its founder and composer, Cartola.

87

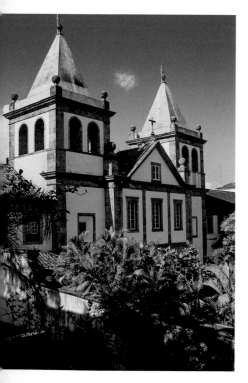

*Below and opposite:
Founded in 1590 by
Benedictine monks, the
Monastery of São Bento,
at the heart of the Centro,
retains a strict architectural
harmony, in spite of having
been constructed in different
periods. One of its daily
attractions is a mass with
Gregorian chants. The interior
of the church is renowned for
the richness of its decoration.*

intimacy without being considered impertinent or invasive. Visitors who come to Rio with different cultural codes and sensibilities can be shocked by what appears to be an excessive degree of spontaneity, but this shock can also create a mutual fascination between foreigners and locals.

Informal, fun-loving, outgoing, friendly and sensual: these are the best-known characteristics of the Cariocas. These attitudes, however, are not a world away from the patterns in any large city, though they may be more accentuated in Rio. A Carioca is more cosmopolitan and, at the same time, more provincial, than a Parisian or a New Yorker. The difference originates in a geography that has favoured a certain mode of living.

With so much of the population moving around on the streets and getting together in public places, leisure time is typically characterized by group activities. Few activities are done merely on an individual level. Even the current vogue for body-piercing and tattooing responds to a need to identify oneself with a group, rather than being an expression of individuality. In the city, hairstyles and clothing fashions change quickly, as do slang phrases and codes of behaviour. Cariocas recognize their peers at a glance and immediately share a common identity with them.

This form of sharing visually identifiable attributes distinguishes each of the recognizable 'tribal' or cult groups in the city: all of whom, however, consider themselves to be Cariocas. This tremendous variety is an example of the rich contrasts that the inhabitants of Rio find in their city. A sense of belonging is a complex thing to analyse, and it cannot be restricted to socio-economic factors alone, but must also take cultural variety into account.

This means that everyone who lives in Rio must adjust to the different ways that their neighbours choose to display their own particular facets of local culture. How to handle one's identity and alter ego are problems that all Cariocas must come to terms with in their youth. This learning process is, perhaps, the key to understanding the ease and skill with which the people of Rio handle relationships with each other. Their warmth and friendliness, therefore, is not just a matter of a natural sensitivity, but rather a key aspect of their personalities.

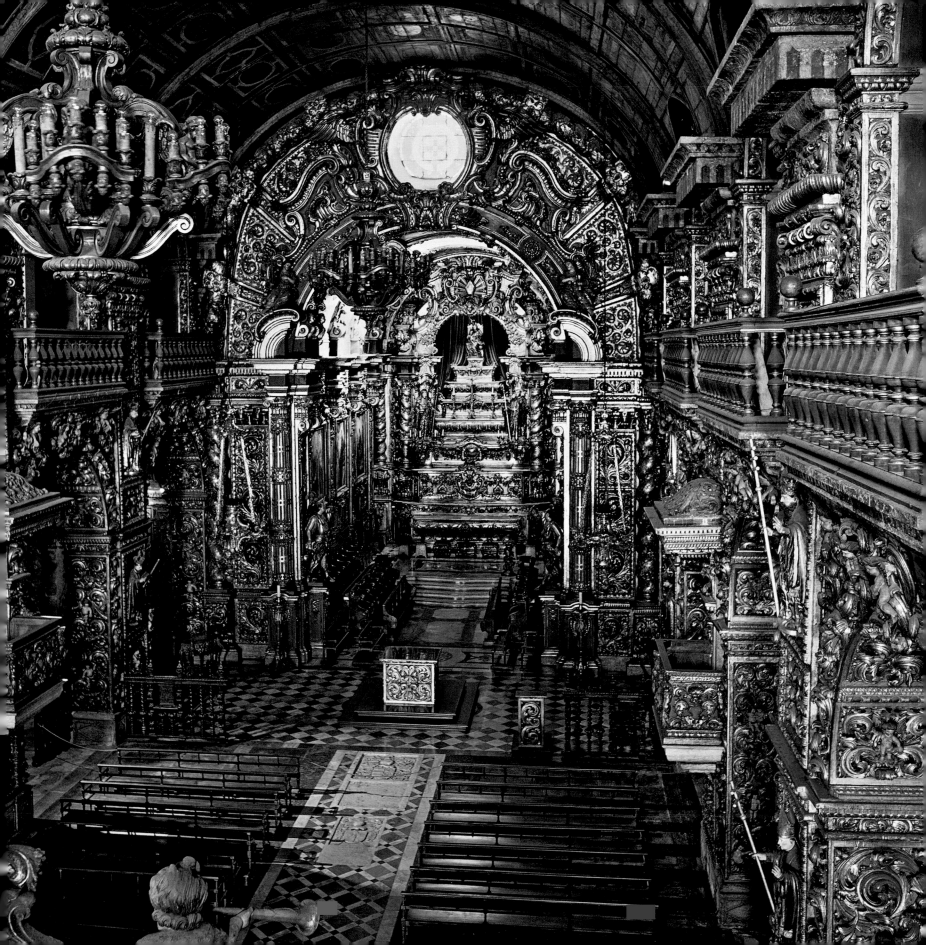

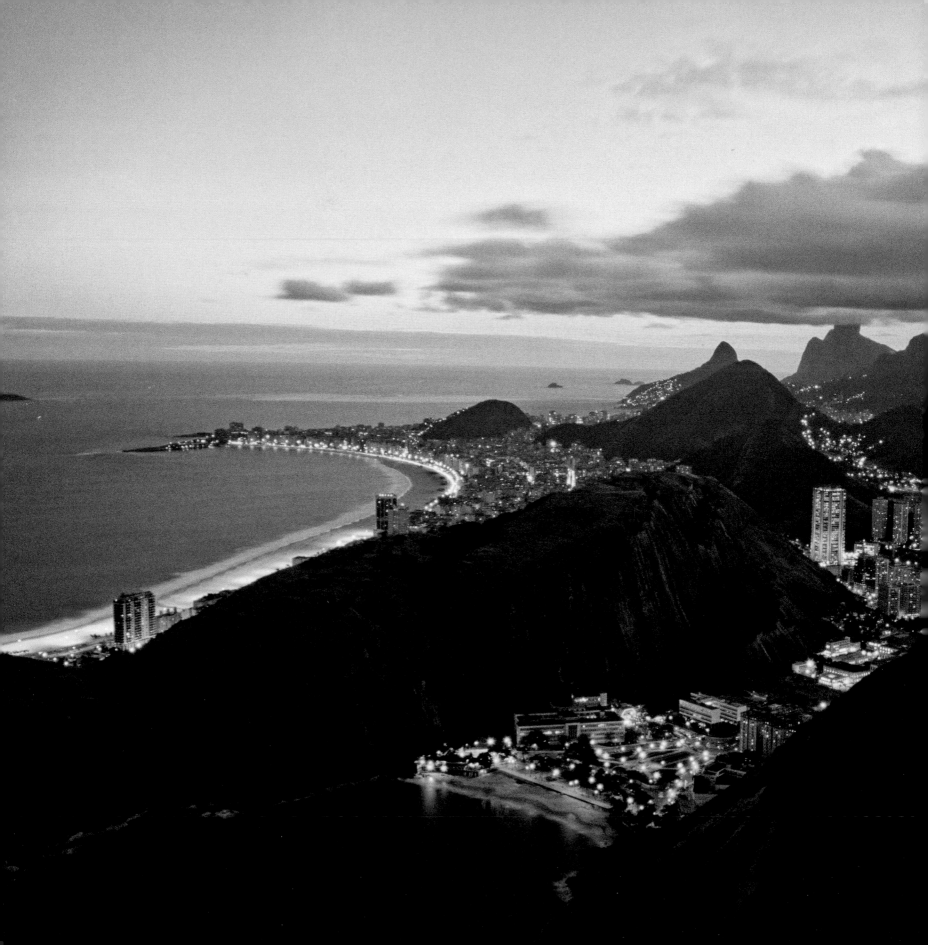

The City Today

A city is more than a collection of streets and neighbourhoods that spring from the imagination of a town planner or an architect, nor is it just a felicitous geographical coincidence. A city is the sum of desires, dreams and, above all, the ways that its inhabitants use it. In this sense, Rio de Janeiro is, without any doubt, a unique place on the planet. The natural exuberance of the landscape, marked by mountains, lagoons, rivers, forests and the ocean, shares its space with the results of a process of urban construction that differs from district to district. This clash of realities, however, does not always occur harmoniously.

Rio was the capital of Brazil for many years. Its political, cultural, administrative and economic importance placed the city in an outstanding position and gave the pride of the Cariocas an almost aristocratic bearing. It was a logical attitude, taking into account that the city had been the cradle of the Portuguese royal family and the seat of the Imperial government, before becoming the capital of the Republic. Each successive historical event was decisive in moulding the city's development and making Rio what it is today, just as each had a similar impact of the history of the country itself.

In order to discover the true sparkle that is so characteristic of Rio, it is necessary to start at the beginning. The starting point of this overview is the area traditionally called the Centro, the very heart of the city. Over time, the flora and fauna that once reigned there gave way to tall skyscrapers, but in its avenues, streets, alleys, squares, palaces, boulevards, cul-de-sacs and promenades, it is still possible to find traces of every period of history that contributed to the creation of Rio's cosmopolitan soul, its own unique personality.

Aerial view of Vermelha and Copacabana beaches.

Left and opposite:
The Centro contains traces from every period of its history, with architecture that combines modern skyscrapers with colonial churches. The city's special topography, with so many hills, led to its characteristic winding streets. After periods of erratic growth, the first comprehensive town plans, dating from as recently as the end of the 19th century, accentuated this mixture of styles and identities. But observing this part of the city as a whole, the urban landscape of the Centro is extremely harmonious and coherent.

Right:
The Metropolitan Cathedral, with its ultramodern architecture and conical form, has a base that measures 104 metres. The building, illuminated by four enormous stained-glass windows, has a capacity of 20,000 people.

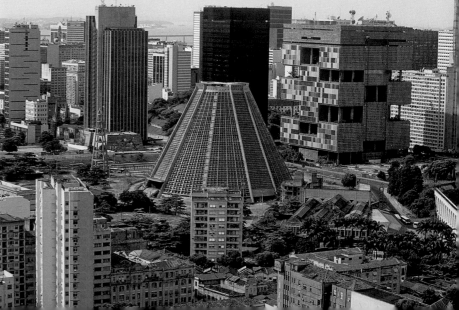

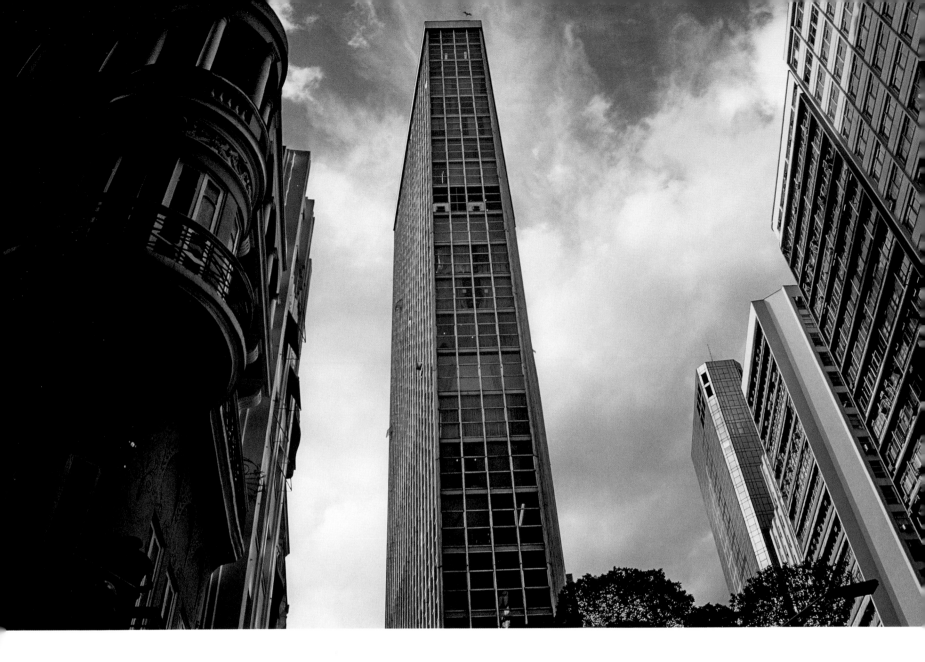

The streets of the Centro still conserve the memory of the city's growth, but you need to look closely; the traces are no longer so obvious today. The aristocratic Rua do Ouvidor, for example, where men and women dressed elegantly to visit its stores selling fine clothing and jewelry, was a refuge for intellectuals, journalists and writers, but ran parallel with the Rua da Alfândega, which connected the docks with the Centro and was a haunt for street vendors, often of Syrian, Lebanese, Armenian and Jewish origin. Since the 1990s, there has been a wave of immigration from Southeast Asia – particularly Cantonese and Mandarin Chinese, South Koreans and Japanese – with each group specializing in different trades.

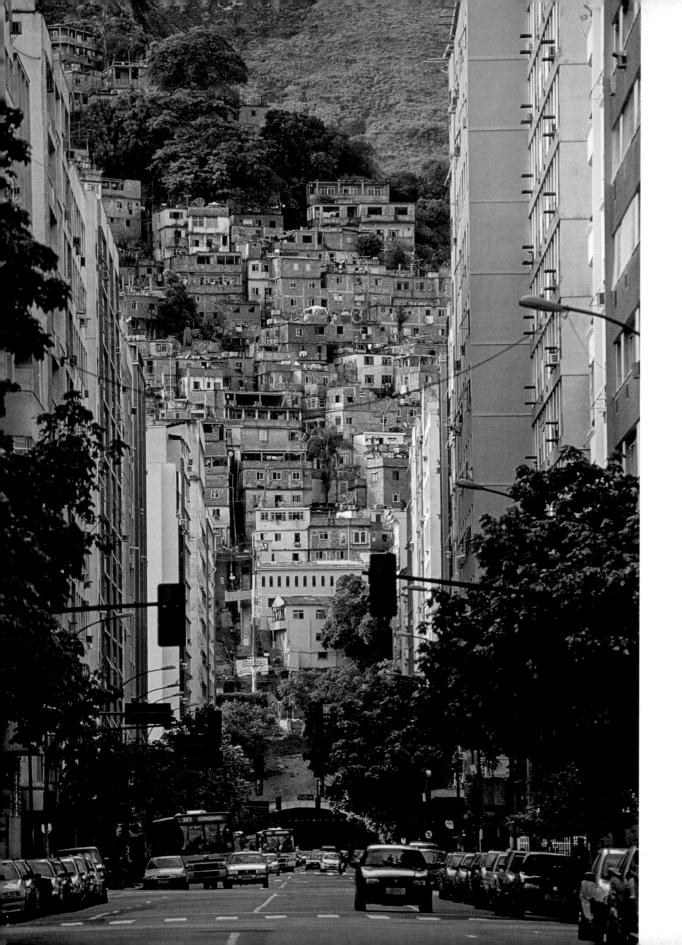

Left:
The contrast between the world of the favela above and the city street below is as physical as it is symbolic. Both areas have totally different lifestyles and this brutal division often has violent consequences. Poverty, discrimination and lack of opportunities characterize life in the Rio favelas and turn their residents into citizens of a parallel universe.

Opposite:
Considered a symbol of both Brazil and Rio de Janeiro, the statue of Christ the Redeemer offers a panoramic view of the city. The controversial statue, with its arms opened towards the entrance of Guanabara Bay to receive visitors, rises from the peak of the Morro do Corcovado. Visitors arrive by car or by a scenic train trip. The Rio authorities calculate that 600,000 people visit this site every year.

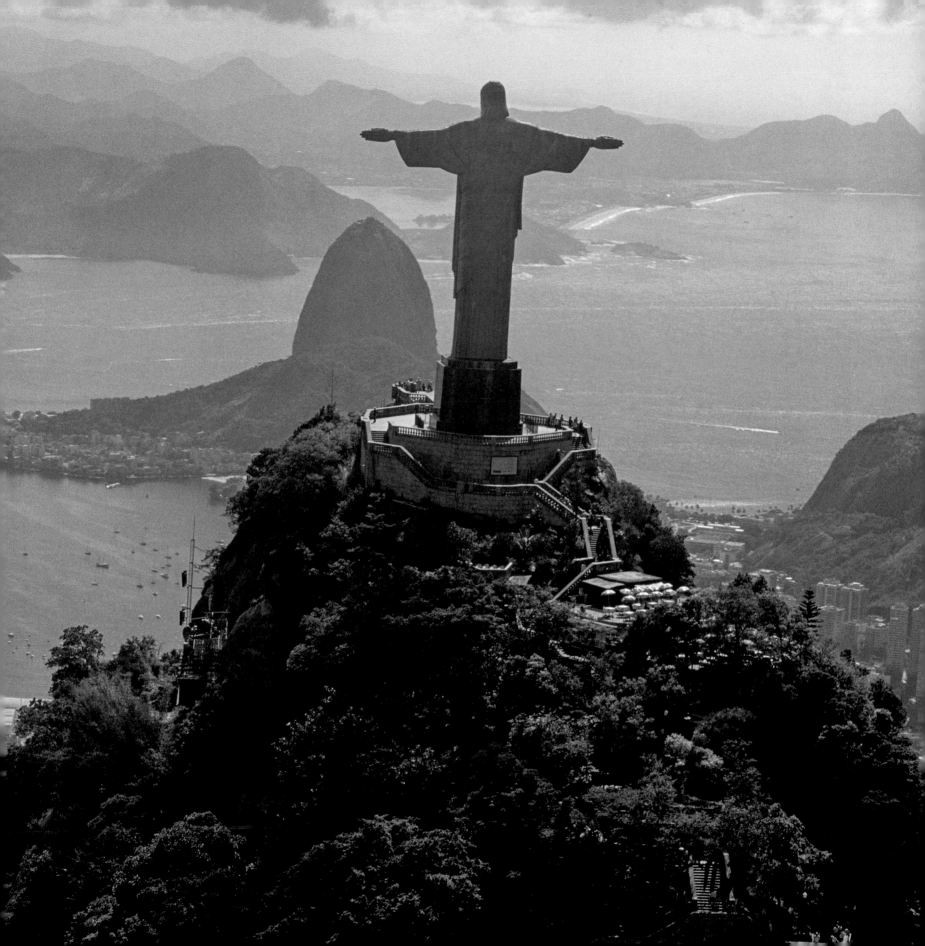

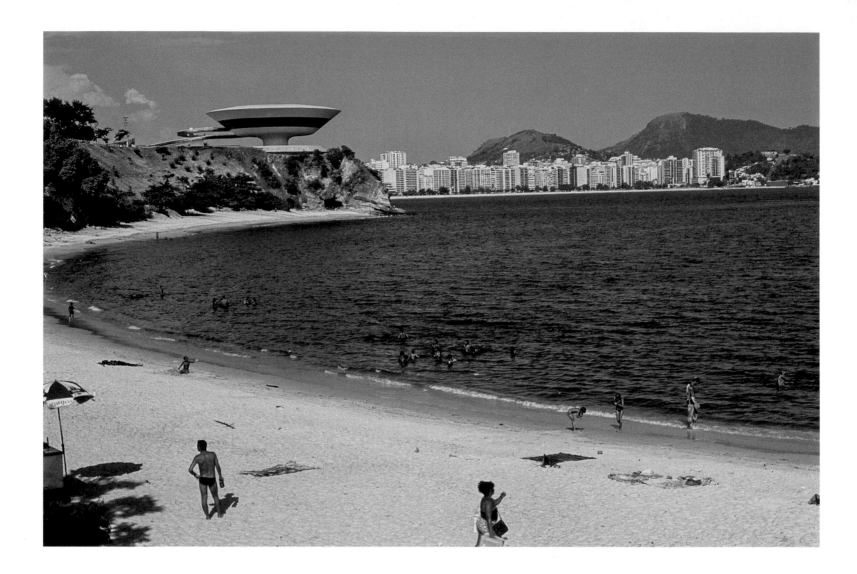

*Above and opposite:
The Museum of
Contemporary Art (MAC) in
Niterói is one of the architect
Oscar Niemeyer's most
beautiful buildings. Like a
flying saucer poised over
Guanabara Bay, the MAC is
part of the so-called Cultural
Corridor that borders the
coast of Niterói.*

Today neither the elegance of Rua do Ouvidor nor the commercial nature of Rua da Alfândega are as clearly defined as once they were, but clues to the earlier personalities of the two streets can still be found. What happened? The city grew, became more modern and adopted new customs and values. Socio-economic divisions became a source of conflict, and the differences were, to a degree, absorbed or incorporated into the fabric of everyday urban life.

In Rio de Janeiro, unlike many large cities, the most prestigious place to live has always been in the Centro and not in the suburbs. Over the years, the neighbourhoods of the South zone of the city, near the Centro and the best beaches, attracted the Carioca elite and the middle classes. The suburbs have always been working-class neighbourhoods, and after a policy of resettling *favela* dwellers was adopted in the 1960s, these more distant communities became home to the poorer members of Rio's

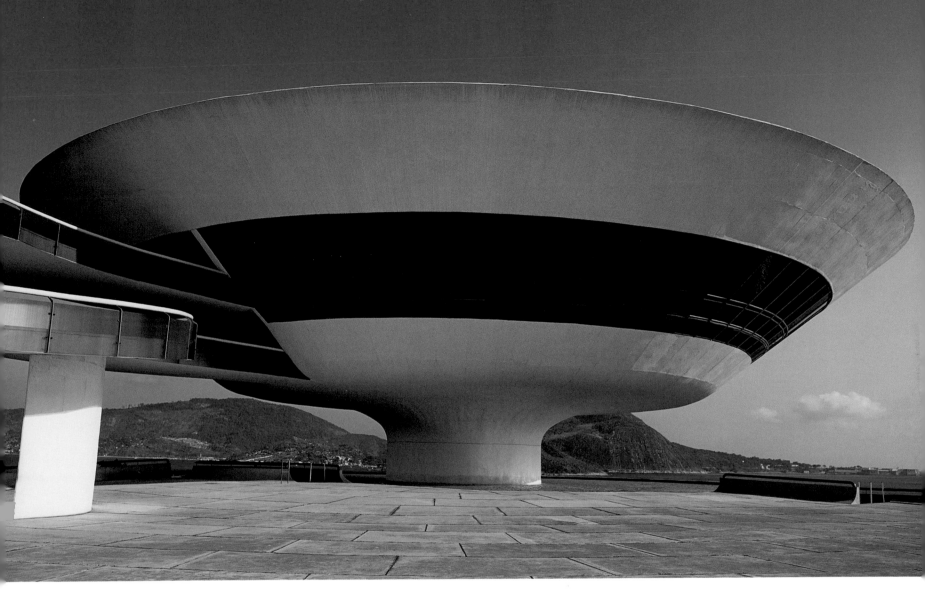

population. As the hillsides are still occupied by *favelas*, even in the best parts of town, the most exclusive neighbourhoods share their territory with the poor, providing interaction between different social strata on a daily basis.

The natural landscape of Rio has imposed itself to such an extent that the city's urban planners have always had to compensate for the curves of the mountains, the river beds, and the sinuous coastline with its numerous beaches. The concept of town planning as such, however, did not exist in Rio until the administration of Mayor Pereira Passos. During his term in office the idea of a radical transformation of the city took hold and was often imposed arbitrarily. This authoritarian style of redesigning the city often provoked violent reactions on the part of those most affected by the enforced changes.

The most important interventions in the field of urban renewal were carried out at the beginning of the 20th century. Many took place during the first decade of that century, under the regime of Pereira Passos, known as Mayor Tear-It-Down, because of the relentless demolition of tenements, shacks and even entire neighbourhoods that were considered dirty and unsanitary. Pereira Passos wanted to convert Rio de Janeiro into a tropical Paris, a coastal version of the City of Light. Colonial homes in the Centro were turned into multi-family dwellings, new water supply and sanitation systems were introduced, and new thoroughfares were opened: the Avenida Central (now Rio Branco) and later the Avenida President Vargas. Although they were resisted at first by those displaced from their homes, the reforms were nonetheless carried through.

The vast public works projects of the 20th century not only modified the city's appearance, but also provided a model for a certain type of citizen, turning the Cariocas into a more cosmopolitan society and also a more competitive one. Divided by the new avenues, the Centro began to develop specialist districts, devoted to activities such as shopping, business, or banking. Residents of the

Left and opposite:
Artist Ernesto Neto is famous
for his conceptual sculpures
and installations. He has
participated in many major
exhibitions in Brazil, as well as
in the United States, Europe
and Australia.

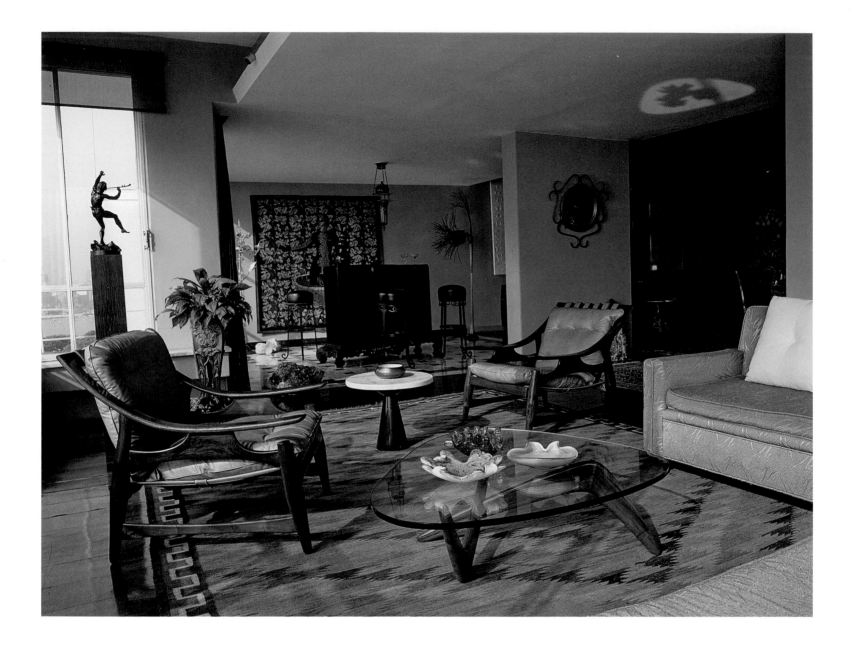

Centro then moved into residential neighbourhoods: the wealthier ones settled in the South zone, with the poorest moving to the North zone and the suburbs. Starting in the 1970s, the West zone began to grow, with communities of middle- and working-class residents springing up.

The expansion of a city that is so closely bound together with its landscape is not a simple process, and results in a constant struggle between the demands of nature and the social, economic and political issues of urban growth. Beaches were refilled with sand, hills knocked down, the course

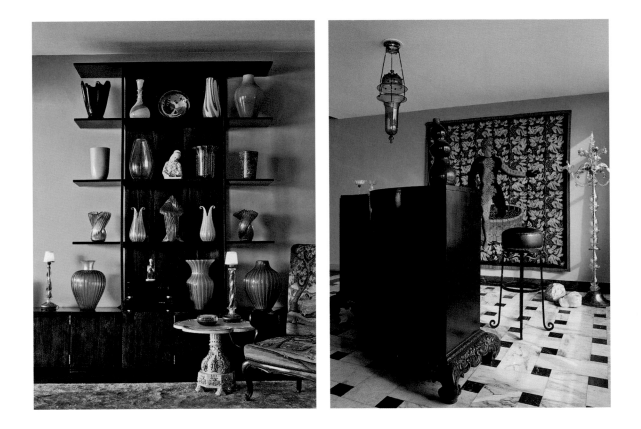

of rivers diverted, and forests felled. All of these measures were necessary to accommodate the second largest population centre in Brazil, combining many origins and social classes. In spite of this, the presence of nature continues to be a key feature of Rio's identity; the beaches, the bay, the mountains and the rainforest all share space with Rio's manmade monuments.

One example of the communion between nature and mankind in Rio is the Cristo Redentor, the famous statue of Christ the Redeemer. His arms open, facing Guanabara Bay, the statue can be seen from most districts in the Centro and the North and South zones. Standing on the Morro do Corcovado, the Cristo Redentor is the most important landmark in Rio, built by the Brazilian engineer Heitor da Silva Costa to a design by French sculptor Paul Landowski. When the statue is illuminated at night, the figure with its outstretched arms dominates the city's skyline, as if the Cristo was blessing the entire city. A train that climbs up the side of the Corcovado provides access to the monument for tourists.

The numerous parks in Rio are another of the city's main attractions. The Jardim Botánico (Botanical Gardens) is one example, founded by Dom João VI when he moved the Portuguese court to Rio. The park's 137 hectares (338 acres) hold many important plant specimens, both from Brazil and from all over the world. The entrance to the Botanical Gardens is lined with a veritable wall of

imperial palms, planted by the prince regent himself in 1809. Many people gather here on weekends to walk, read or relax.

The Floresta da Tijuca, which covers 120 square kilometres, also conserves many floral treasures of the Mata Atlântica region, such as the *jacarandá*, the *manacá*, and the *pau brasil*. These species formed an ecosystem that lined the Brazilian coastline at the time that the Portuguese arrived in 1500. Today this vegetation has been reduced to only eight per cent of its original area. The Floresta da Tijuca, which is the largest rainforest in an urban setting in the world, is part of this unique habitat and has been declared a World Heritage site and a Biosphere Reserve by UNESCO. In addition to its plant life, it is home to a variety of wild animals, mostly monkeys, as well as birds of many species.

Barra de Guaratiba, the estate of Roberto Burle Marx, Brazil's most renowned landscape architect, is located in the West zone of the city; the gardens were his gift to the community. When he died in 1994, he left it to the people of Rio as a living museum. The site has over 3,500 varieties of plants, many of them endangered species. There are countless works of art, mostly paintings and sculptures, in the architect's former home, as well as a specialist library of more than 2,500 volumes.

The Parque Lage has 52 hectares (130 acres) planted with native species of the Mata Atlântica and is one of the favourite parks of the Cariocas who live in the South zone, and was declared a

This page and opposite: Often compared with Montmartre, Santa Teresa is very reminiscent of that Parisian quartier with its historic buildings and intense artistic life. The only place in Rio where it is possible to take a tram, Santa Teresa offers several panoramic views of the city. The area has become renowned for its many galleries and artists' studios. During Carnival, the bloco das Carmelitas also draws large crowds to the old neighbourhood.

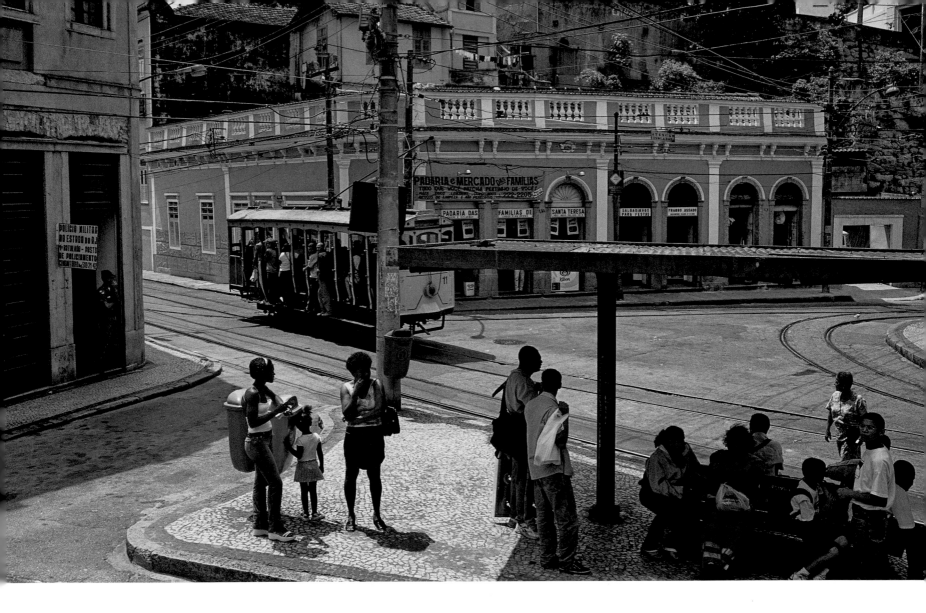

heritage site in 1957. There is also an enormous house designed in the eclectic style, built by Henrique Lage as a loving tribute to his wife, Gabriela Besanzoni Lage, an opera singer famous for her interpretation of Bizet's *Carmen*. It was the scene of memorable parties attended by the Carioca elite, and many motion pictures, including Nelson Pereira dos Santos's *Macunaíma*, were filmed there. The Parque Lage is now the home of the School of Visual Arts of Rio de Janeiro.

Human intervention in the natural landscape of Rio can best be seen in the city's architecture. Oscar Niemeyer is just one of the world-class architects whose works are spread throughout the city, as well as in nearby Niterói, Rio's sister city on the other side of Guanabara Bay. His best-known works are the MAC (Museum of Contemporary Art) in Niterói and the Sambódromo (Samba Stadium) in Catumbi, one of the city's many neighbourhoods.

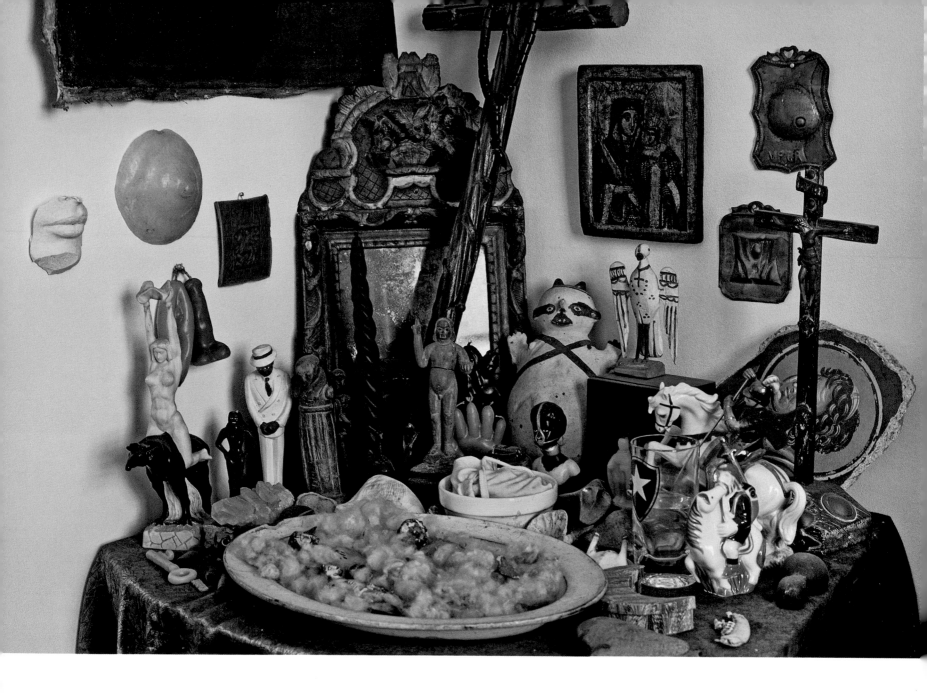

*The work of photographer
Miguel Rio Branco is known
internationally. His images.
usually in striking colours,
have intense emotional depth.*

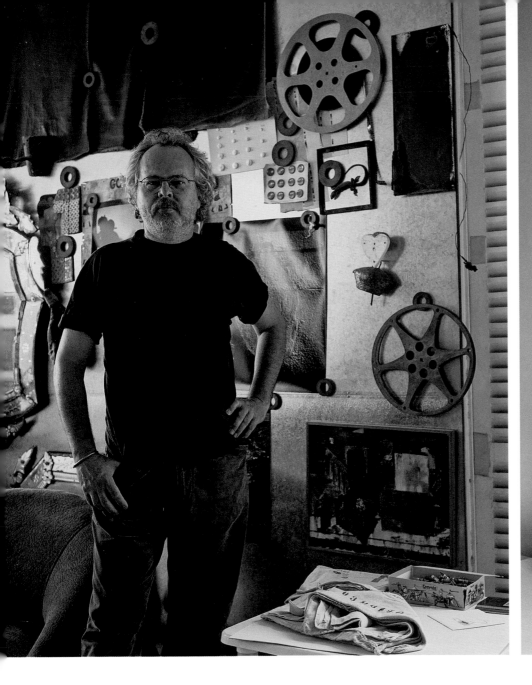

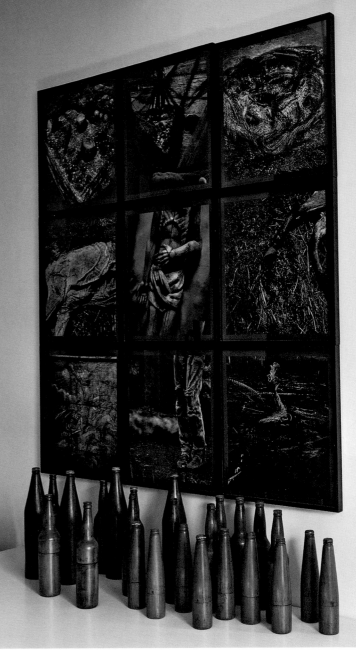

In his home in Santa Teresa, antiques from the world of film and photography decorate the walls, in a homage to the traditional filmmaking processes that are gradually being replaced by digital technology. On a kind of altar, he displays mystical and religious figures such as a statue of St George and the deities of Afro-Brazilian cults.

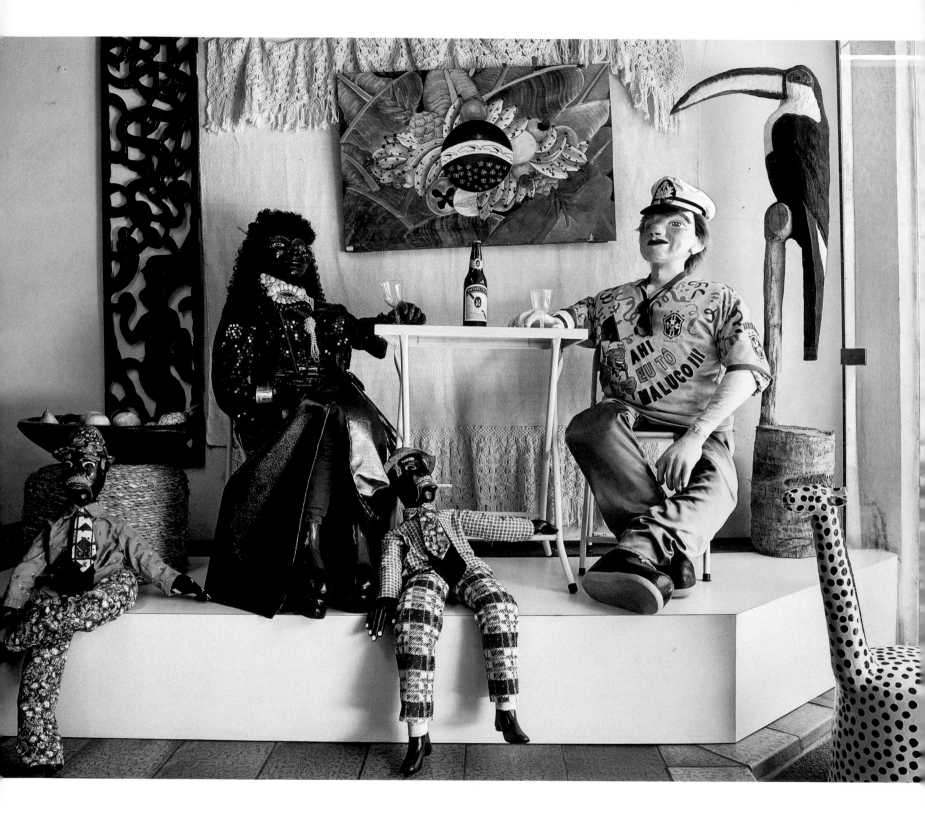

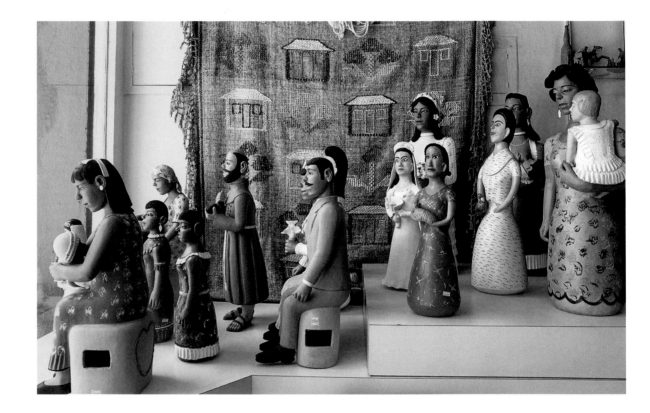

Right and opposite:
The Pé de Boi gallery built its
identity on the joint efforts of
artists and craftspeople, with
close connections to popular
Brazilian culture. The pieces
there reflect work from many
regions of the country.

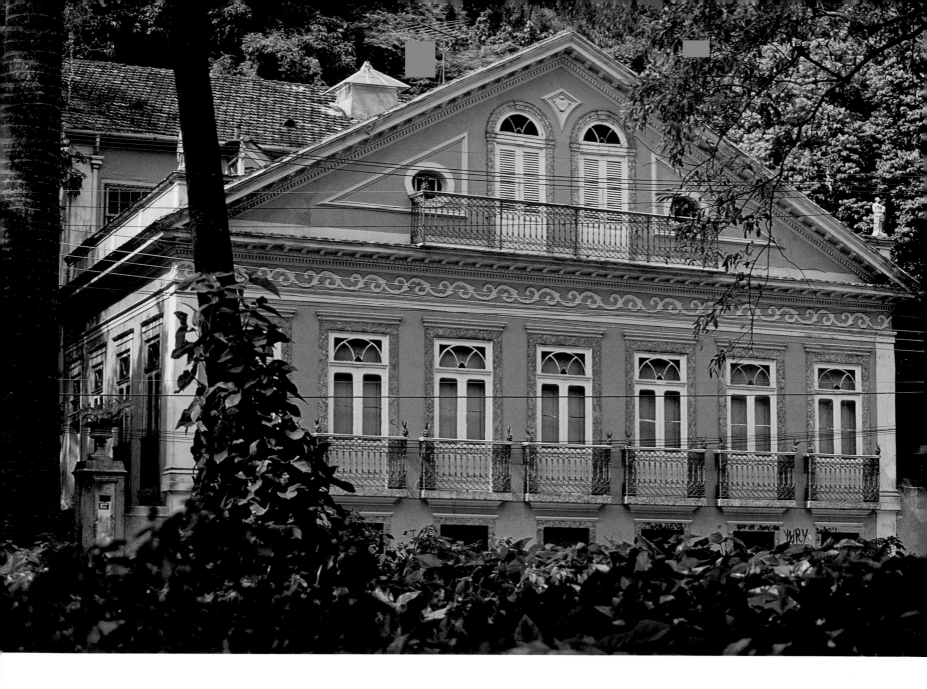

Above:
Built in 1831, this neoclassical
house on Rua Cosme Velho,
near the Largo do Boticário,
remains perfectly conserved.

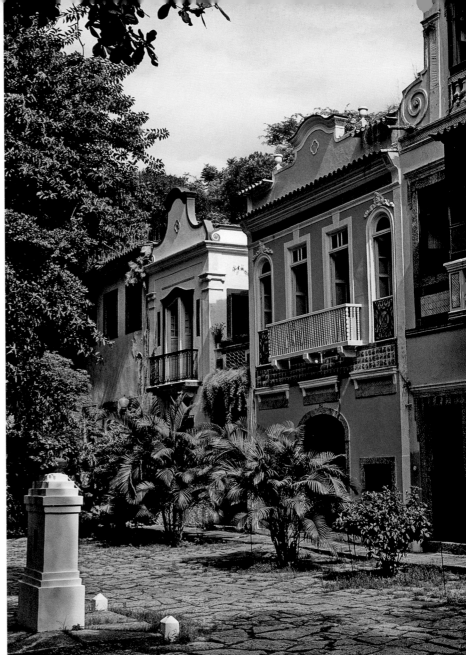

Right and below:
The paved plaza of Largo do
Boticário is one of the most
scenic spots on Rua Cosme
Velho. It is named in honour of
Joaquim Luís da Silva Souto,
the owner of a pharmacy
*(*botica*) in the centre of the*
city, where he prepared tonics
and medicines. He once
owned the land where the
square stands today.

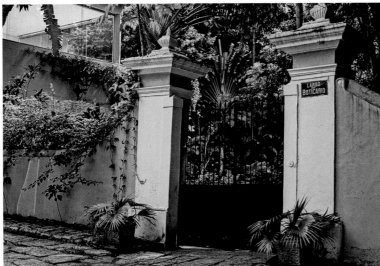

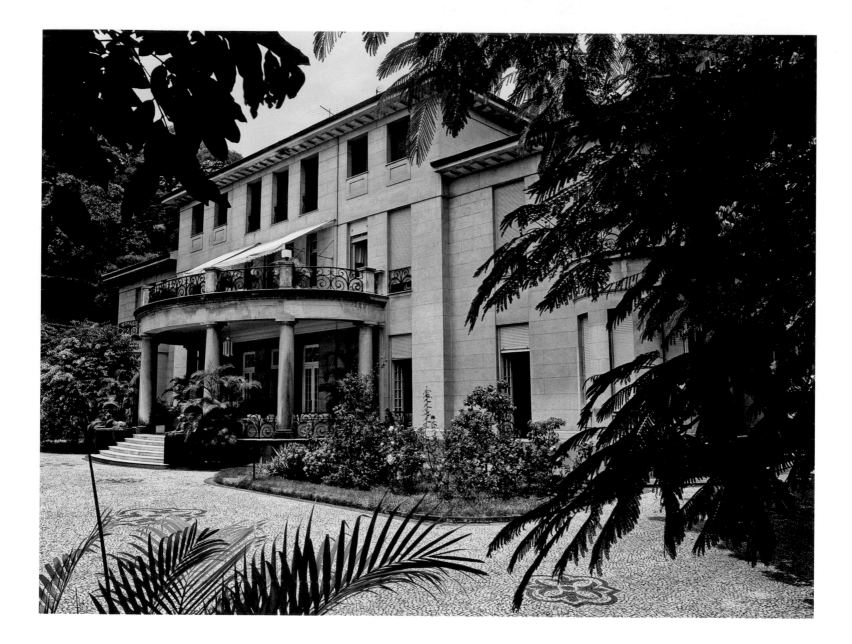

The art deco buildings of Copacabana stand out among other modern constructions of more questionable style and taste. The beautiful Copacabana Palace Hotel (1923), designed by French architect Joseph Gire in the Louis XVI style, deserves special mention. Buildings, churches, palaces and homes in neoclassical, modern, art nouveau, colonial, neocolonial, eclectic and a variety of other styles appear in most districts. These structures contrast strongly with the hillside *favelas*, an unmistakable sign of the social inequalities in Brazil.

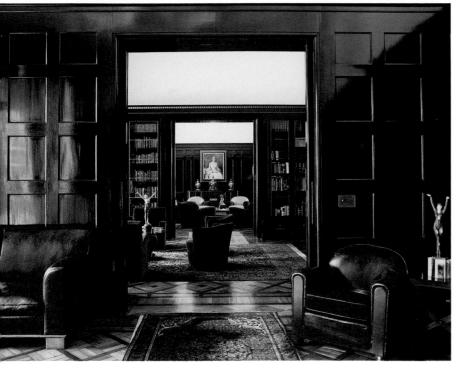

This page and opposite:
The residence of the Monteiro de Carvalho family is a tribute to art deco. Located in Santa Teresa, its furniture and decorations are typical of the designs of that period.

In Rio, art deco is associated with a period of sustained growth and urban development in the city. Its sober lines were based on a revaluing of reason and the dialogue between art and science.

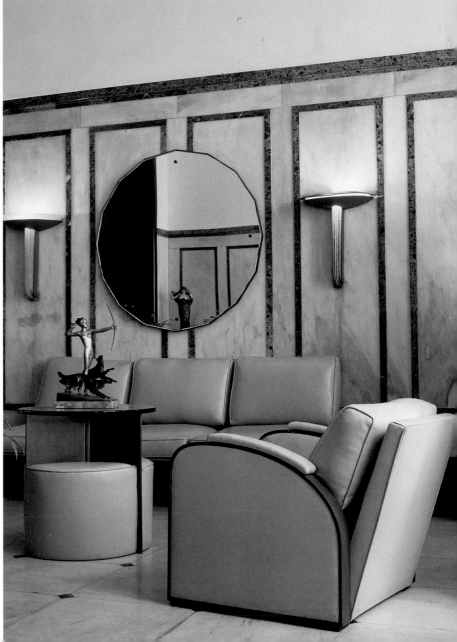

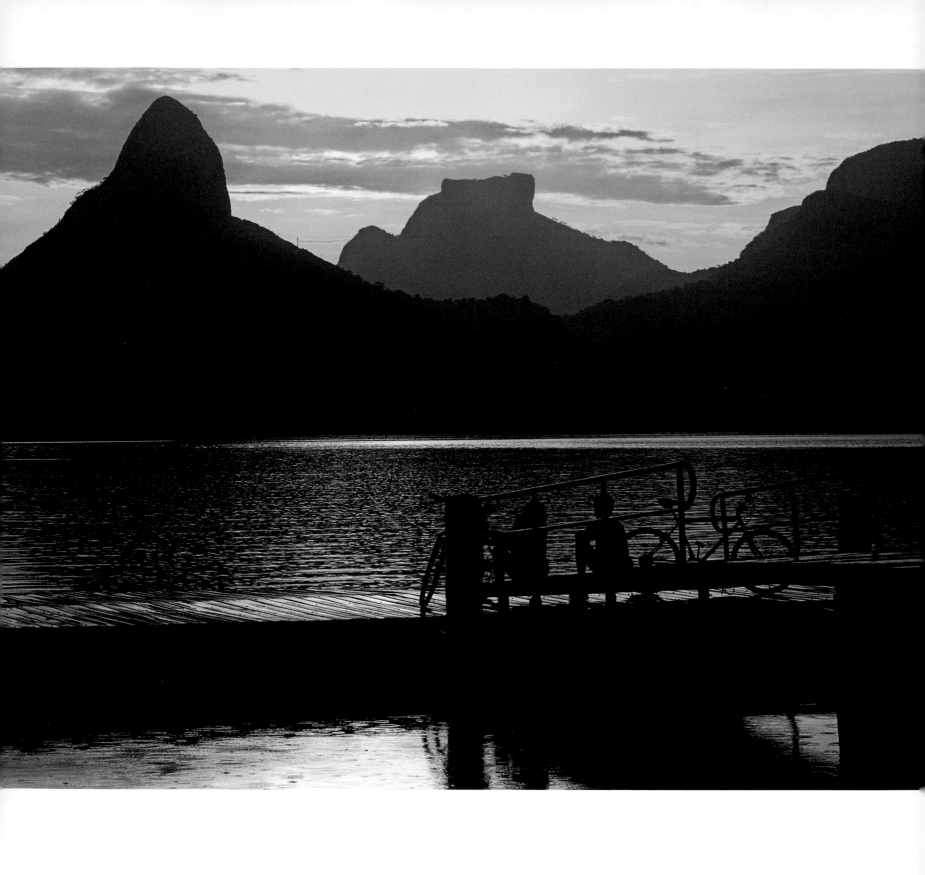

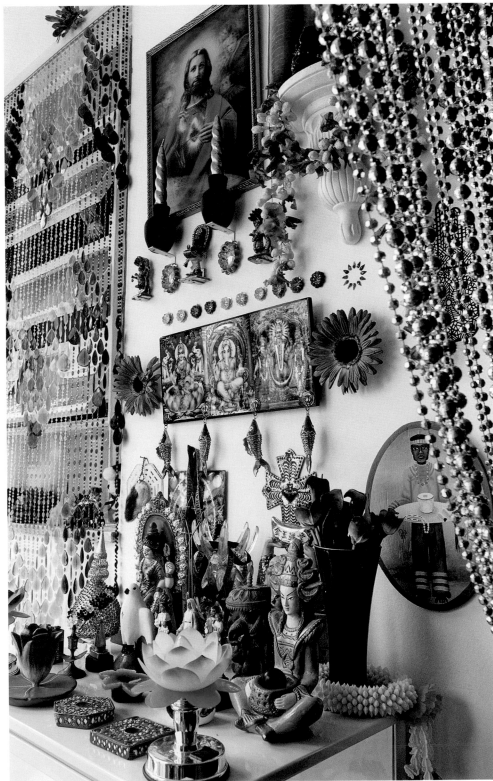

Right and below:
Felipe Veloso is a designer
whose colourful work has pop
influences. His home in Santa
Teresa is a permanent
showcase for his work.

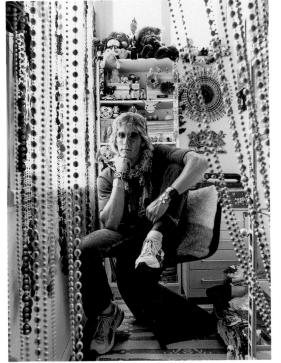

Opposite:
At nightfall, the Lagoa
Rodrigo de Freitas offers a
dramatic view of the hills
against the fading light.

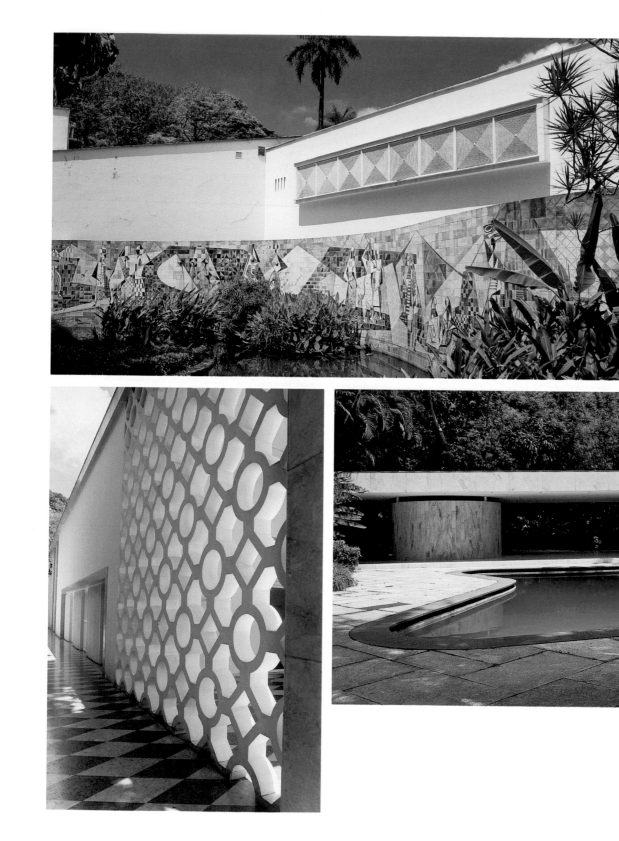

This page and opposite:
In 1990, Walther Moreira
Salles transformed his home in
Gávea into an institute that
bears his name. Designed in
1950 by architect Olavo Redig
de Campos with a garden by
Roberto Burle Marx, the
Salles Institute is dedicated
exclusively to the arts and
cultural events.

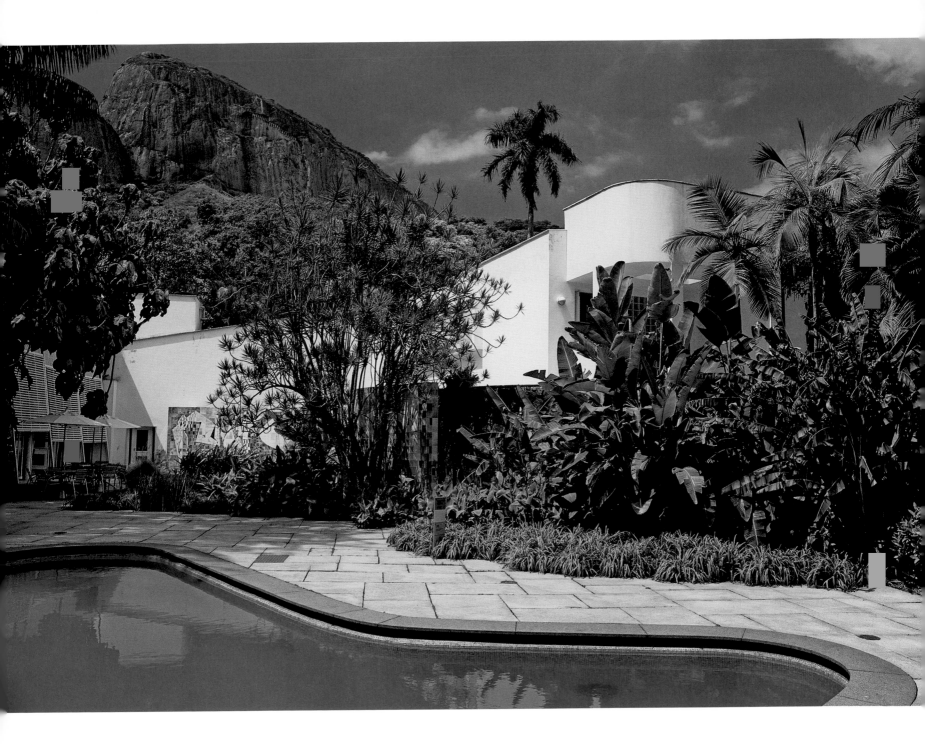

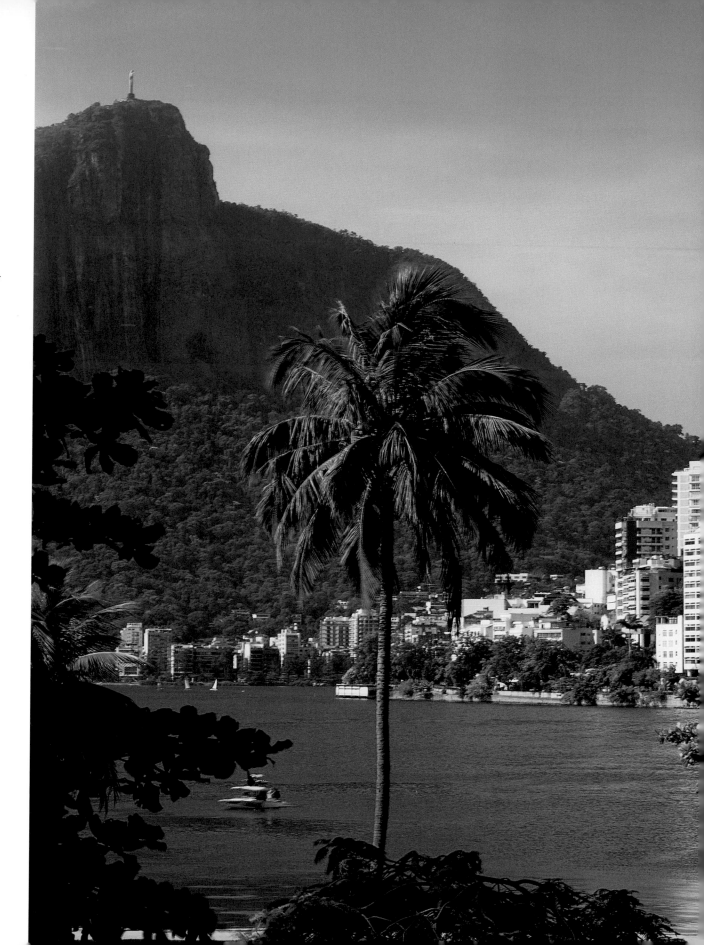

Located in the South zone of Rio, the Lagoa Rodrigo de Freitas connects the affluent districts of Leblon, Ipanema, Copacabana, Gávea and Humaitá. The salt-water lagoon was originally called Sacopenapã *by the Tamoio Indians. Today, its five-mile perimeter has become a gastronomical and entertainment centre that takes advantage of its natural setting. This area is now one of the most expensive in the city.*

Many churches are from colonial times, dating back to the 17th and 18th centuries. Among the most notable are Nossa Senhora da Candelária, built in 1634 and reconstructed in 1811; the church and convent of Santo António, in the Largo da Carioca, built in 1608 and 1620; the church and monastery of São Bento (1602); the church of Nossa Senhora da Penha (1635); the church of São Gonçalo Garcia and São Jorge (1758); and the Presbyterian Cathedral, built in neo-gothic style in 1925; the Evangelical Church of Rio de Janeiro (1888), also in neo-gothic style; and the Jewish Synagogue, built in eclectic style in 1932.

Above, left and right: Professor Ivo Pitanguy, one of the best-known plastic surgeons in Brazil, founded the clinic that bears his name in 1963. The clinic caters to a large proportion of the Carioca upper classes.

His house was designed by architect Sergio Bernardes and is a prime example of the style that made him famous. It is architecture with a strong humanistic bent, in which the individual is the architect's principal concern.

The majority of Cariocas are Roman Catholic, but many practise Afro-Brazilian religions, predominantly *candomblé* and *umbanda*, which often incorporate Catholic saints and rituals into their traditions, making it difficult to differentiate between the separate faiths. In recent times, there has also been a rapid growth in Pentecostalism.

With its natural advantages, Rio de Janeiro is an ideal place for open-air sports, including the more extreme variety. *Futebol* (soccer) is the national game. While the professionals play in stadiums

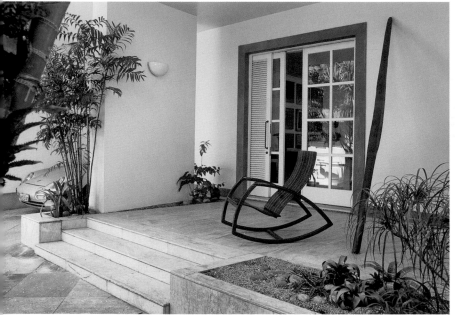

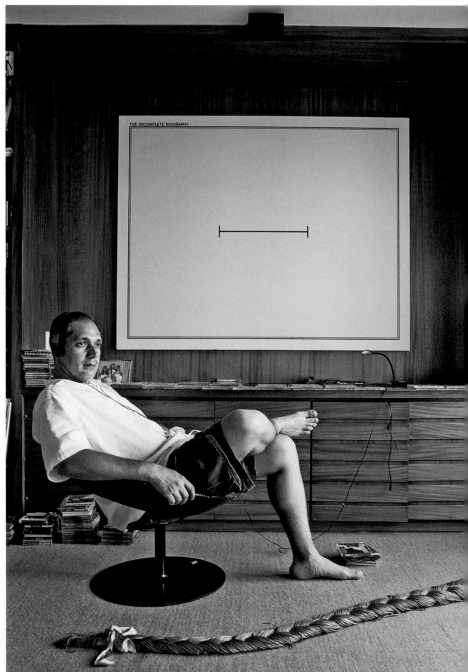

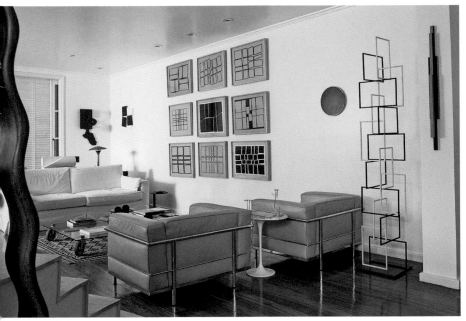

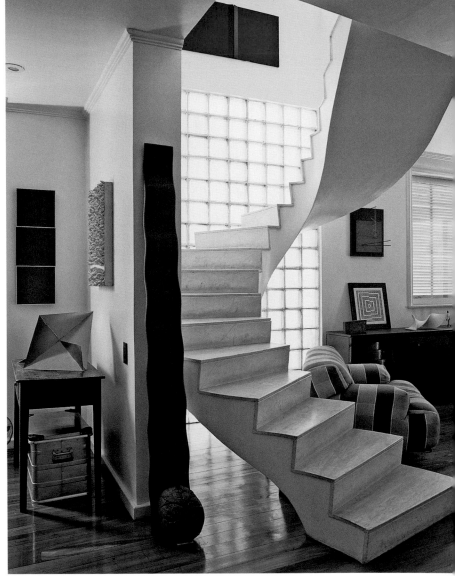

Ricardo Rego owns one of the
most interesting collections of
Brazilian contemporary art.
Most of it is housed in his
home in Urca and in his
gallery, Lurixs. Rego sees the
growth of collecting in Rio as
something that will make the
contemporary art circuit in the
city more professional.

Right and below:
Writer and connoisseur of
popular Brazilian music,
Ricardo Cravo Albin lives in
Urca, one of the city's most
tranquil neighbourhoods.
The buildings and houses
are low and hardly disrupt
the landscape, which is
marked by the Morro da
Urca and Pão de Açúcar.

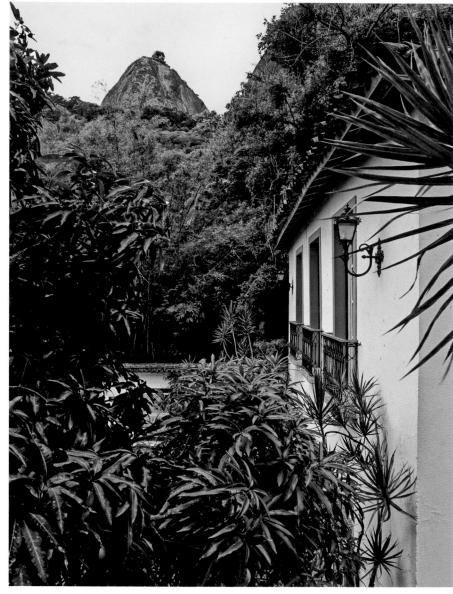

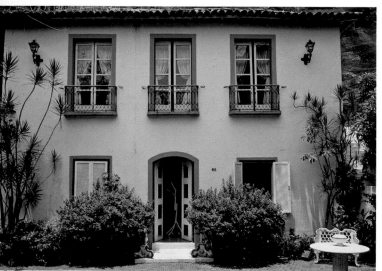

Opposite:
The Albin home is a typical
Urca residence, with its colonial
style and rustic interior and the
striking presence of basic

materials, especially wood.
The collection of handcrafted
objects accentuates the
traditional atmosphere.

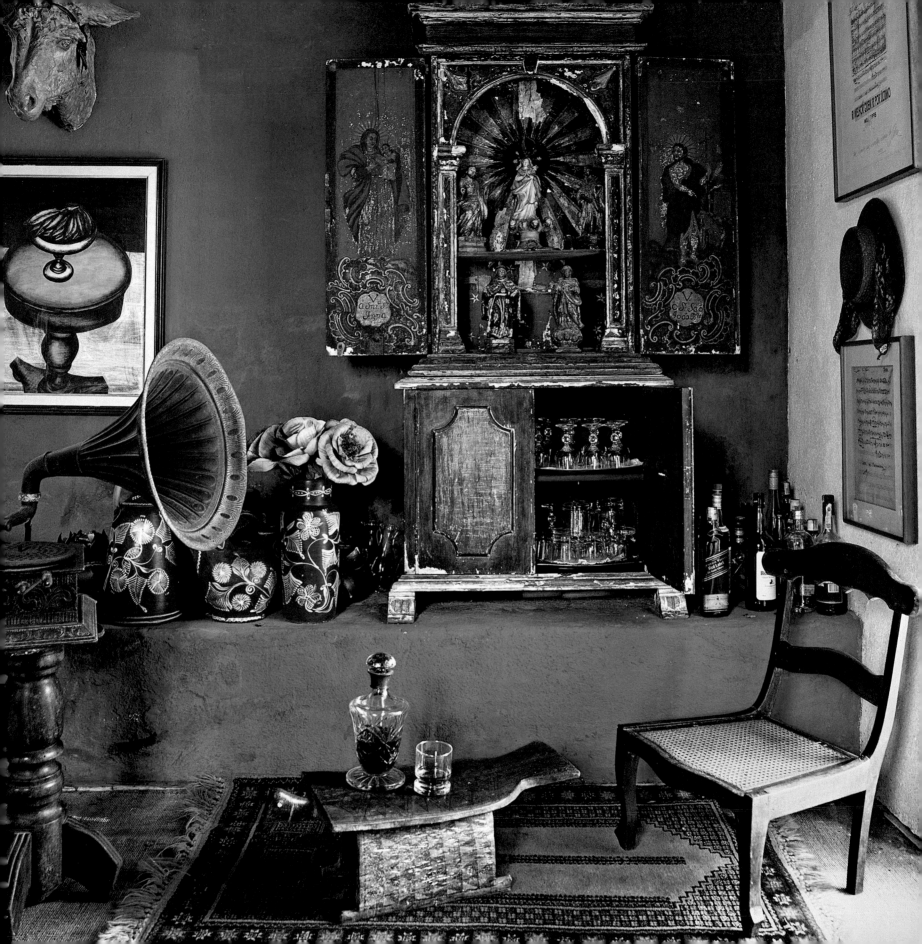

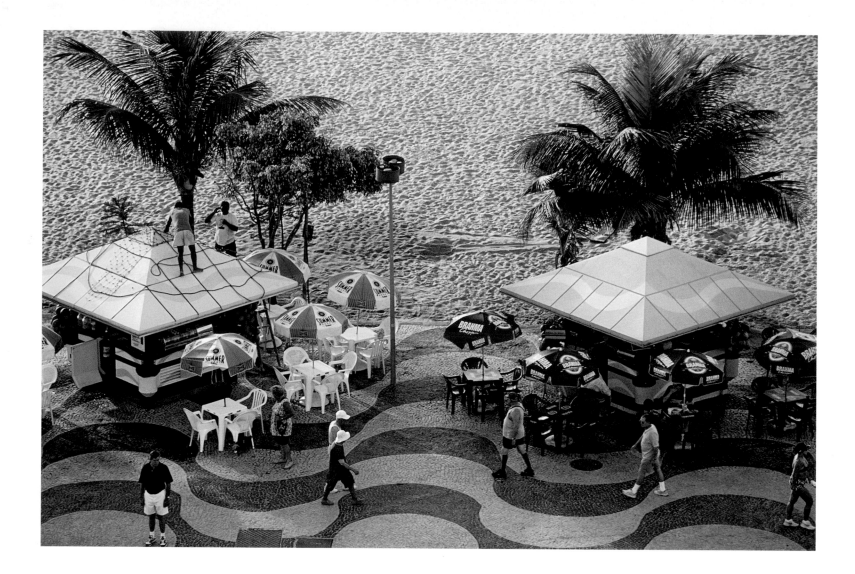

Above and opposite:
The almost three kilometres
of calçadão *that borders*
Copacabana Beach has many
kiosks where visitors can eat
and drink while they watch the
comings and goings of bathers
and holidaymakers.

like Maracanã, one of the world's largest, the fans play on the beaches, in the parks and even in the streets. With the growth in popularity of volleyball, from the 1980s on, the Cariocas invented *futevolei*, a mixture of *futebol* and volleyball, which is played on sand at the beach. It is a variety of volleyball in which players cannot use their hands.

Mountain climbing, from scaling tall peaks to gentler hikes, has become more and more popular among young people, who prefer to be close to nature. Surfing, windsurfing, diving, sailing, gliding and paragliding are also sports that are well adapted to the geography of the area. A bicycle path runs along the entire coast of Rio, and on weekends, entire families can be seen pedalling through the city. However, there are still many prefer to walk, a perfect way to get some gentle exercise and enjoy the landscape.

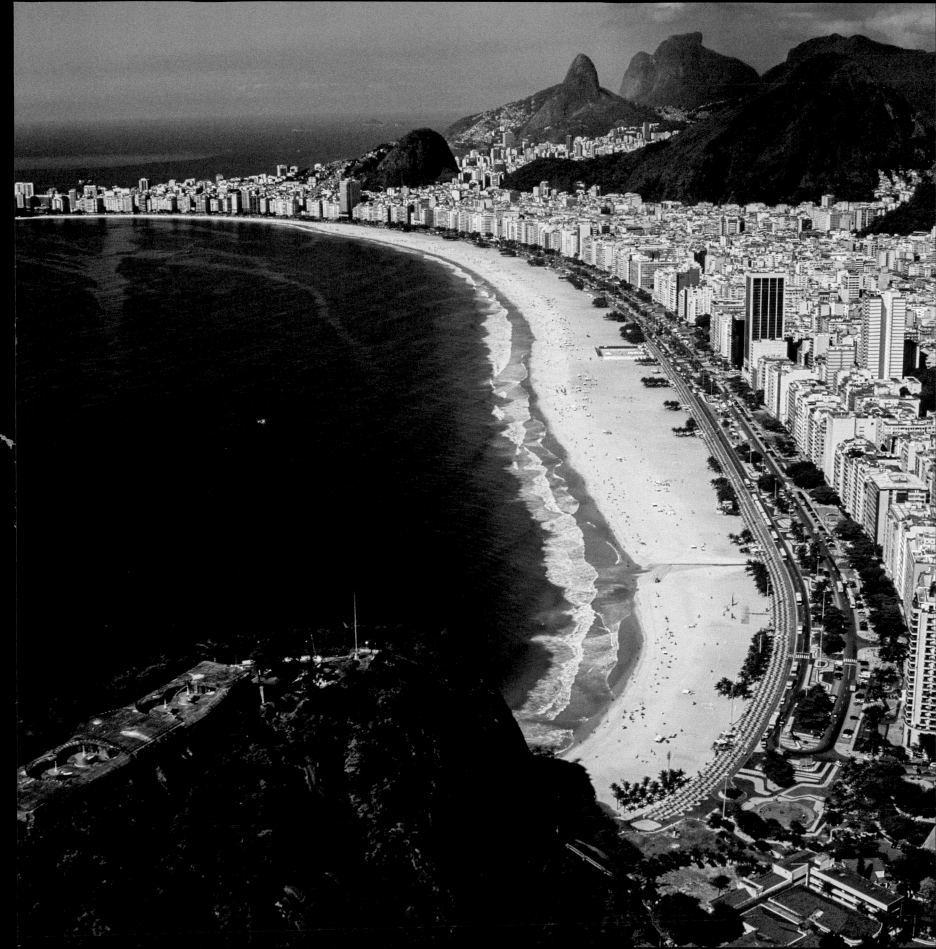

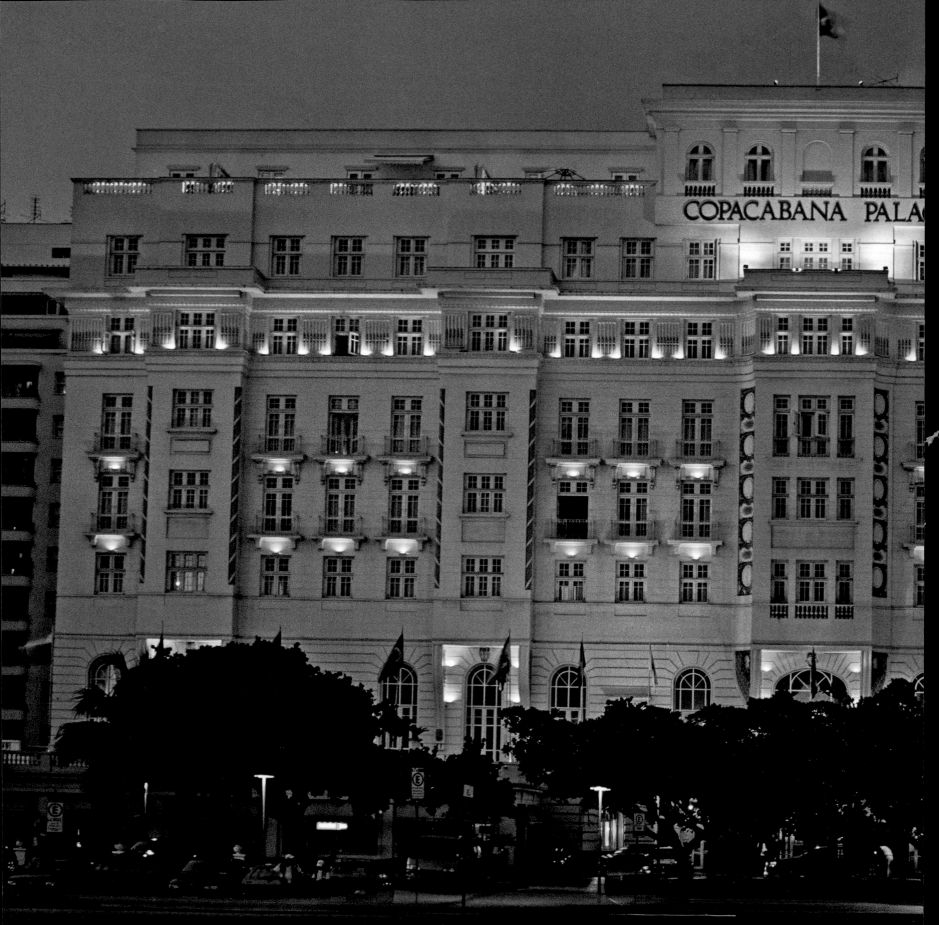

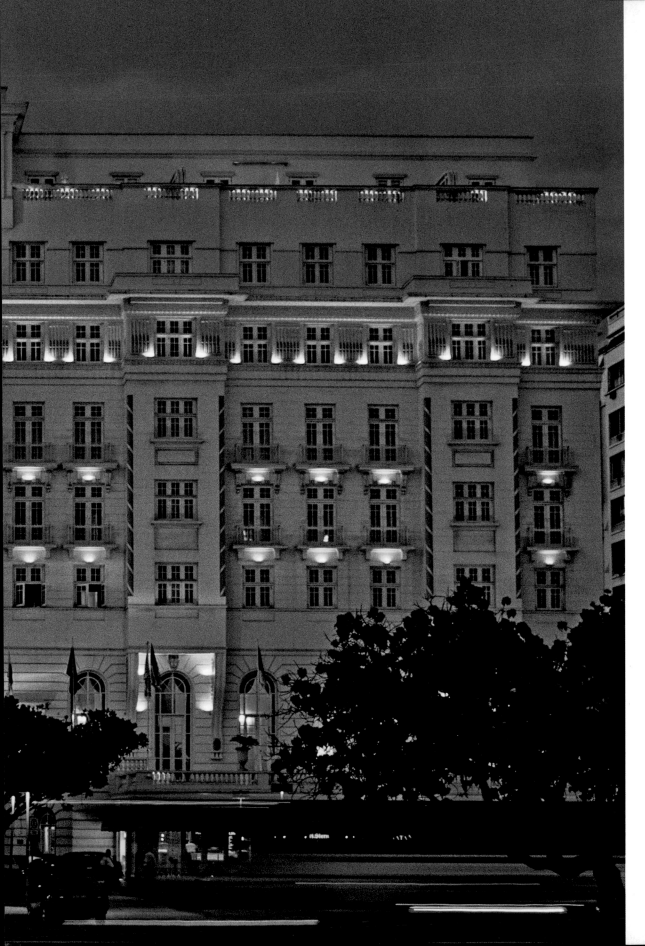

Built in 1923, the Copacabana Palace Hotel was the first step in the district's transformation into an international resort. The presence of the hotel encouraged the construction of modern buildings and shops in this area which had previously been no more than a popular bathing beach. With its Louis XVI style, the original design of French architect Joseph Gire has been conserved intact. The hotel's guestbook counts Charles de Gaulle, Ava Gardner and Orson Welles among its distinguished visitors.

125

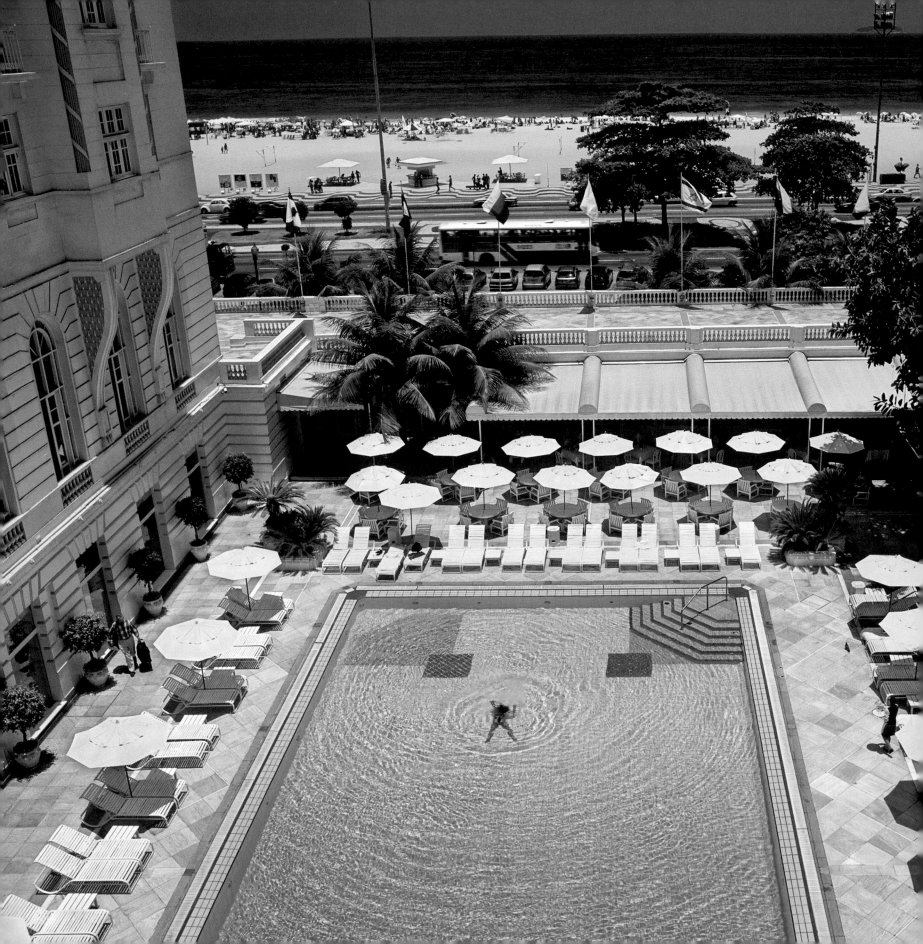

Guanabara Bay is not just the ideal spot for watersports, but has many other attractions. In the Centro, the Glória Marina, the Second World War Monument, and the Museum of Modern Art compete with the compelling view of the Bay. The islands in the Bay are also landmarks: one, for example, is Ilha Villegaignon, where the French settled in 1555, hoping to found the colony of France Antarctique. The island is now connected to the mainland and functions as the campus for the Naval School. Ilha Fiscal has a handsome, neo-gothic palace that is open to visitors, while Ilha Paquetá is the destination for a typical excursion to visit Guanabara Bay. The boat trip there takes an hour, but it is worth the trip to see this remote neighbourhood of Rio de Janeiro, characterized by houses, bicycles, bars and restaurants.

Niterói is located opposite Rio, on the other side of the Bay. This neighbouring city has its own identity and offers numerous cultural and leisure activities. Its oceanfront beaches are the most sought-after by residents of both cities. Not only is the water cleaner, but nature is better preserved. The Rio-Niterói Bridge, one of the major construction projects of the military regime, connects the two cities; a rapid catamaran service from Praça XV to the centre of Niterói is also available. If you

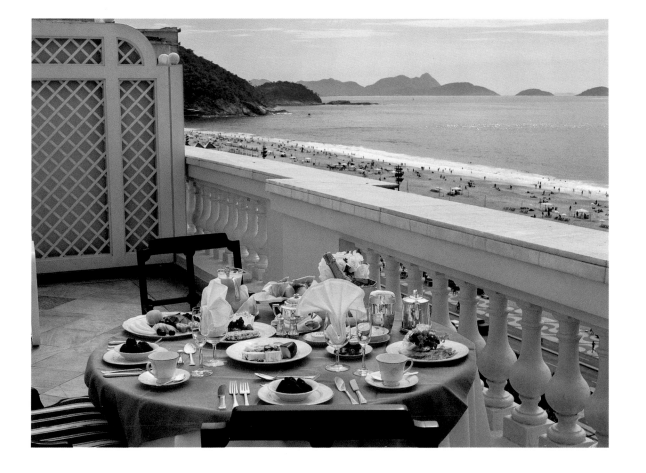

The view of the beach from the terrace of the Copacabana Palace Hotel makes breakfast there a pleasure.

have time for a more leisurely trip, the most pleasant way to cross the bay is by boat, which takes less than half an hour and allows an opportunity to enjoy the natural beauty of Guanabara Bay.

Almost every Carioca neighbourhood has an identity of its own, but some are more visible than others. That is the case of Santa Teresa. Founded in 1750, a settlement grew up around the Carmelite convent. The neighbourhood extends across a chain of hills, with access to the Centro and the South zone. The best-known way of getting to the city is by an electric tramline to Lapa that passes across a former aqueduct built in 1723 to supply Rio with fresh water.

Santa Teresa is home to many artists and craftspeople. The neighbourhood organizes an event every winter called 'Santa Teresa of the Open Doors', for which all the artists' studios open their doors to visitors. It is also one of the city's most bohemian areas, with bars, restaurants and party venues with panoramic views of the city. There are a variety of museums and attractions, such as the

The Casa das Canoas in São Conrado was built by Oscar Niemeyer for his family in 1953.

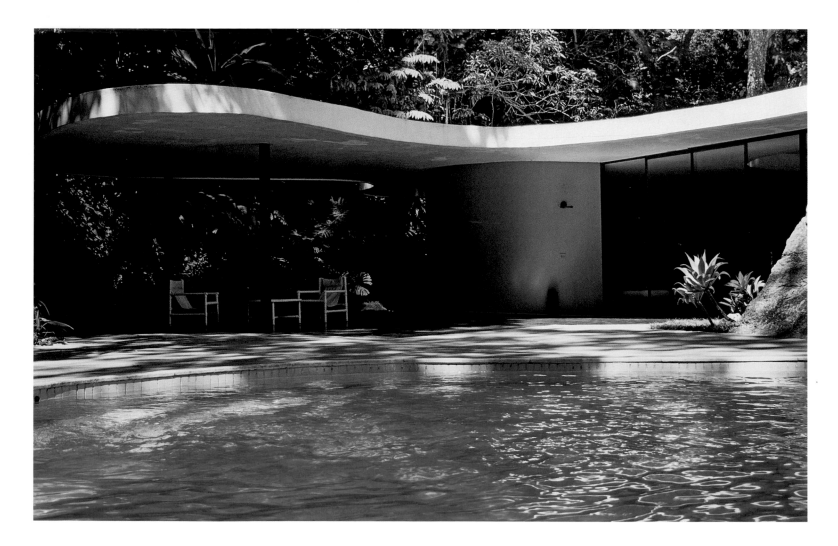

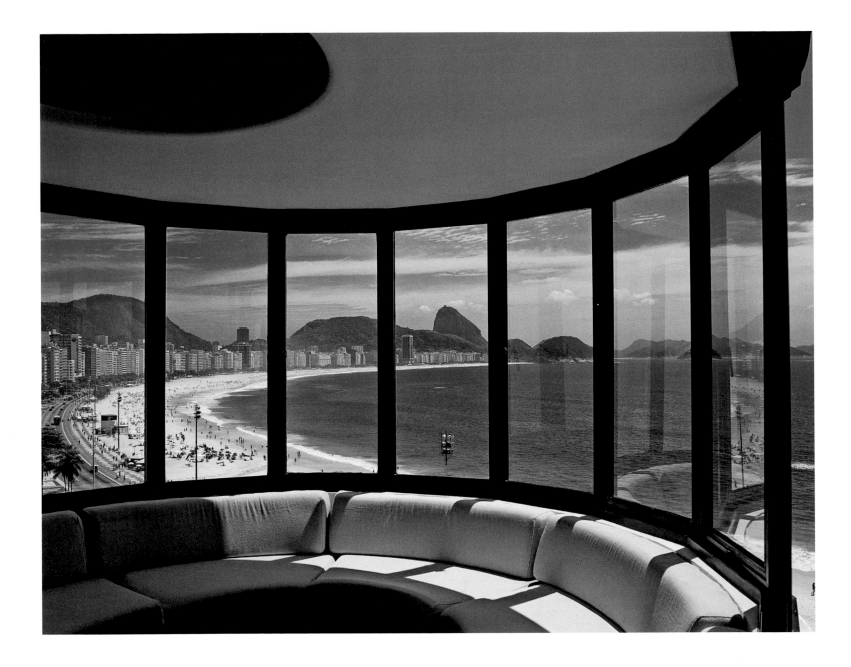

The complex and varied architectural style of Copacabana has many unique features, like the art deco buildings from the 1940s, as well as those designed by famous architects. This curved room that overlooks the bay is the studio of architect Oscar Niemeyer.

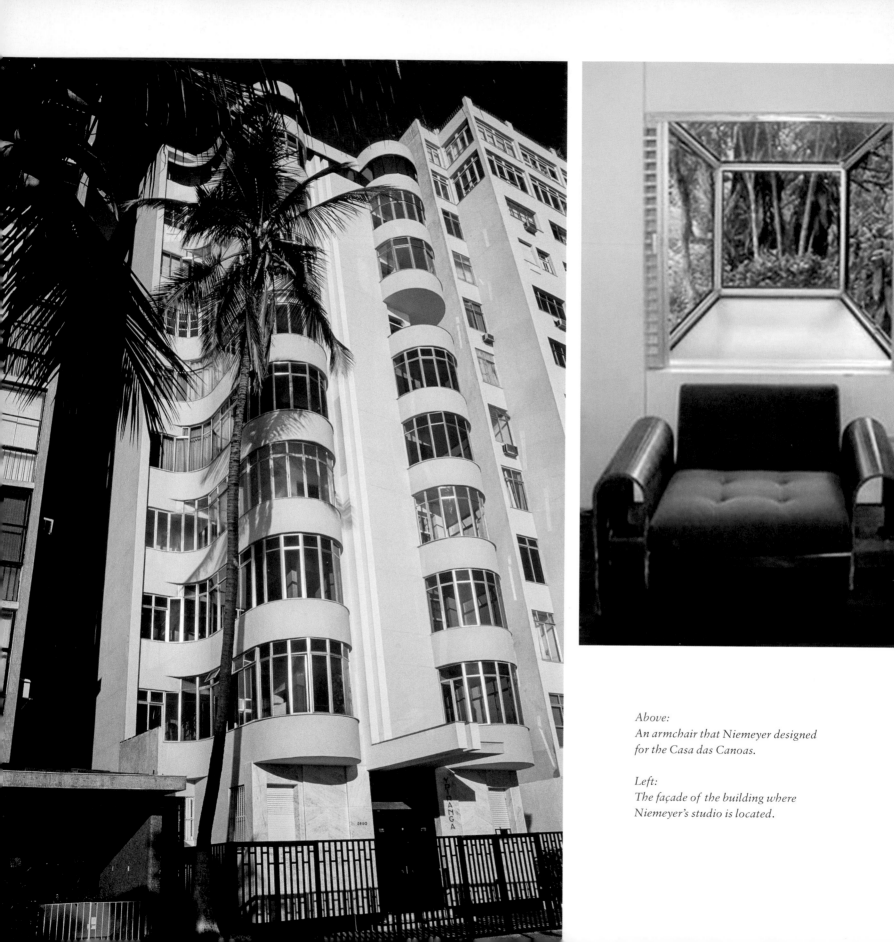

Above:
An armchair that Niemeyer designed
for the Casa das Canoas.

Left:
The façade of the building where
Niemeyer's studio is located.

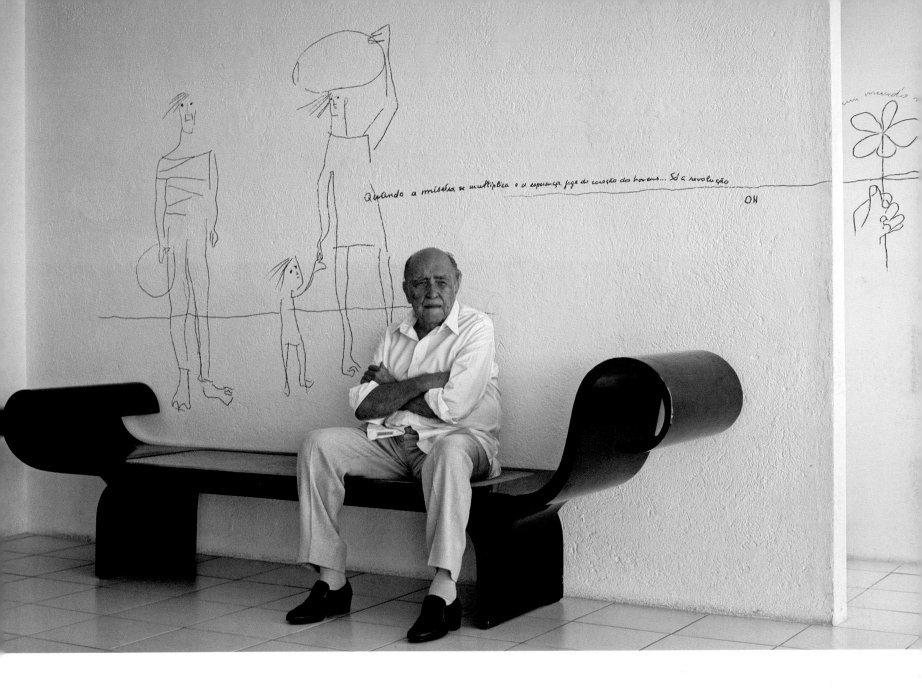

Parque das Ruinas, the Museu do Bonde (Tram Museum) and the exhibition spaces of the Laurinda Santos Lobo Cultural Centre. In addition, the typical architecture found on any of the local streets is an attraction in itself. All of these features have led to Santa Teresa's nickname of the 'Montmartre of Rio'.

Several of the streets that wind down from Santa Teresa lead to the Largo da Lapa. This district, the seat of the Brazilian Senate in the years that Rio was the country's capital, is the centre

The most famous Brazilian architect, Oscar Niemeyer is now in his 90s and still active.

of bohemian life in the city. Its *botequins*, cabarets, Carnival groups and samba schools not only give the area a cultural identity, but also make it a meeting place for a variety of the Carioca 'tribes'. There are the rich who enjoy good *rodas de samba*, young members of the middle class, poorer residents from nearby communities, and Cariocas from the suburbs. There is a mixture of conmen, prostitutes, transvestites, students, musicians, poets, pickpockets and all the other 'wildlife' of Rio by night. Numerous antique shops line Rua do Lavradio, many of which have recently been transformed into

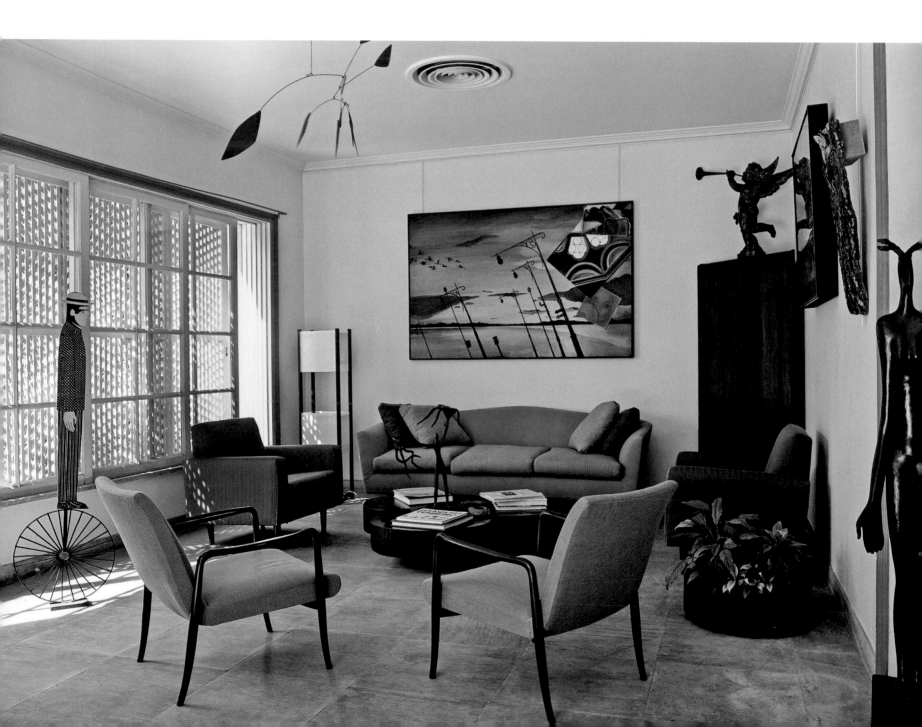

Art dealer and gallery owner Jean Boghici represents artists such as António Dias and Rubens Gerchman.

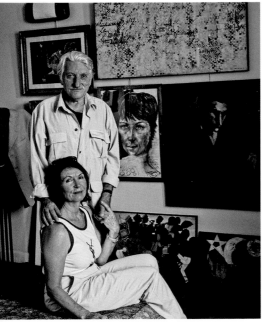

The decoration of Jean and Geneviève Bhogici's apartment in Copacabana is a model of balance. From the furniture by Joaquim Tenreiro to the sculptures, from the lamps and light fittings to the paintings, everything has a restrained harmony.

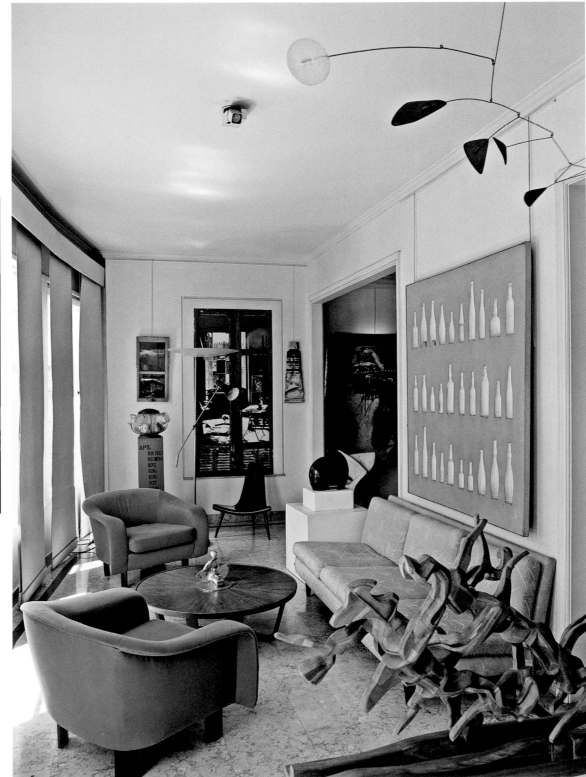

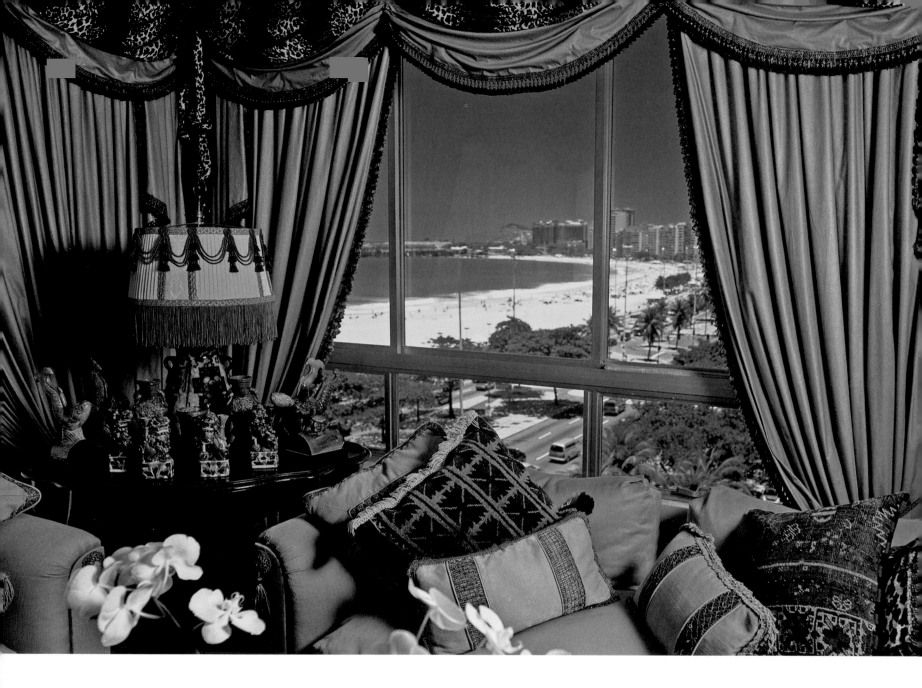

musical cafés, with samba, jazz and rock music. *Botequins*, both traditional and contemporary, line the sidewalks of Avenida Mem de Sá and attract a varied clientele every night.

Copacabana is totally different from Santa Teresa and Lapa. Together with Ipanema, the beach resort is the most famous area of Rio de Janeiro around the world. It also has a bohemian atmosphere and appeals to a wide range of social groups. The entertainment on offer here ranges from the so-called *inferninhos* (little hells) – nightclubs with prostitutes – to famous bars and restaurants that date back to the birth of the bossa nova. Copacabana, a favourite among

international visitors, has always had a cosmopolitan air, and is one of the few areas to boast bars and businesses that are open twenty-four hours a day.

The neighbourhood is also home to many elderly people who live alone in all kinds of residences. These range from sub-divided art deco mansions to ten-storey buildings with 30 tiny apartments per floor. Copacabana shares the coastline with Ipanema, and, further to the east, Leblon and Gávea: these four beach areas are home to the city's elite. They offer the most modern shops and services in Rio, as well as the most expensive real estate, especially when a property has a view of the beaches in the South zone.

The largest *favela* in the world, Rocinha, is set on a hillside in São Conrado, directly behind these luxurious neighbourhoods. The precarious community began to cover the slopes of the Morro Dois Irmãos in the early 20th century and has now spread over the entire area. On the Gávea side, the Vidigal *favela* is now almost connected to Rocinha, forming an urban complex that is larger than many of the city districts. No matter how much progress is made by the inhabitants of the *favelas*, however, the stigma attached to living in a marginal community still greatly affects their population.

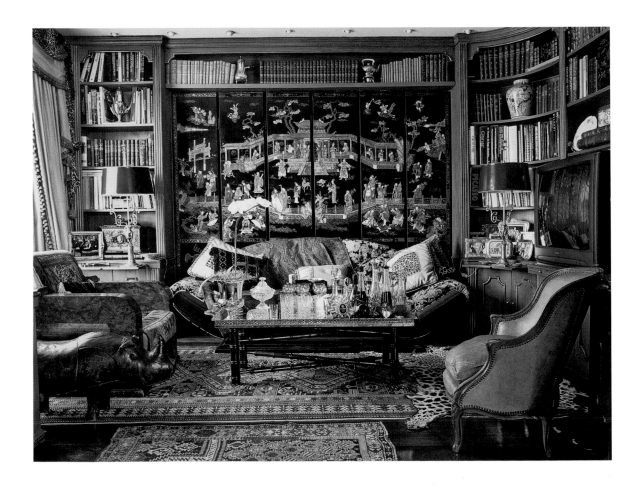

Left and opposite: The apartment of Paulino and Fernanda Basto on Avenida Atlántica in Copacabana is another example of a specifically Carioca sense of interior design, in which many varied elements come together to form a coherent whole.

The zones of the North, Vila Isabel, Méier, Tijuca and Maracanã also form a major cultural corridor, with large events that are primarily based around the world of samba. Although these districts are less lauded in the media than their southerly neighbours, they, as well as other districts in the suburbs and the West zone, play a crucial part in determining the Carioca identity, to such an extent that many young people from wealthier neighbourhoods are starting to look to these areas to find the true spirit of Rio.

The city's urban development, especially over the last four decades, has followed changes in the country's political, social and economic circumstances. During this period, Brazil saw a rise in economic growth – the military regime's so-called Economic Miracle – which was then followed by

Opposite and above: Paulo Herkenhoff, seen in the library of his apartment in Copacabana, is director of several art institutions, including the Museum of Fine Arts in Rio de Janeiro. In his home, he has assembled a small collection of work by Brazilian artists from different generations.

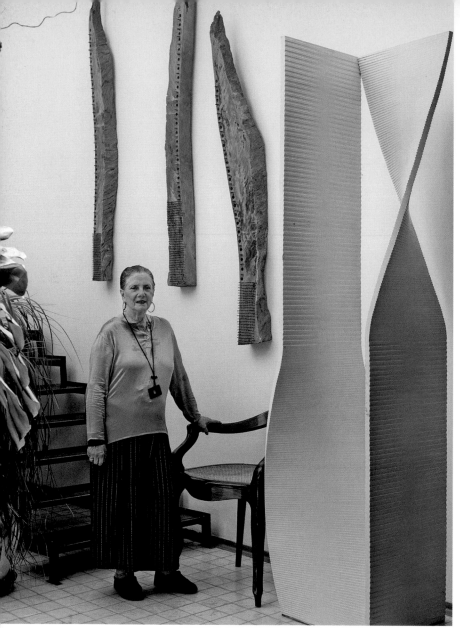

The home of interior designer
and architect Janete Costa,
on Avenida Niemeyer, is a
showcase of good taste,
mixing sculpture, paintings
and plants within an unusual
architectural design. Among
the outstanding works in her
personal collection are the
series of sculptures of heads
and masks (opposite above).

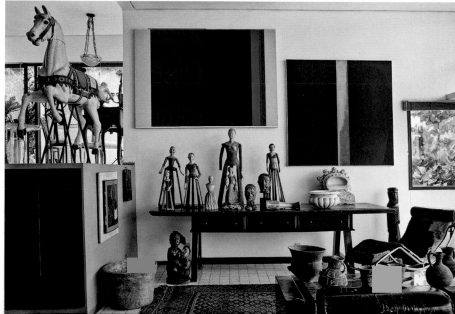

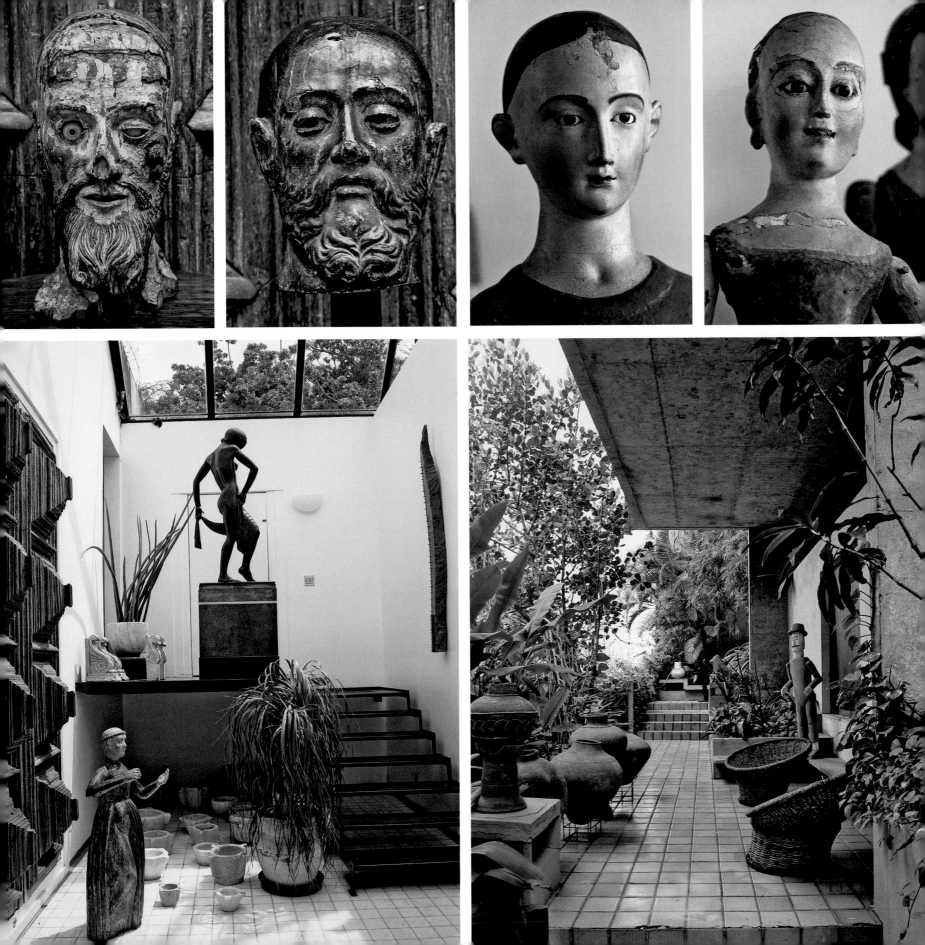

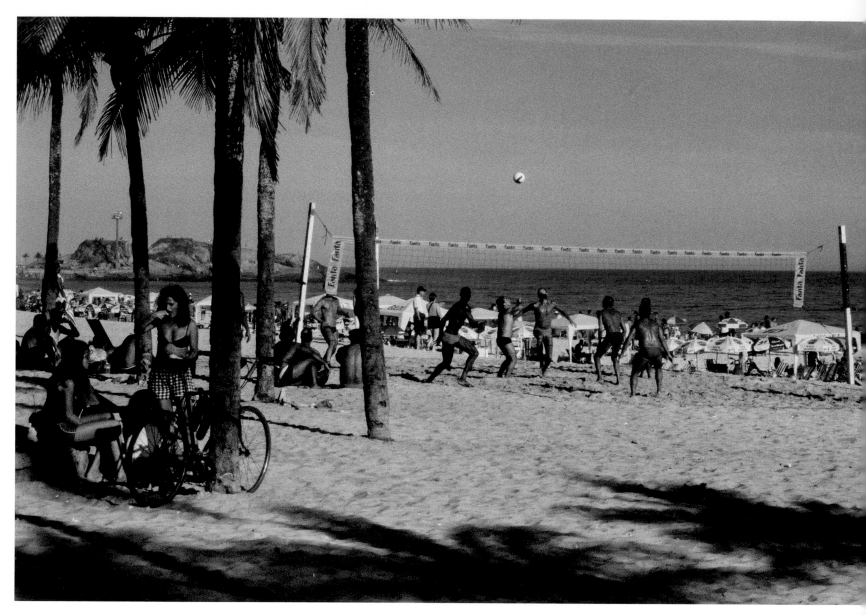

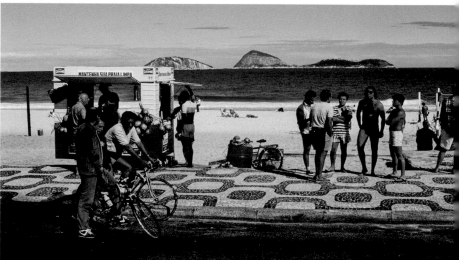

Perfect for a variety of sports, Ipanema Beach offers a healthy lifestyle. Volleyball, surfing, soccer, racquetball, or just walking on the calçadão, *enjoying the beautiful panorama of people and nature, watched over by Morro Dois Irmãos, are activities that help to keep the body in shape and reduce stress.*

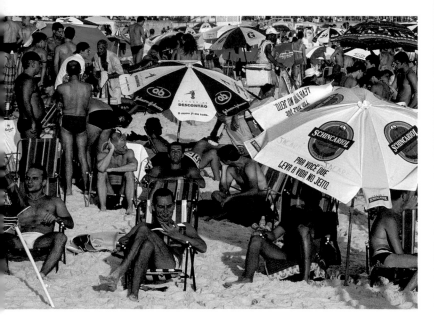

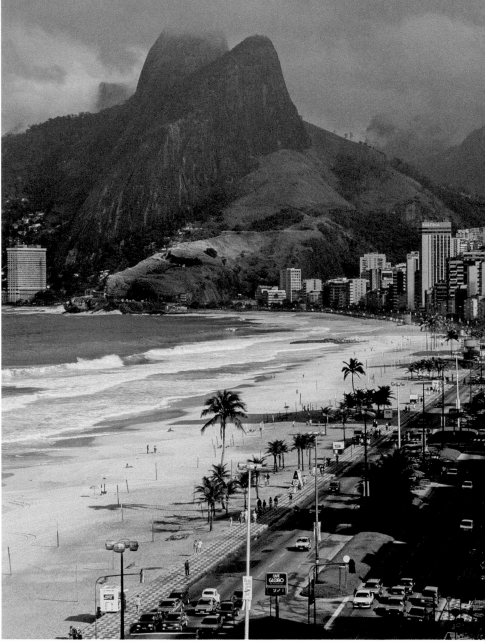

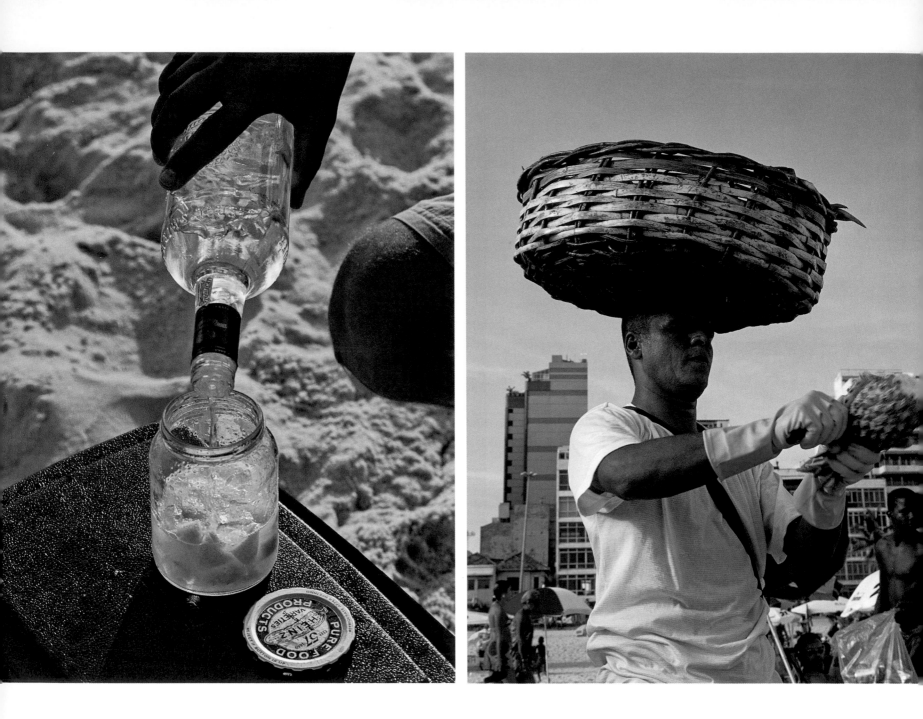

*Visitors can find almost anything
on the beach: fruit, snacks and
sandwiches, sun lotions or the
famous* caipirinha *cocktail.*

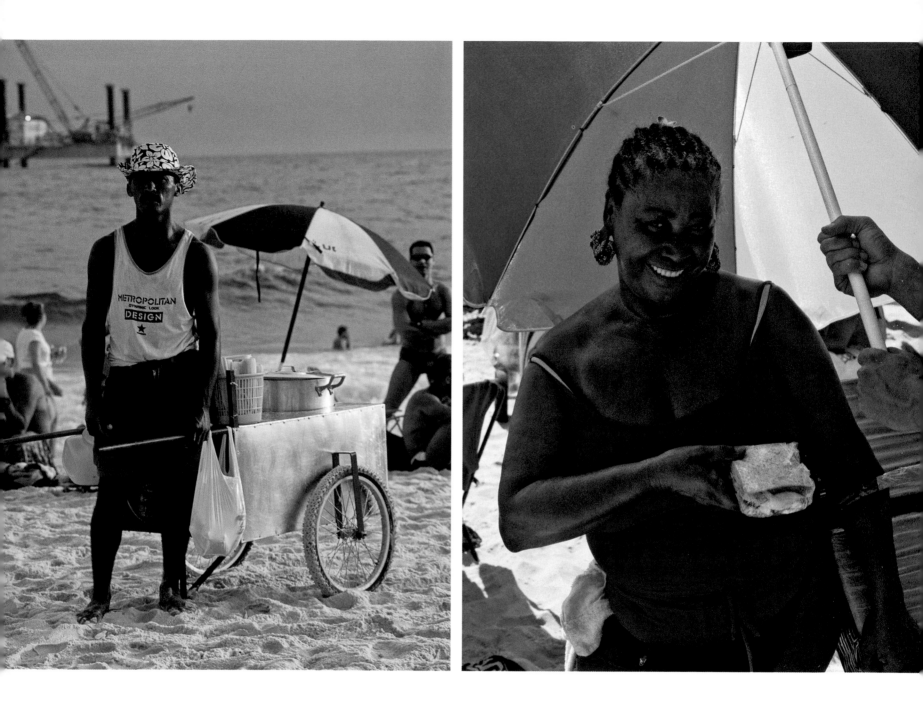

*The beach also provides a livelihood
for a number of Cariocas, mostly
food and drink sellers who conduct
their business on the sand.*

143

Below and right:
Adriana Varejão is one of the
most important visual artists
of her generation. Her work
and the exhibitions she
prepares are renowned for
their organic intensity and
powerful sensuality.

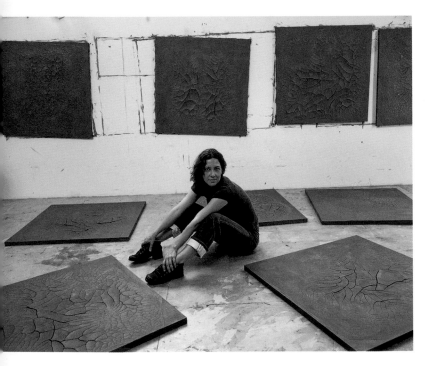

Opposite:
José Bechara is another artist *of Visual Arts at Parque Lage.*
from the Geração 80 *group* *His work is exhibited in major*
and a graduate of the School *galleries in Brazil and abroad.*

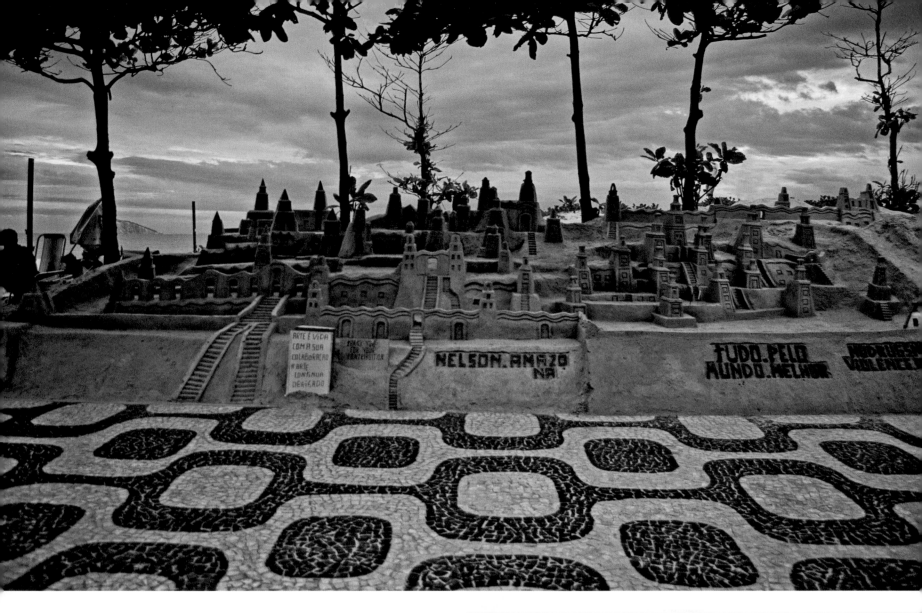

Unlike Ipanema, which receives visitors from all over the city, the beach at Leblon is primarily enjoyed by locals, giving it a quieter and friendlier atmosphere. There are still plenty of street vendors, nevertheless, including Bahian women who prepare their famous acarajé (fried bean patties).

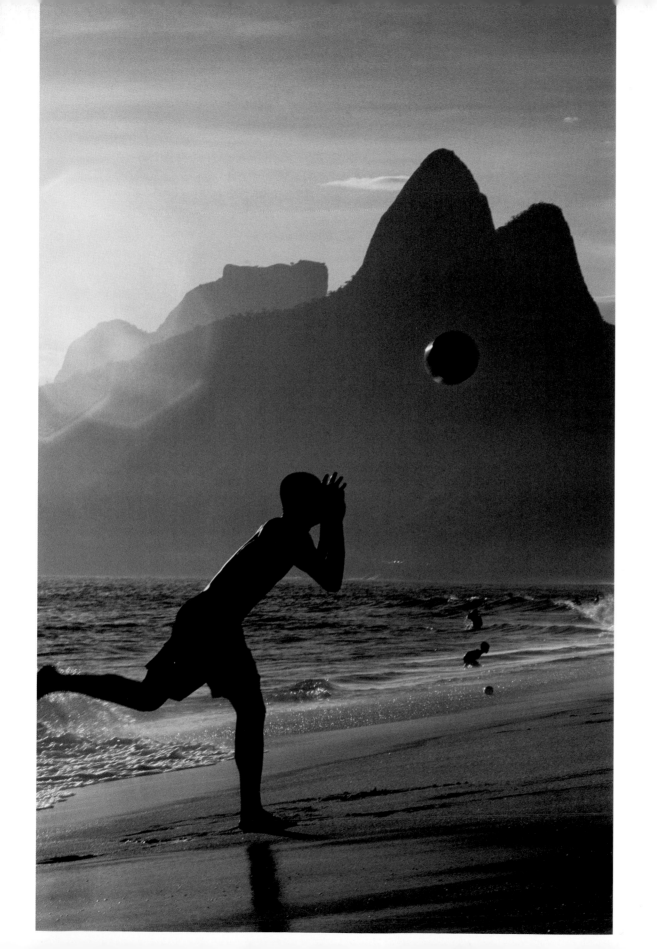

At first sight, it might look like an extention of Ipanema Beach, but Leblon Beach has its own identity. Less hectic than its more famous neighbour, this small stretch of sand – less than a mile long – runs from the Jardim de Alá canal to the base of Morro Dois Irmãos and is popular with bathers who prefer quiet surroundings.

147

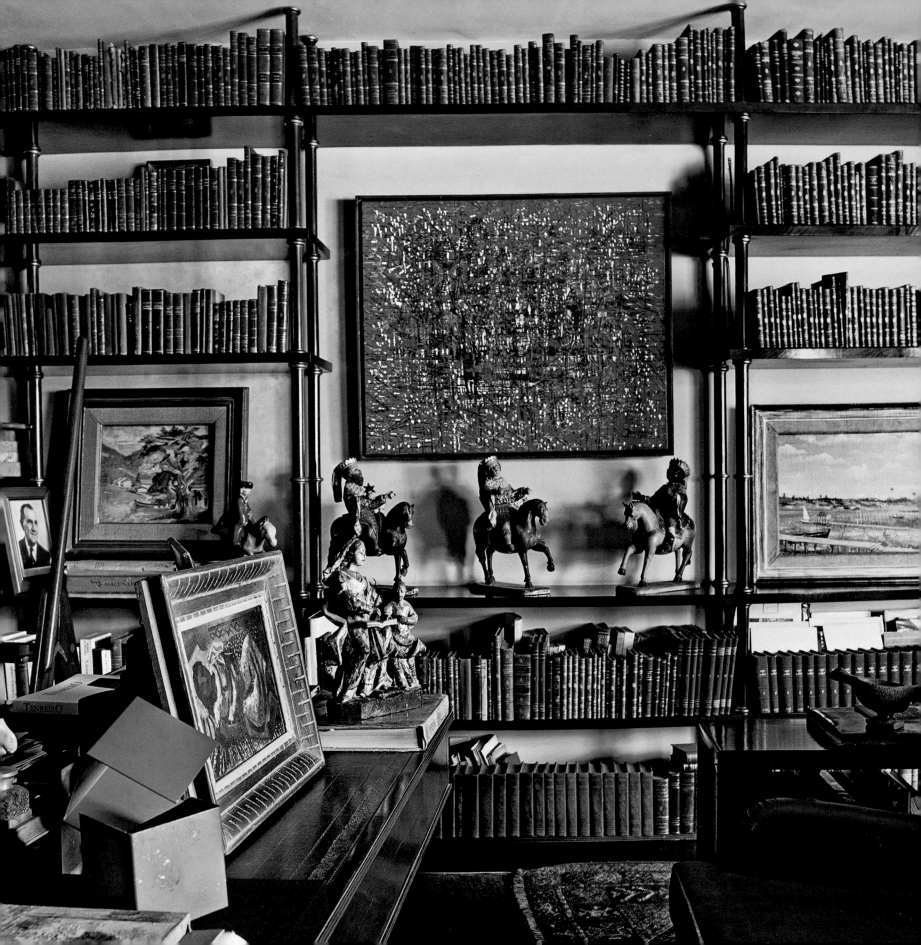

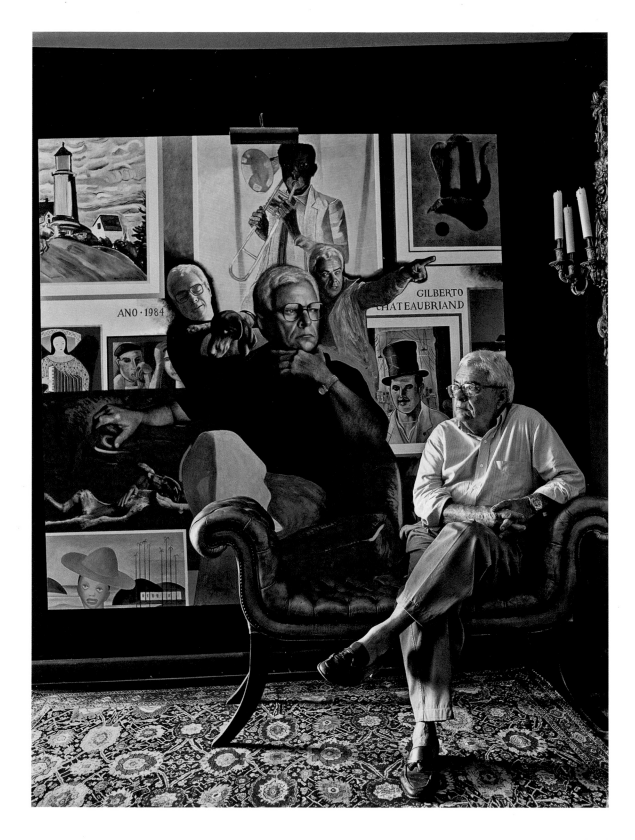

Gilberto Chateaubriand is perhaps the most famous art collector in Brazil. The size and scope of his collection is such that it has become a distinction for artists to have their work included in it. Since 1993, his collection has been on permanent loan to the Museum of Modern Art of Rio de Janeiro.

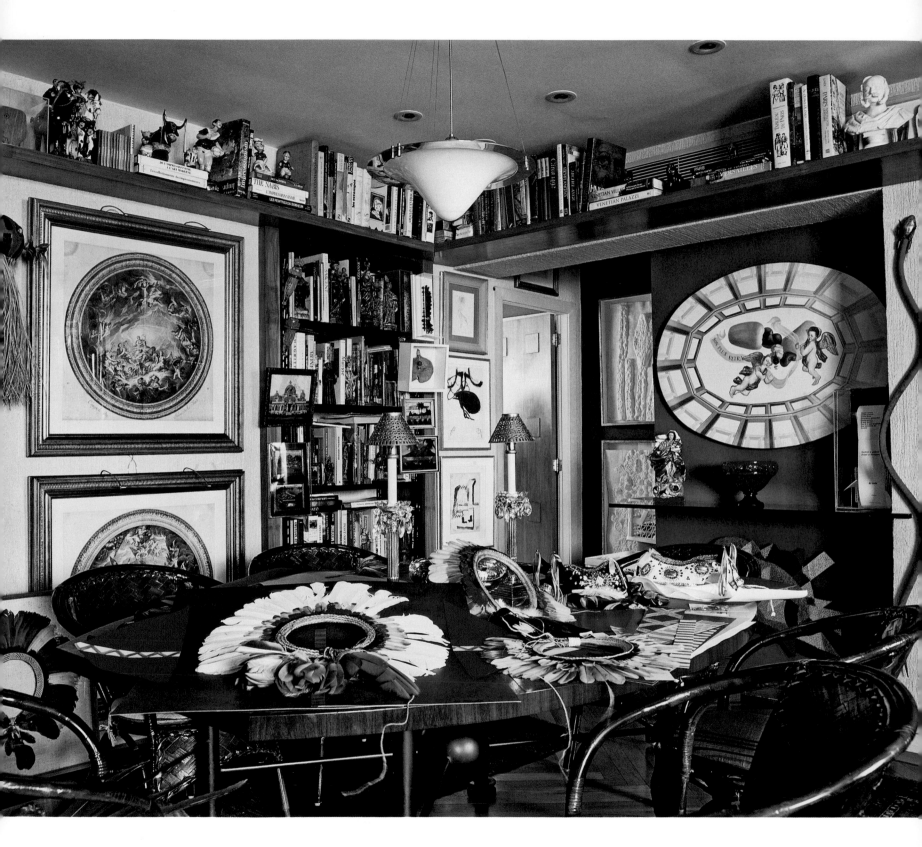

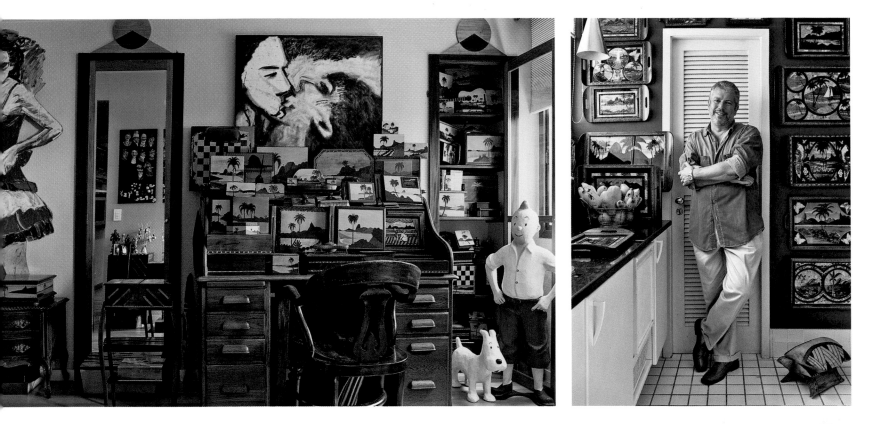

a series of crises that raised the level of poverty in the city and destroyed businesses and jobs, as well as the hopes of the younger generations.

Rio de Janeiro, in spite of its splendour, has not been immune to this reality. The self-esteem of the Cariocas suffered a serious blow when the nation's capital was moved to Brasilia and many industries and their employees resettled in São Paulo. In recent years, nevertheless, the inhabitants of Rio have learned to value their sense of belonging, and this spirit has sparked a renaissance of the city as the country's cultural capital and a dynamic, financial and commercial centre.

The old values of the city, such as friendliness and hospitality, which were extolled for centuries, are now being reinterpreted and relearned by the new generations. In spite of tough times, the difficulties of day-to-day living and the fear of urban violence, it is possible to see that the Cariocas are once again proud of belonging to Rio. It is a subtle, even inexplicable, cultural phenomenon, but perfectly understandable to anyone who lives in the *Cidade Maravilhosa*, the 'marvellous city' lauded in Rio's official anthem.

Architect and interior designer Chicô Gouveia is a well-known face in the city. Recognized as daring and creative, he was one of the first to revitalize the city's botequins, *while conserving their essential atmosphere.*

151

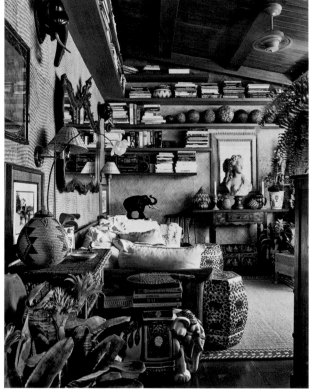

Fashion designer Carlos Ferreira, pictured in his apartment in Ipanema, has worked with Oscar de la Renta in New York.

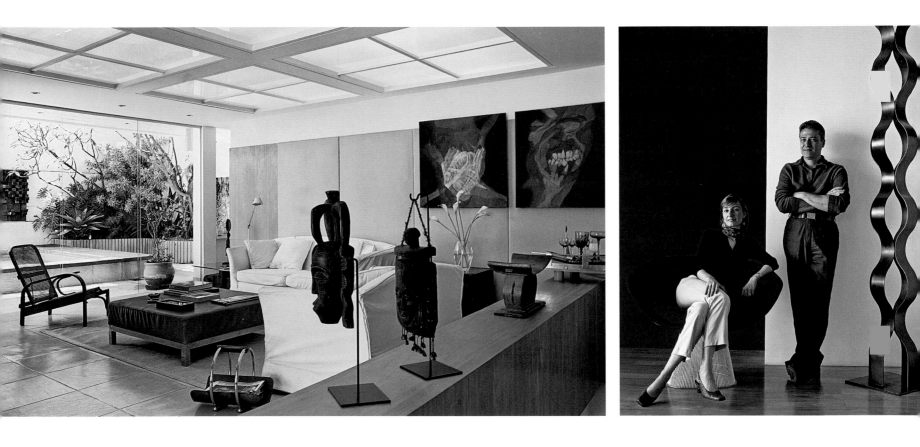

Architects Patricia and Luis
Marinho in their apartment
in Leblon.

153

Art dealer Alfonso Costa has found his own way of storing his books (opposite). His wife, the artist Valeria Costa makes paper sculptures. The collection of dancers (below) confirms the Cariocas' love of art nouveau.

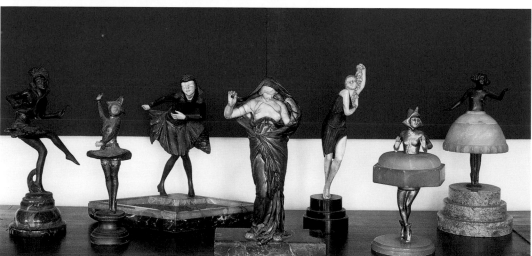

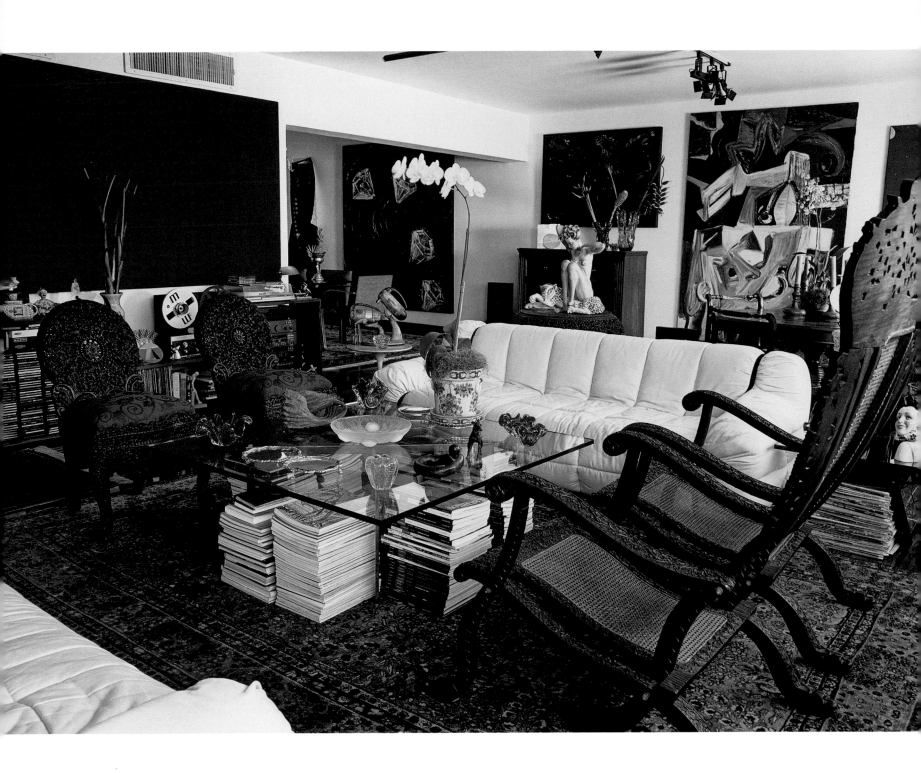

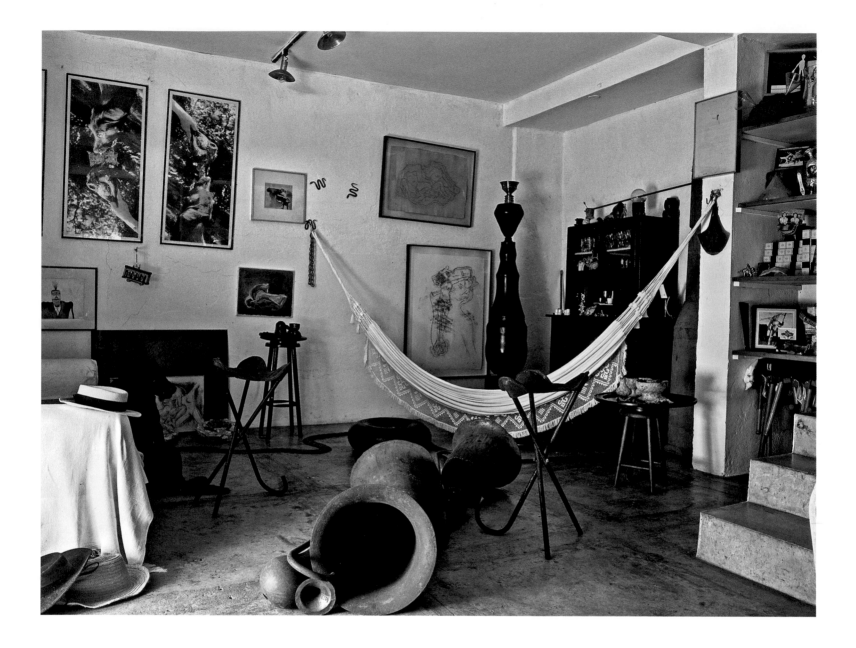

Above:
One of the most audacious
visual artists of his generation,
Tunga is recognized for the
original and powerful body
of work he has produced.
His art is known worldwide.

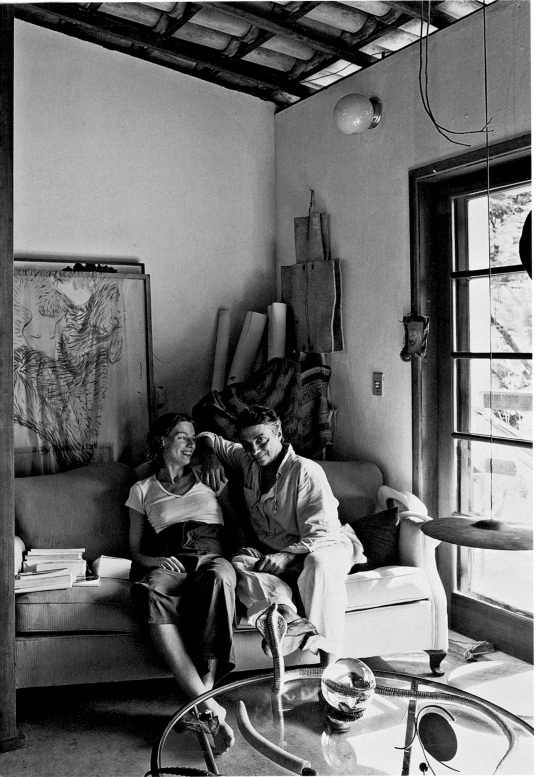

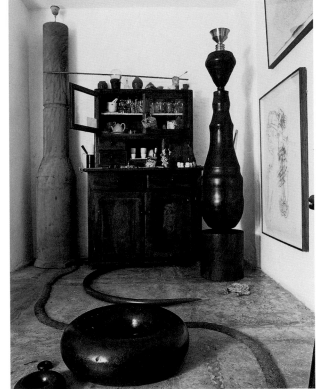

Left and above:
Tunga and Cordelia and
several of the artist's pieces
in the house in Joatinga
where he works.

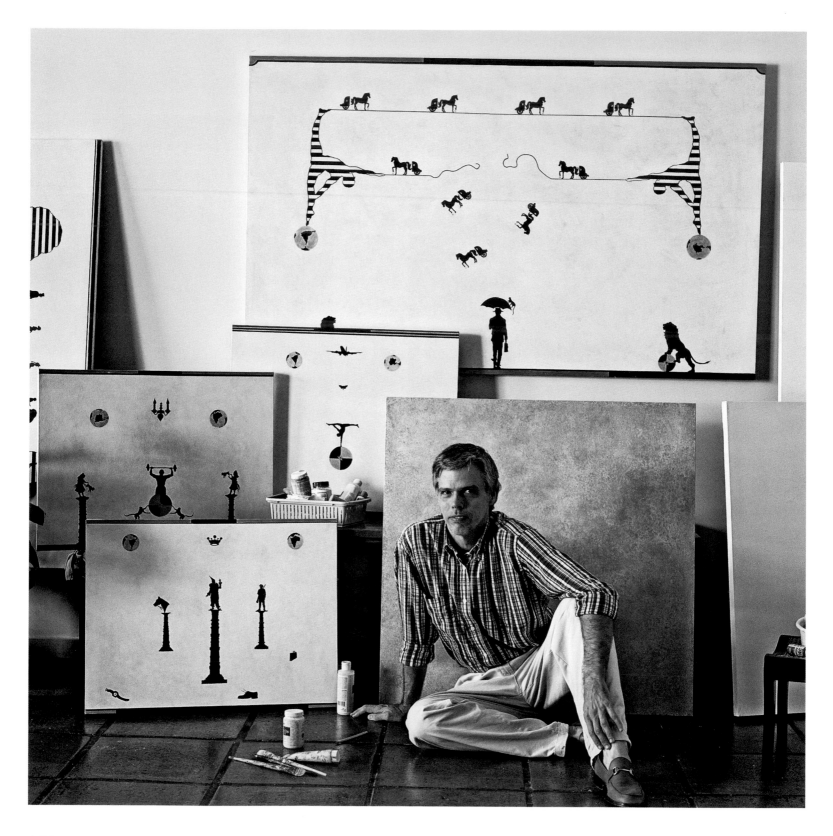

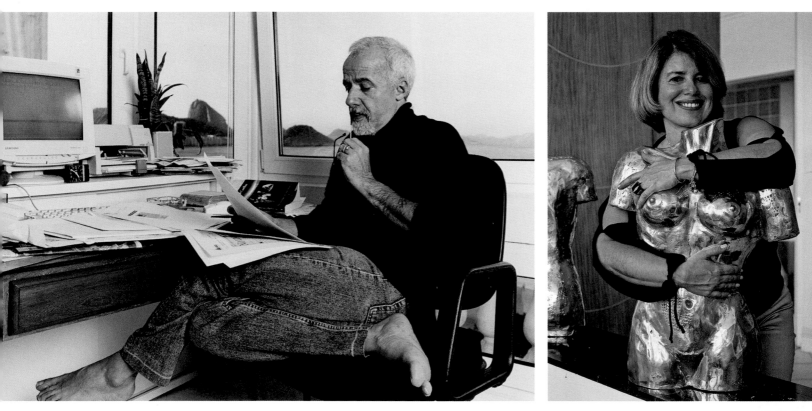

Above and below right:
Author Paulo Coelho works at
home. From his studio there is
a view of Copacabana Beach
and the Pão de Açúcar.

Opposite:
Walter Hoffman in his studio
in Leblon.

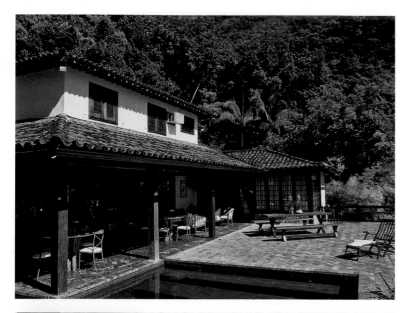

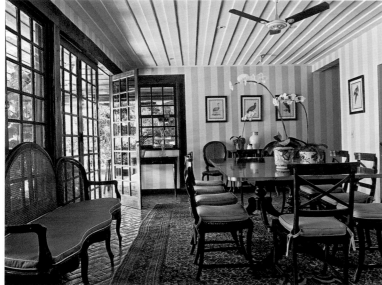

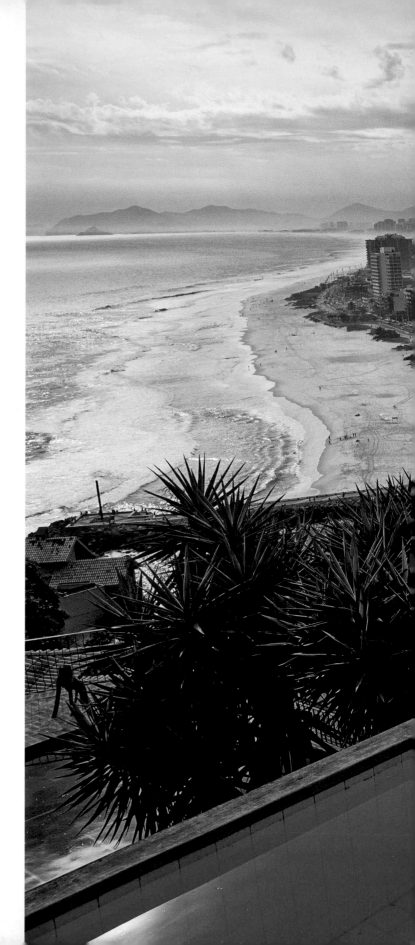

Above:
The home of Luiz Fernando Mendes de Almeida, one of the deans at the Facultad Candido Mendes in São Conrado: a model of simple elegance and comfort.

Opposite:
A swimming pool designed by Zanini for a house in Joatinga, overlooking the natural beauty of Barra da Tijuca.

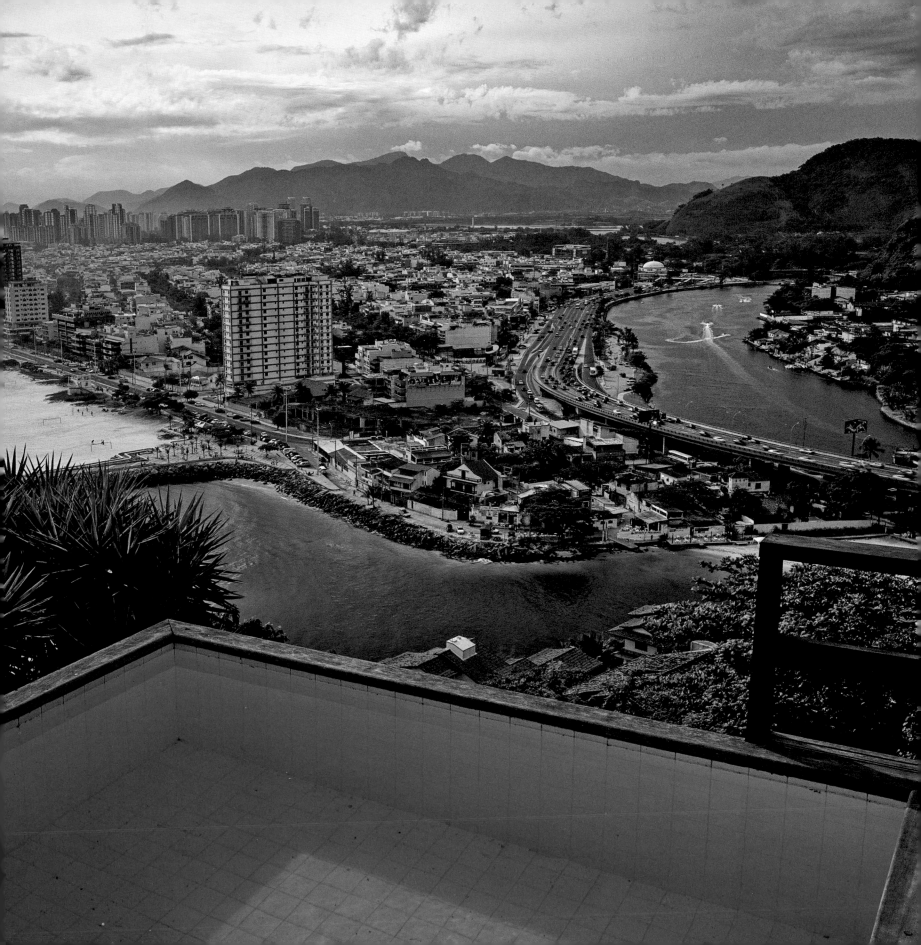

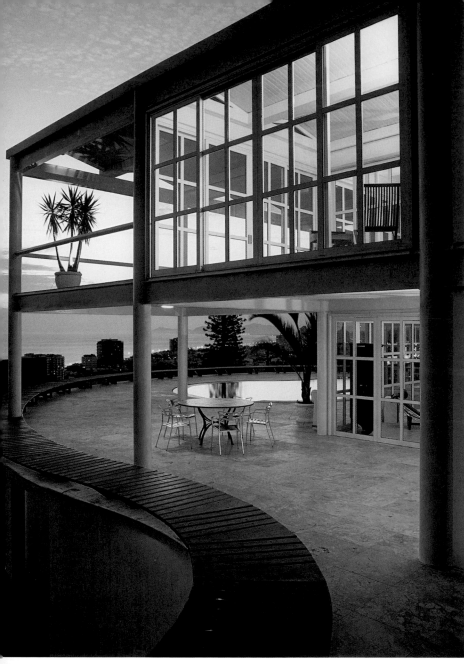

German investment advisor
Heiner Pflug saw the home of
his dreams become reality
through the work of architects
Cláudio Bernardes and Paolo
Jacobsen. A loft-style design,
the structure is made of metal
and glass, which provides
extraordinary transparency
and allows the landscape of
Joatinga to be integrated
into the building.

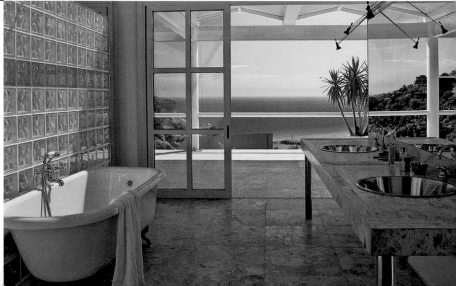

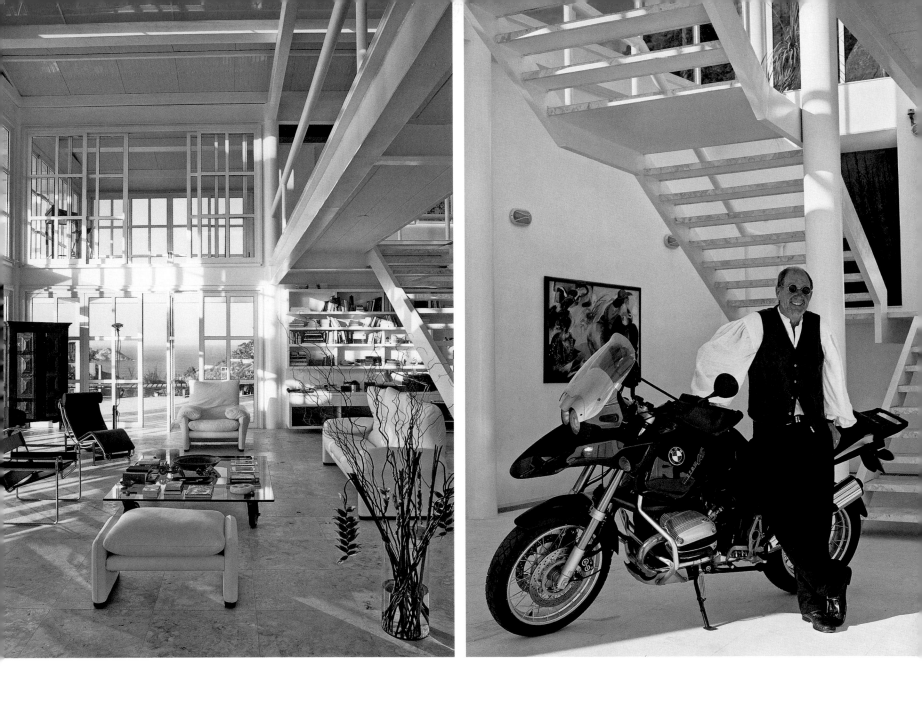

A resident of Rio since 1982,
Heiner Pflug considers himself
to be a true Carioca, totally
adapted to the culture and
lifestyle of the city. Now over
60, he still rides a motorcycle.

Above and opposite:
A descendant of Dom Pedro II,
Dom João de Orléans y Bragança
and his wife Stella live in
Itanhangá. Their home is filled
with memorabilia of the royal
family. Dom João is a
photographer and owns a hotel.

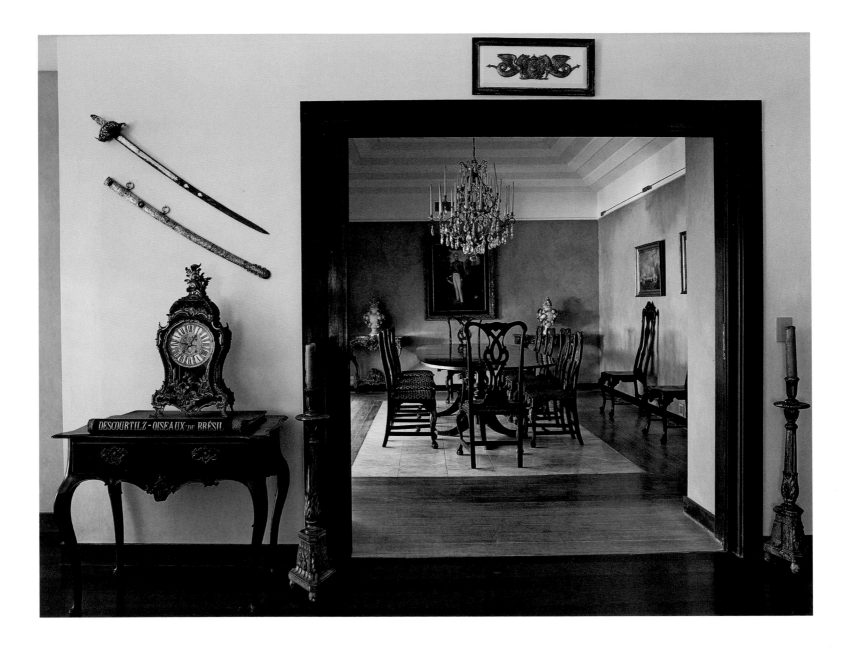

Overleaf:
The country houses of
Roberto Burle Marx are one
of the attractions in the West
zone of Rio: in Barra de
Guaratiba and in the Serrana
region of Teresópolis. In both,

Burle Marx created botanical
gardens with native Brazilian
flora. These are now the
legacy of this landscape artist
who was preoccupied with
the conservation of nature.

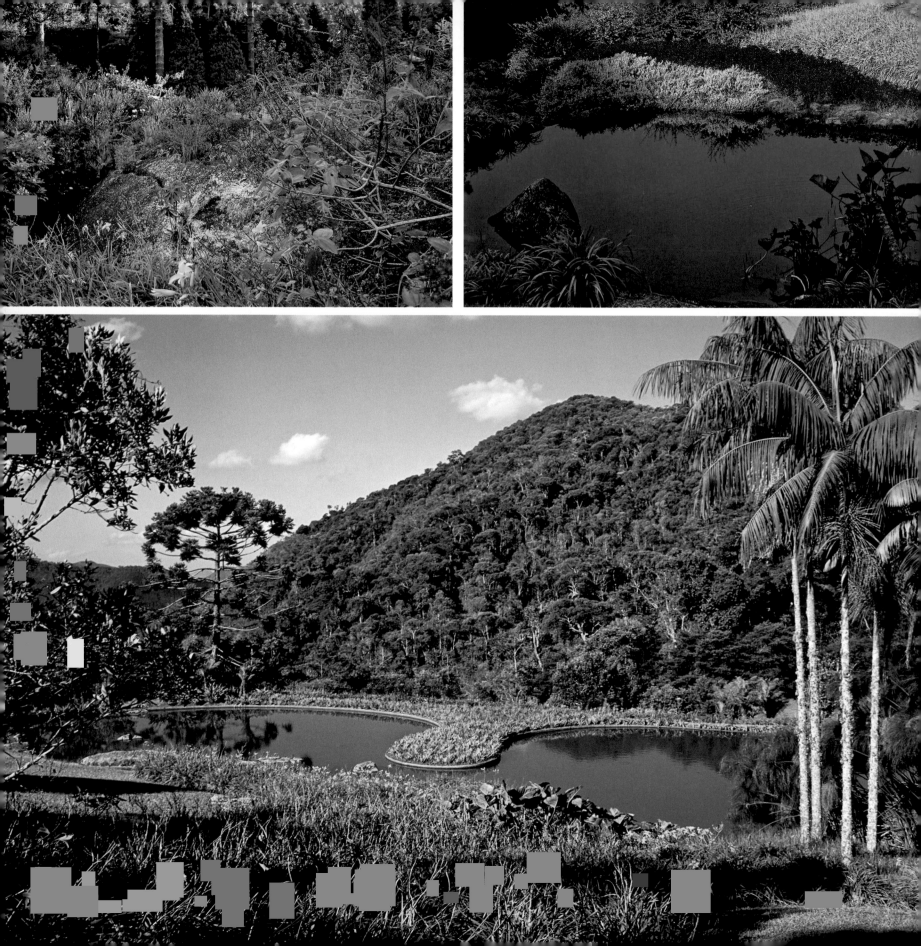

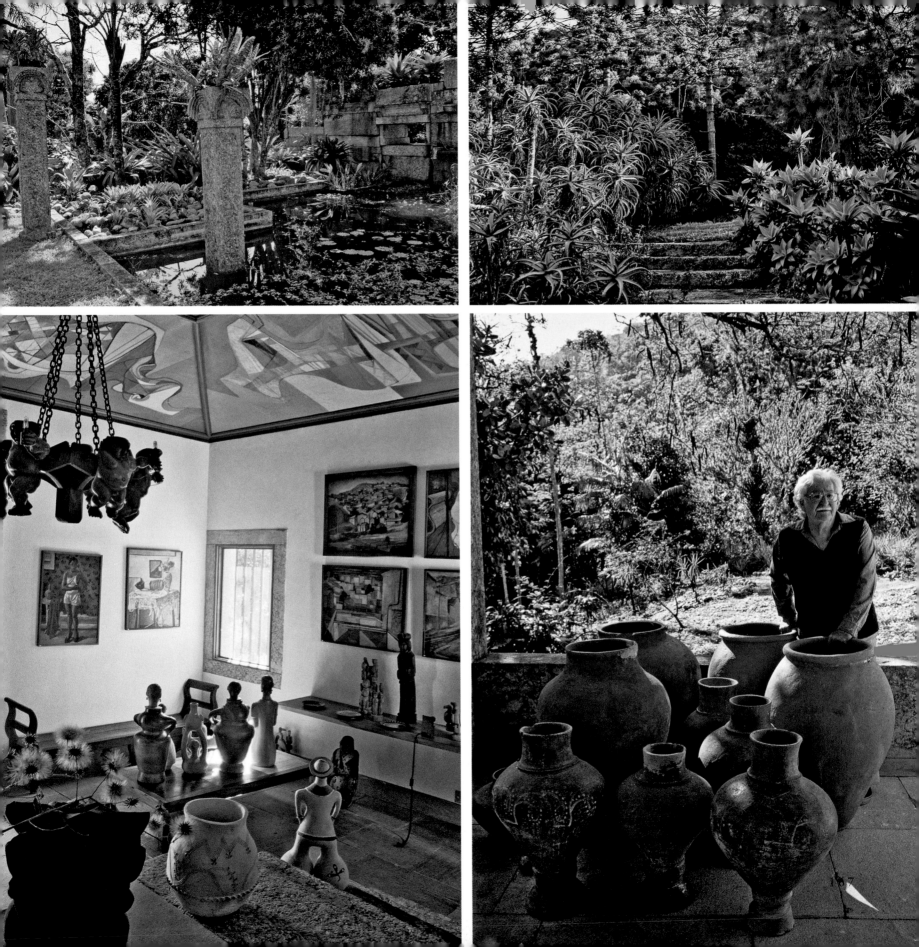

Around the Region

The natural characteristics which make Rio de Janeiro one of the most beautiful cities in the world can also be found in nearby towns in Rio de Janeiro State. Situated in the heart of the Mata Atlântica, the coastal rainforest that is one of the country's most richest ecosystems, the Fluminense region (the name that refers the land around Rio de Janeiro) has mountains, rivers, valleys, beaches, lakes, lagoons, and an innate appeal for tourists.

The metropolitan area of the State is made up of the principal Fluminense towns, which are now increasingly connected to Rio de Janeiro. The network of cities, in fact, extends all the way to neighbouring São Paulo, forming Brazil's major urban belt. The cities of Duque de Caxias and Nova Iguaçu, an important industrial and commercial centre with large petrochemical plants, are located in the Baixada Fluminense district, in the inland part of the State. In Greater Niterói, besides the city of Niterói itself, famous for its excellent quality of life, there are the cities of São Gonçalo, Magé and Maricá. This area is also known for its industrial and service industries, in addition to being one of the main fishing centres in the region.

The State's coastline goes from Lagos in the north to the Costa Verde in the south. Towns in the north of the region include Saquarema, Cabo Frio, Arraial do Cabo and Armaçao dos Buzios, all known for tourism, fishing and salt production. To the south are Mangaratiba, Angra dos Reis and Paraty, considered to be the State's principal tourist attractions, with their beautiful beaches and islands, especially Ilha Grande, one of the ecological paradises of Rio de Janeiro. Brazil's controversial nuclear power stations, built under the military regime, are located in Angra dos Reis.

The house of architect Cláudio Bernardes in Angra dos Reis is a tribute to the rustic style.

The Serrana region, a centre for textile and furniture manufacturing, is also an active tourist destination. Other well-known cities are: Petrópolis, where Emperor Dom Pedro II lived and is buried; Nova Friburgo, with its population of German and Swiss origin; and Teresópolis, with its beautiful parks. This area is still well conserved, with low levels of pollution, and this has made it popular with people seeking a healthier and more peaceful lifestyle. A more moderate range of temperatures makes it cooler in summer, when the torrid heat hits the towns on the coast.

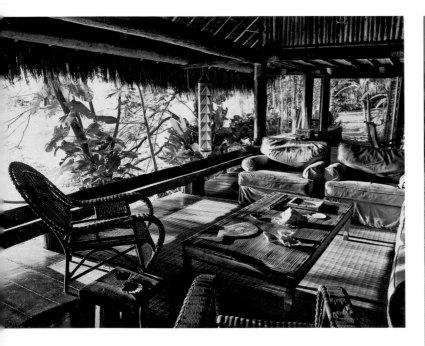

Built with natural elements, particularly wood and straw, Cláudio Bernardes's house proves that it is possible to combine comfort and simplicity in a country home. Among the noteworthy details is an outstanding wooden totem (right).

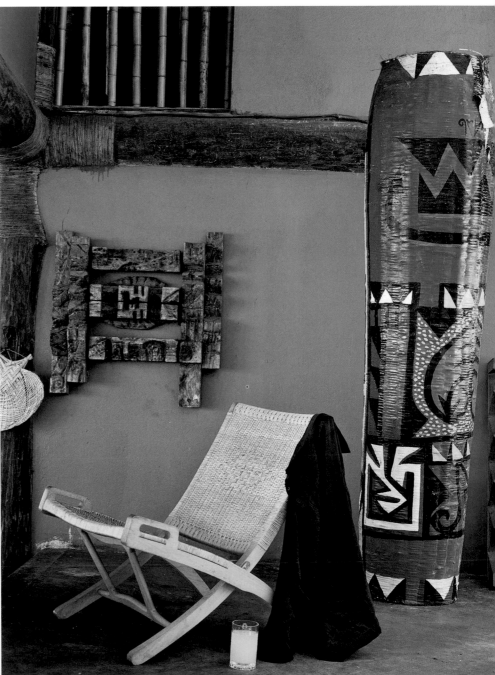

In the bedroom, the mosquito net guarantees a peaceful night's sleep. The artworks combine with the rustic style of the house, as seen in the wooden staircases. The beams joined by rope are based on indigenous building techniques used in the Brazilian Amazon region, which inspired the architect to adapt the idea for his home.

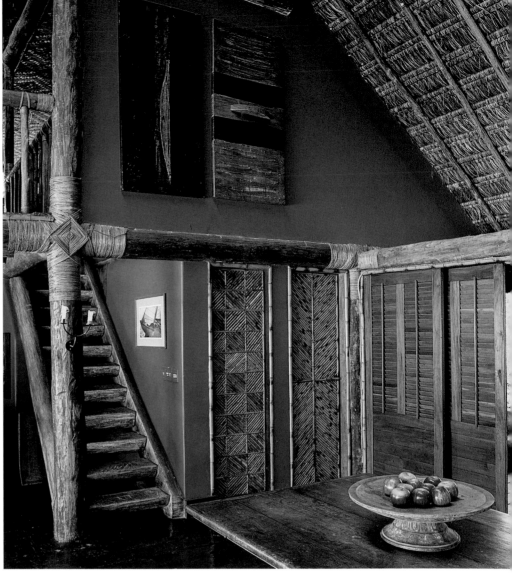

The north and northeast regions are vital to the State's economy. The north is concentrated around oil refining and fishing, industries which do not always coexist harmoniously. The northeast is a farming and cattle-raising area, with Campos dos Goitacazes, Macaé and Rio das Ostras as its largest towns.

The region south of Rio houses the area's iron and steel industries, particularly in Volta Redonda and Barra Manza. The automotive industry is based in Resende. The towns in the mountains of this region are also major centres for tourism because of the wild beauty of the surroundings, especially in the area around Visconde de Mauá, Penedo and the Pico das Agulhas Negras. These mountain peaks are the tallest in the State, making them an ideal spot for climbing, ecotourism and adventure sports.

171

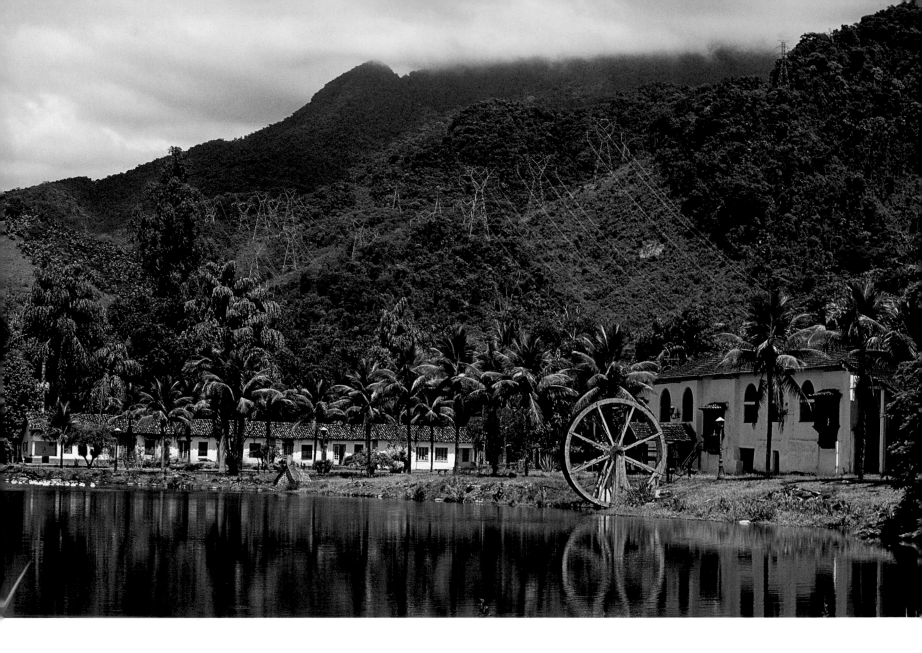

The Costa Verde is one of the most beautiful stretches of the Rio coastline. Located in the southern part of the state, this region boasts several cities that are important centres for regional tourism, such as Angra dos Reis and Paraty.

Paraty

Paraty, in the south of the State and located midway between the state capitals of Rio de Janeiro and São Paulo, is a living example of a colonial city, thanks to the careful preservation of its historical centre. The old *sobrados*, houses of two or more floors from the 17th and 18th centuries, and the cobbled streets built by slaves are relics of colonial times. In those days Paraty was occupied by the Portuguese, in alliance with the local Guarani population, the earliest inhabitants of the region. The region, known for its beaches and the hundreds of bays that permit relatively safe navigation, is where

the nomadic Guaranis once fished. These indigenous people were responsible for opening the paths and trails that permitted access between the coast and the interior across the imposing Serra do Mar, a vertical obstacle that confined the Portuguese to the coast. Their trails, back in the 16th century, connected the São Paulo plateau with Paraty, where travellers would then continue on to Rio by boat. The town became a strategic centre, both as a trading port for merchandise and slaves, and as the gateway to the southern part of the country.

With the division of Brazil into areas called *capitanias*, the region south of Rio de Janeiro became the Capitania de São Vicente, which included Angra dos Reis, the largest town, and Paraty. Finally, in 1667, after a popular uprising demanding the independence of Angra dos Reis, a new township was created, called the Vila de Nossa Senhora dos Remedios de Paraty. Gold and precious gems were discovered in Minas Gerais in the 17th century, and the former Guarani trails became trade routes for the mineral wealth shipped to the coast by the *bandeirantes* and other explorers of the age. Paraty was now integrated into the Gold Route, which produced a revolution in the town.

During the period of the gold boom, Paraty's population grew quickly. Merchants, shopkeepers, politicians, soldiers and adventurers of all sorts flocked to the town. The large movement of people to the regions where gold had been discovered caused supply problems and shortages of food and other goods. The tradesmen of Paraty, taking advantage of their port, began

Boat trips are among the activities that most pousadas *(traditional hotels) in the region offer their guests. These outings allow visitors to get to know these lovely islands and their beaches.*

to import and sell foodstuffs and other basic products to satisfy the growing demand in the gold-producing areas. The local economy, however, was based on sugar mills, refining the locally grown sugar cane. The town became famous for the quality of its *cachaça*, a spirit distilled from sugar cane, to such a degree that Paraty was synonymous with this drink.

With the arrival of the Portuguese royal family, at the beginning of the 19th century, the occupation of the region intensified, along with demand for its products. The gold rush had passed its peak and coffee plantations began to spring up in Minas Gerais and São Paulo. Paraty, nevertheless, still remained a busy seaport, attaining an even greater degree of economic expansion and prosperity.

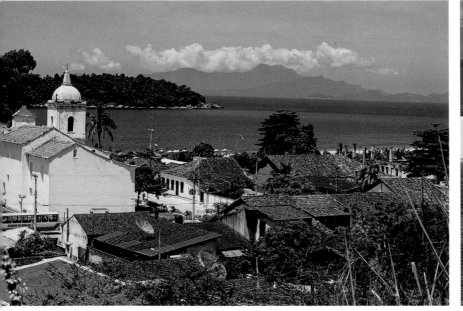

The Paraty region is characterized by colonial architecture that has been relatively well conserved over the years. Many of the local residents earn their livelihood from fishing.

By the second half of the 19th century, however, Paraty lost its significance as a port and a halfway point between Rio and São Paulo. The opening of a railway line across the Vale da Paraíba to connect the two largest cities in Brazil meant the end of Paraty's role in the expansion of the Brazilian economy. The city now entered into a period of economic decadence. The abolition of slavery in 1888 made matters worse; the sugar industry and the area's *fazendas*, or ranches, depended on slave labour for their existence.

Paraty, far from the railway system and later from the São Paulo–Rio highway, was forgotten. The town's population shrank, and life slipped into the rhythm of a community with no links to the nation's economic growth. While, on the one hand, this isolation brought financial disaster to the

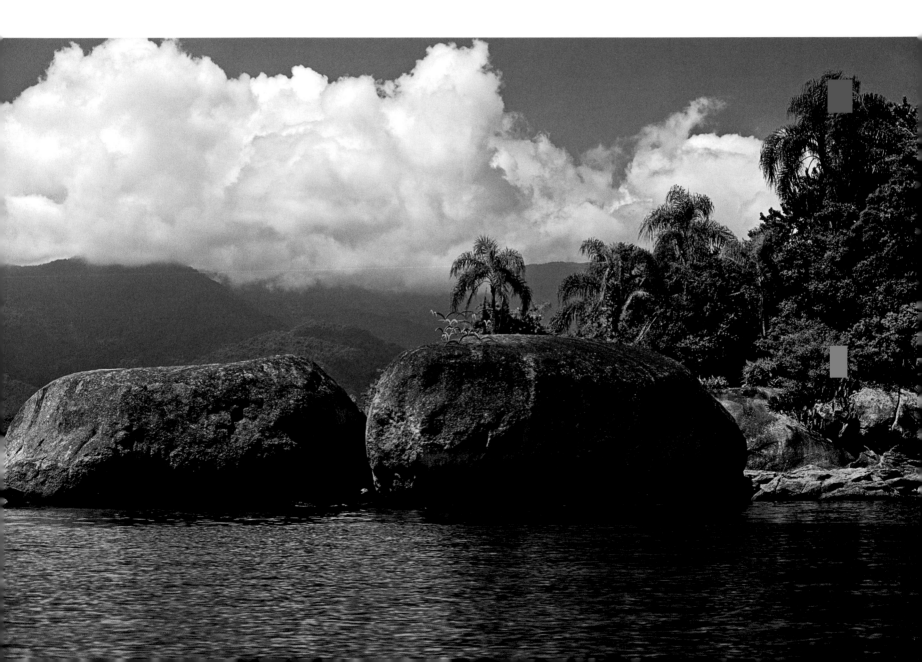

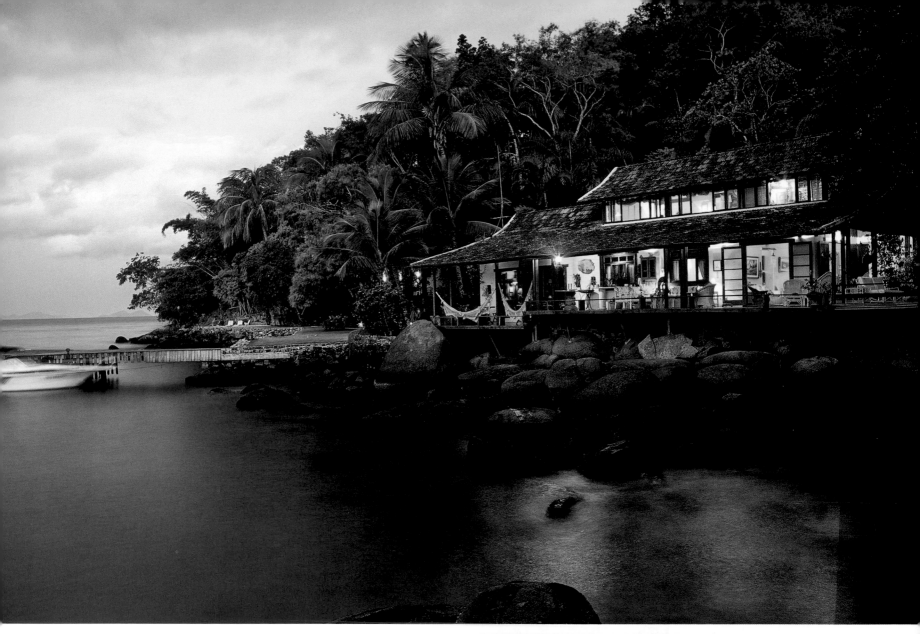

Above and right:
The true star of the Costa
Verde is Ilha Grande. It is a
small gem of a spot with a
unique atmosphere, whose
conservation is carefully
controlled by local authorities,
due to the large numbers of
holiday visitors.

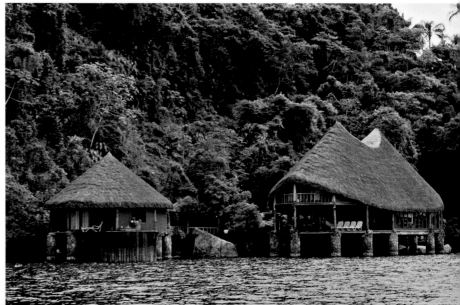

Below and right:
Entrepreneurs like Julinha
Serrado, owner of the Pousada
Sítio do Lobo, also promote
the careful use of tourism to
preserve the natural beauties
of Ilha Grande.

community, on the other, it preserved the city from the damaging effects of unbridled growth, protecting the social, ecological and historic environment of the town.

The clock seemed to have stopped in Paraty, and it was this twist of fate that preserved its most important attribute: its socio-historical identity. Much of this coastal region underwent a similar process, the natural environment being preserved for the benefit of future generations. These special qualities have given Paraty a different character today: it is now a centre for visitors interested in the natural and cultural attractions that the city offers. The beauty of the beaches, the islands and bays make Paraty and the surrounding areas a paradise.

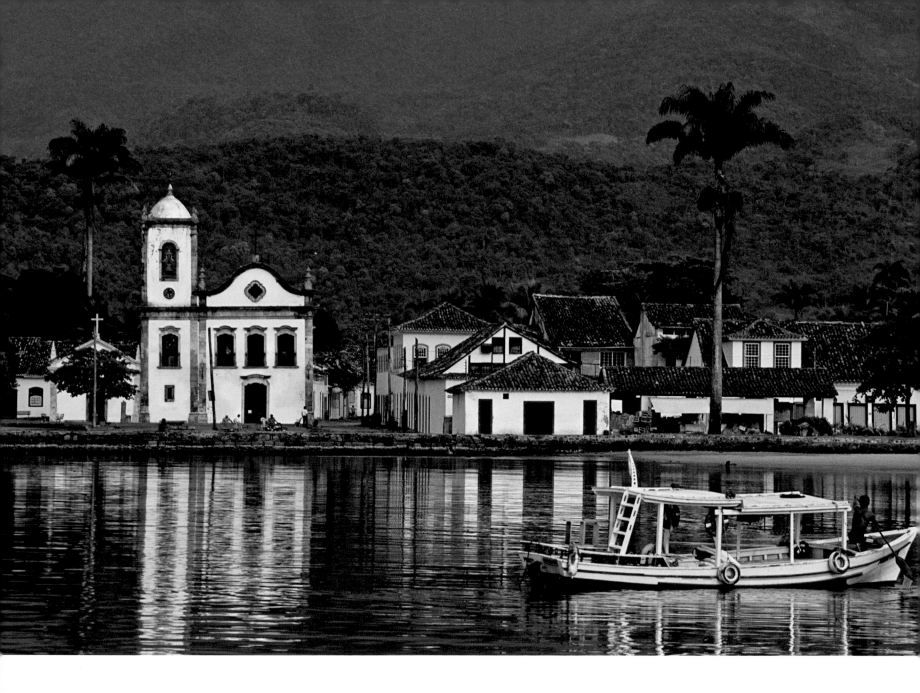

Paraty is like taking a trip into the
past. Its colonial houses and streets
paved with stone, built by slaves,
make it a piece of history. Nowadays,
however, the city is known for fine
food and cachaça, *the local spirit.*

Angra dos Reis

With more than three hundred islands and hundreds of beaches, Angra dos Reis is one of the principal sea resorts on the Rio coast. Angra is a small town set between the mountains and the Atlantic Ocean. It provides perfect facilities for all sorts of adventure sports, such as trekking, canoeing, diving, mountain climbing, sailing and jet ski. But, above all, it is an ideal place to get in contact with nature, making Angra dos Reis one of Brazil's major destinations for ecotourism.

The region was discovered on 6 January 1502 by Portuguese navigator Gonçalo Coelho, an officer in Pedro Álvarez Cabral's fleet. Discovered on Twelfth Night, the bay was baptized Angra dos Reis, 'Cove of the Kings'. The economic development of Angra was similar to that of neighbouring Paraty. The land around Angra's bay was also inhabited by the Guarani people, and the town's early residents raised cattle. Little has changed in Angra in the last two centuries.

Angra also enjoyed the fruits of the gold boom and was part of the Gold Route to and from Minas Gerais in the 18th century, which brought rapid economic growth to the region. After the gold boom, the business class in Angra turned to coffee exportation, while the local population produced sugar cane. Following another period of relative isolation, Angra, during the early years of the

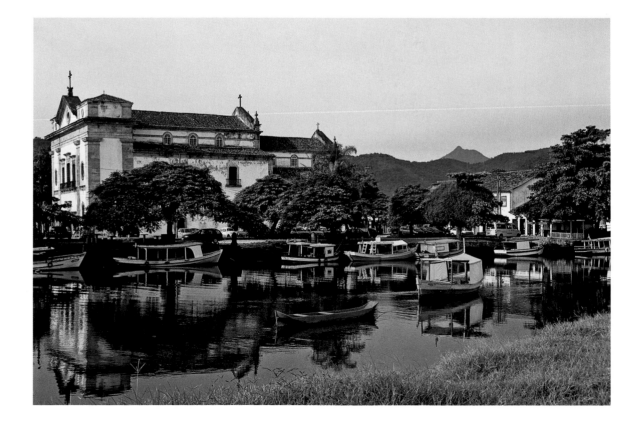

There are no beaches in Paraty itself, but the beaches of the sixty-five islands in the bay can be reached by wooden boats called saveiros.

Republic, became a banana producer, and thanks to a railway connection at the beginning of the 19th century, a new period of economic growth began. Cattle-raising once again thrived, as did the mining of iron ore for the national steel mill, Companhía Siderúrgica Nacional, located in Volta Redonda.

Starting in the 1950s, Angra became one of the State's largest shipbuilding centres. The construction of nuclear power plants during the military regime provoked controversy, especially by ecological groups. The city found itself divided between its diverse industrial interests and its natural

Details of the windows and lace curtains of Paraty. The city is an active centre for the production of handicrafts, one of its principal tourist attractions.

appeal to tourists. Even today, these ambiguities are present in the city, and are the source of constant conflict. The attitude of the environmentalists is understandable, considering the risks of contamination by industrial waste. On the other hand, the need for jobs and economic stability are recognized by a local population aware of the importance of sustainable growth.

The tourism industry in the region has in recent years become more professional and more efficient. Operators are conscious of the need to preserve the local ecosystem, and ecological

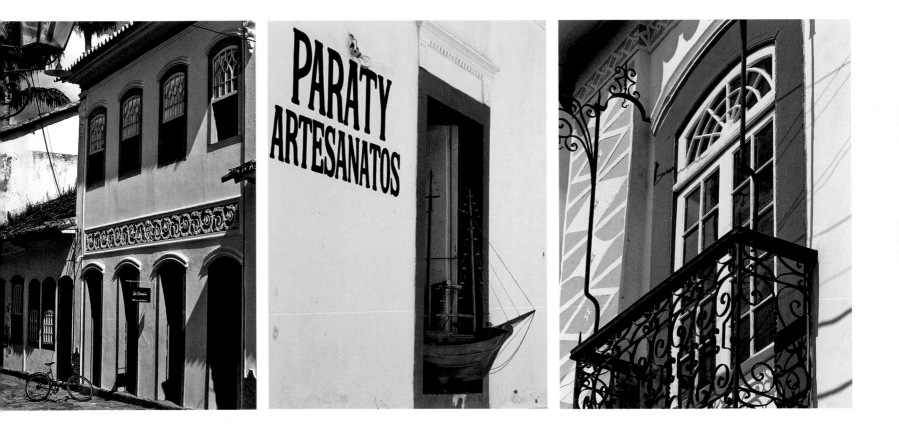

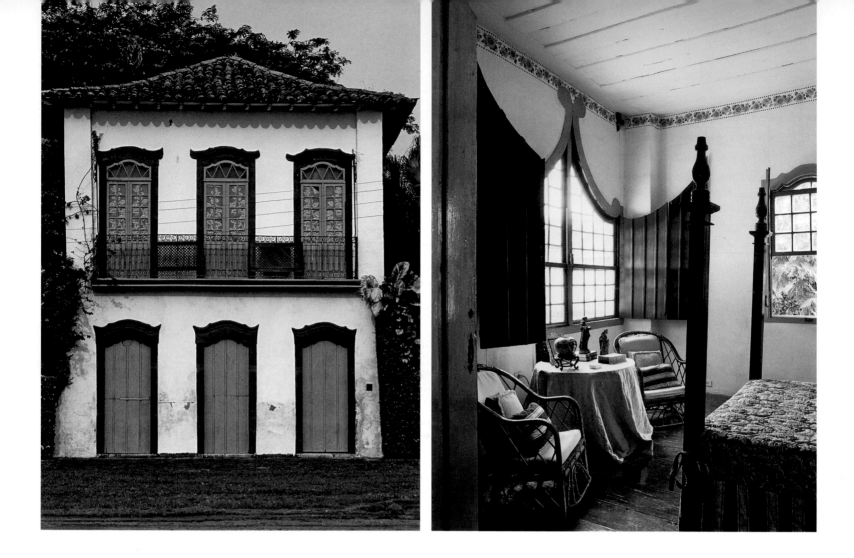

Above left:
The house in Paraty where
Dom João and Dona Teresa
de Orléans y Bragança live.

Above right:
His son Dom João with his
wife Stella transformed an
old house in Paraty into the
Pousada do Príncipe.

campaigning has forced the principal industries in the area to adopt anti-pollution measures, which has resulted in an improvement in the treatment of chemical wastes, as well as support for environmental protection and reforestation programmes.

The principal attraction of Angra is its islands: Ilha Grande, in particular, is one of the most important ecological paradises in Brazil. With strict zoning codes and an intense campaign to promote awareness of ecological issues, Ilha Grande has been maintained virtually intact, in spite of a recent growth in population. Ilha Grande was formerly the home of the Colônia Penal Cândido Mendes, a jail where both common criminals and political prisoners were interned during the dictatorship of Getúlio Vargas and the military regime. The prison was closed in 1992, and today all that remains are its ruins, silent testimony to the tragic presence of so many prisoners on the island.

Another point of interest is the Pico do Papagayo, the island's second tallest mountain peak (990 metres or about 3,000 feet). Its name means 'Parrot Peak' because of its shape when seen from

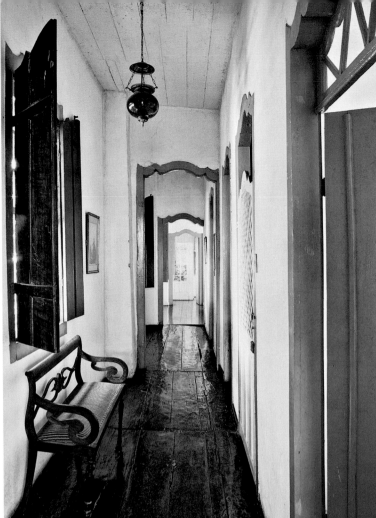

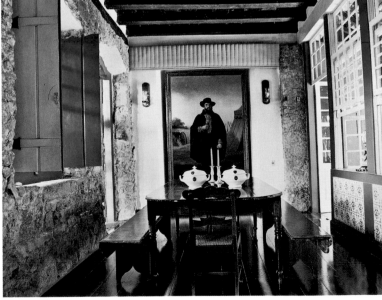

Like the other pousadas in Paraty, the Pousada do Príncipe makes the most of its colonial heritage to create an appealing atmosphere.

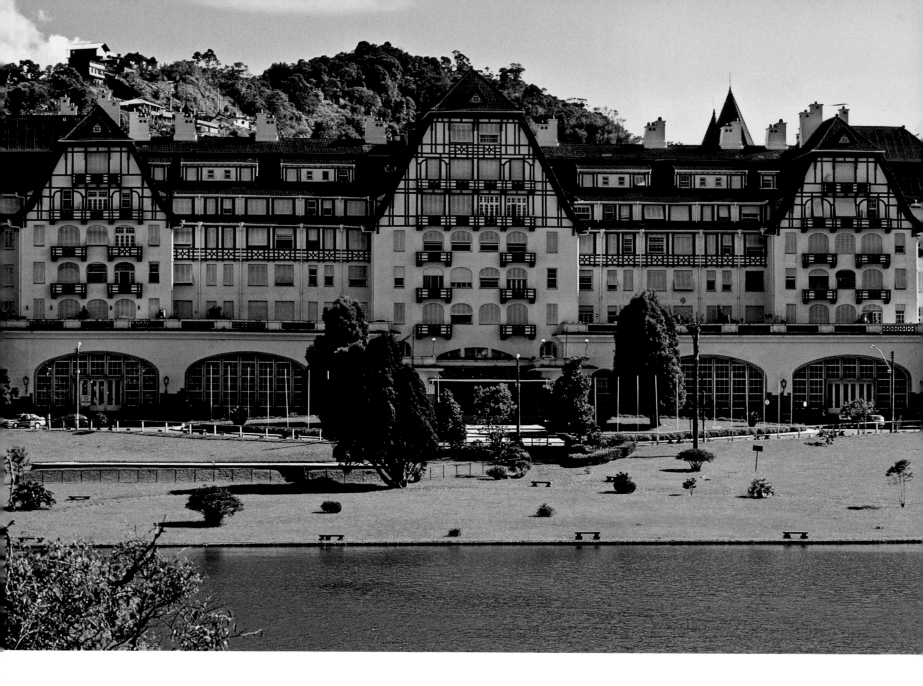

Above:
Located on the way into Petrópolis,
also known as the imperial city, the
imposing Quitandinha was opened
in 1944, primarily for use as a casino.
The majestic building is now a hotel
and convention centre.

Vila de Abraham, the main seaport on the island. The biggest attraction of Ilha Grande, however, is its beautiful beaches, which stretch along a varied coastline. There are good surfing conditions on the side of the island that faces the ocean and, on the other side, small, peaceful inlets, where the sea appears to be a large natural pool. You can rent a boat to get to these beaches or walk there along trails that cross mountains and forests.

Angra dos Reis, where tourists arrive from all over the world, has a calendar of activities that covers the entire year. New Year's Eve is celebrated with a parade of boats crisscrossing the bay. The

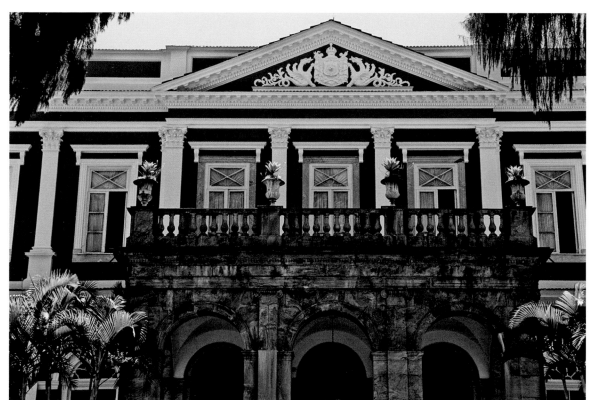

The historic town of Petrópolis was the summer residence of Dom Pedro I, who enjoyed the pleasant climate of this region. The town itself was officially founded in 1843.

boats that take part range from the most humble *traineras* (sardine-fishing boats) to the most sophisticated yachts, with celebrations aboard every vessel to honour Yemanjá, the goddess of the sea in the Afro-Brazilian *candomblé* faith. The best-decorated boat is awarded a prize.

The Feast of the Divine is one of the most important festivals in Rio State, but this celebration, which combines religious and cultural aspects, now takes place only in Angra and Paraty, and no longer in the other towns of the State. The event consists of a procession with costumed participants

*Christina de Orléans e
Bragança, another member
of the royal family, lives in
Petrópolis, where she owns
the Portobelo antique shop.*

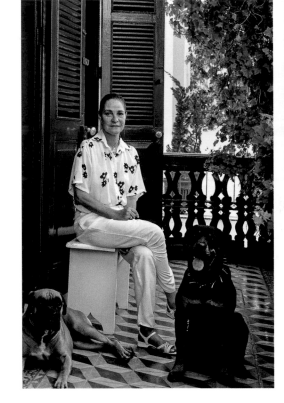

who represent knights on a pilgrimage, and who go from house to house as a representation of faith and integration.

This varied range of cultural activities makes Angra dos Reis and Paraty the major centres for tourism in Rio State, rivalling the equally attractive region of Os Lagos, on the northern coast. In contrast to the over-development of that area, the southern region has been reasonably well preserved because of the care taken in controlling its growth.

*Portobelo sells a wide range
of antiques, from teapots to
furniture. In every piece,
excellence is what matters.*

Petrópolis

The history of Petrópolis is linked to the events that led to Brazil's independence from Portugal. In 1822, Emperor Dom Pedro I was traveling to Vila Rica in Minas Gerais in search of support for the movement to liberate the country, when he stopped to rest in the place where Petrópolis stands today.

It was no more than a *fazenda*, or farm, at that time, and Dom Pedro decided to purchase the land. Following the struggles for independence, Dom Pedro decided to leave the land to his son and successor as Emperor of Brazil. The Prince built a summer residence there, which was later transformed into the Imperial Museum, a neoclassical building where an important part of the legacy of these two historic rulers is on display.

The region was eventually settled by large groups of German, Italian and Portuguese immigrants who recreated their European lifestyles in an area with a mild climate and a mountainous landscape, set in the Fluminense hills. The city has prospered and today is one of the largest in the region, with several districts such as Araras and Itaipava, where textile manufacturing, farming and ranching are the leading industries. Petrópolis is also famous for the high quality of its restaurants and as a centre for tourism both nationally and internationally.

The Serra dos Órgãos National Park, a natural paradise set in the Mata Atlântica, has countless waterfalls, such as the Jinóia (Boa), which falls from a height of almost 100 metres (300 feet). It is difficult to reach, with steep climbs required, but it worth the effort to be able to bathe in its crystalline waters. The pool formed by the falling water is almost four metres (12 feet) deep, which permits swimming and diving. The best-known waterfall, however, is the Véu da Noiva (Bride's Veil), whose waters fall almost 40 metres (120 feet) down the mountain side. The sport of abseiling or *rapel* is also common at Véu da Noiva.

In the city of Petrópolis itself, the main attractions are historic, cultural and gastronomic. A number of old homes, such as the residences of Santos Dumont, the founder of Brazilian aviation, and the Barão de Mauá, the founder of the Banco do Brasil and of the first railroad in Latin America,

The Petrópolis area is famous for its flowers, especially its rare orchid varieties. This natural richness makes the city and its surroundings a special attraction for nature lovers.

have been converted into museums. The Castelo do Barão de Itaipava, a landmark building designed by architect Lúcio Costa, has received visits from many famous figures, such as former president Getúlio Vargas. The city's churches, plazas and palaces are also required visits for those interested in Brazilian history. The Palácio do Rio Negro, for example, was the seat of the State government; today the building is the official residence of the President of Brazil when he visits Petrópolis.

With so many cultural options located just an hour from Rio de Janeiro, Petrópolis is one of the most visited sites in Rio State. It is ideal for anyone who wants to spend a weekend away from the hustle and bustle of Rio.

Right:
The Tijuca National Park makes Rio de Janeiro a special place: the only city in the world with a rainforest in the midst of its urban sprawl. Cariocas enjoy watching its waterfalls and walking its eco-trails, which provide a leisure-time alternative to the beaches.

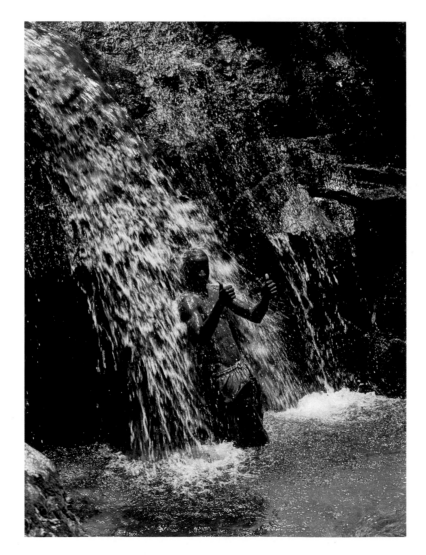

Opposite:
On Ilha Grande, the native flora is a source of pride to the locals. Rare plants are conserved and used as decoration.

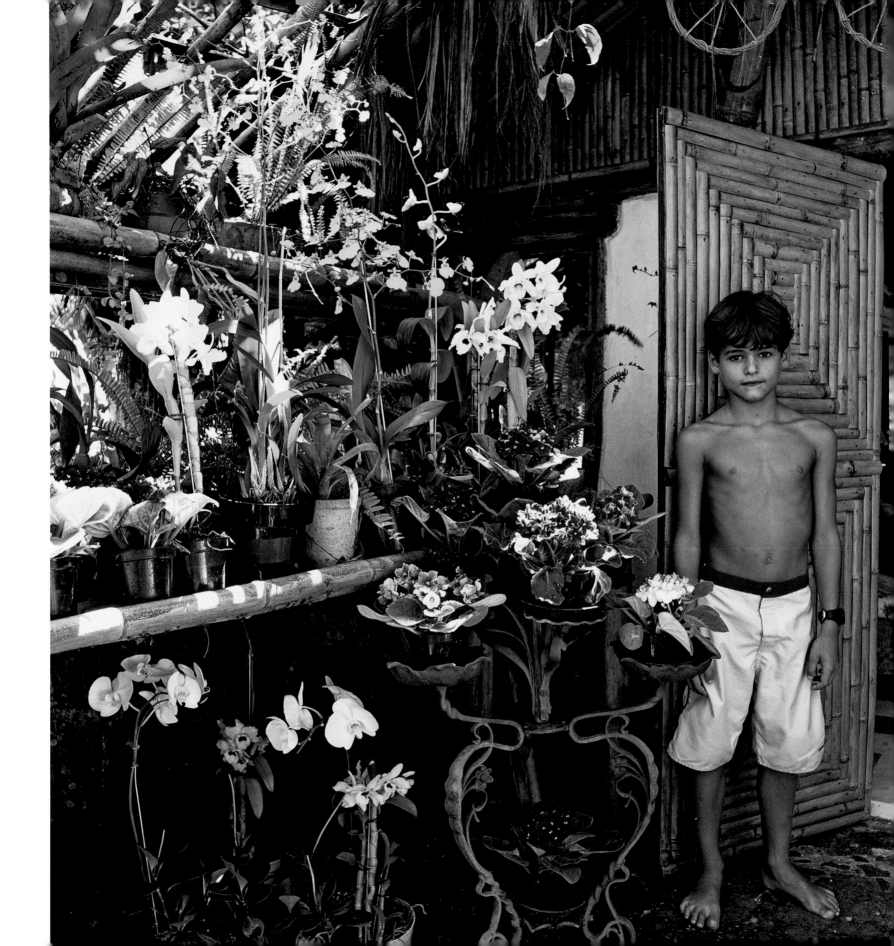

Visitor's Guide

HOTELS

AMBASSADOR HOTEL

Rua Senador Dantas 25
Centro
Tel: 021/2531-1633
Fax: 021/2220-4783
Nestled in the heart of Rio, this hotel is close to the Cinelândia subway station and minutes away from Santos Dumont Airport. Its comfortable apartments and location make it ideal for those who are also in Rio on business.

ARPOADOR INN

Rua Francisco Otaviano 177
Leblon
Tel: 021/2523-0060
Fax: 021/2511-5094
ipanema.com/hotel/arpoador_inn.htm
This is the only hotel in Rio that overlooks Arpoador Beach in Ipanema. It is a small hotel with just six floors and standard en-suite apartments. Its proximity to Ipanema, Leblon and Copacabana and the fact that it is only a few feet away from the beach make location one of this hotel's main advantages.

CAESAR PARK HOTEL

Avenida Vieira Souto 460
Leblon
Tel: 021/2525-2525
Fax: 021/2521-6000
www.caesar-park.com
Overlooking the most famous stretch of Ipanema beach, this hotel is situated in one of Rio's most magnificent locations. Conveniently close to all the best shops, restaurants and bars in the neighbourhood, the Caesar is the very definition of luxurious comfort. The view from the rooftop pool deck is breathtaking. The hotel also provides an exclusive beach service, complete with a lifeguard, security, chairs, towels and even refreshments, so that clients can enjoy the Brazilian beach in style.

COPACABANA PALACE

Avenida Atlântica 1702
Copacabana
Tel: 021/2548-7070
Fax: 021/2235-7330
www.copacabanapalace.orient-express.com
This is where it all began. Built during the jazz age in 1923, the lavish Copacabana Palace retains the charm that made it world-famous

when it was one of the few buildings on the beachfront. The poolside suites, featuring a partial ocean view, are highly recommended.

HOTEL SOFITEL

Avenida Atlântica 4240
Copacabana
Tel: 021/2525-1232
Fax: 021/2525-1230
After a multimillion dollar renovation, the H-shaped Sofitel is once again one of the best hotels in Rio. Elegantly perched on the edge of Copacabana beach, it boasts rooms facing the mountain, the sea or both at the same time, as well as two pools positioned to make the most of the sunlight and a superb French restaurant that attracts locals.

IPANEMA PLAZA

Rua Farme de Amoedo 34
Leblon
Tel: 021/3687-2000
Fax: 021/3687-2001
www.ipanemaplazahotel.com
This modern, elegant hotel is a member of the Dutch-based Golden Tulip chain. It is located

a block away from Ipanema Beach. Sleek wood and beige dominate the decor of the rooms, which are quite spacious. Several rooms have a large balcony. An excellent buffet breakfast is included in the rate.

MARINA ALL SUITES

Avenida Delfim Moreira 696
Leblon
Tel: 021/2172-1100
www.marinaallsuites.com.br
The Marina All Suites is a stunning patchwork of ideas by local designers and architects. Each suite is decorated in a unique style with outstanding pieces of original art. The gem in this crown of the cutting edge is the two-bedroom Diamante suite. In keeping with its modern standards of comfort and avant-garde design, there's a lounge on the top floor where guests can log onto the internet or watch movies in the DVD movie theatre. Its restaurant-bar attracts locals and is one of the hippest nightspots in Rio. Located in Leblon, this is the ideal place for those who want a new way to enjoy the city.

MARRIOTT RIO DE JANEIRO

Avenida Atlântica 2600
Copacabana
Tel: 021/2254-6500
Fax: 021/2545-6555
www.marriott.com
The bold glass design of the Marriott building gives a feeling of light and air. Its amenities and friendly service live up to its cutting-edge architecture. The hotel also provides each room with a complimentary newspaper, mineral water, iron and ironing board and CD player, as well as a beach service that includes towels, chairs and drinks.

MELIÁ CONFORT

Avenida Das Américas 7897
Barra da Tijuca
Tel: 021/2438-8800
Fax: 021/2438-8801
www.solmelia.com
The two towers that make up this modern hotel host a wide array of conventions yearly, ranging from the Iberoamerican summit to the

Rock in Rio festival. It is located in Barra da Tijuca, one of Rio's most modern neighbourhoods, and offers the convenience of being close to the beach and yet only ten minutes from the Centro.

SHERATON RIO HOTEL & TOWERS

Avenida Niemeyer 121
Leblon
Tel: 021/2274-1122
Fax: 021/2239-5643
www.sheraton-rio.com
The Sheraton hotel's location sheds harsh light upon Rio's class disparities: it faces a beautiful beach on one side and a hillside favela *on the other. Despite this, people mingle safely on the beach, overseen by hotel security. An emblem of luxury, the hotel's three swimming pools are set in a beautiful park like atmosphere, also boasting beachfront access. The Sheraton has excellent amenities and all bedrooms have a terrace with a full or partial ocean view.*

MUSEUMS

CASA DO PONTAL FOLK-ART MUSEUM

Estrada do Pontal 3295
Recreio dos Bandeirantes
Tel: 021/2490-3278
www.popular.art.br
This museum boasts one of the most spectacular exhibitions of Brazilian culture, featuring pieces in clay and wood by artists such as Ciça, João José, Maria Otília, Zé do Carmo and Antonio de Oliveira as well as a whimsical mechanical sculpture representing the different escolas de samba. *The collection formerly belonged to the French designer Jacques Van de Beuque.*

MAC DE NITERÓI (MUSEUM OF CONTEMPORARY ART)

Mirante de Boa Viagem
Niterói
Tel: 021/2620-2481
www.macniteroi.com
This spectacularly designed structure by architect Oscar Niemeyer is shaped rather like

a flying saucer. Its ingenious observation gallery allows visitors picture-perfect views of Rio, Sugarloaf Mountain and Guanabara Bay as well as the city of Niterói. Its inner ringed galleries feature an ever-changing stream of the best contemporary art Brazil has to offer.

EDISON CARNEIRO FOLKLORE MUSEUM

Rua do Catete 179/181
Catete
Tel: 021/2285-0441
www.museudofolclore.com.br
Spanning some 1,500 square metres, this is one of the most interesting museums in the city. Extensive field work brought together the twelve thousand pieces from all over the country that are exhibited in this space. The museum boasts a vast picture archive, audio collection and recorded statements that ensure the survival of different styles of handicrafts, currently under threat from the increasing urbanization of Brazil.

INDIAN MUSEUM (MUSEU DO ÍNDIO)

Rua das Palmeiras 55
Botafogo
Tel: 021/2286-8899
www.museudoindio.org.br
This traditional mansion in Botafogo dates back to 1880. It has an impressive ethnological library made up of five hundred thousand documents as well as fourteen thousand works of indigenous culture and lifesize models of Guarani and Caiapó housing. It is overseen by the National Native Indian Foundation and is also used as the administrative centre for the foundation in Rio de Janeiro.

MUSEUM OF MODERN ART (MAM)

Avenida Infante Dom Henrique 85
Parque do Flamengo (Aterro)
Centro
Tel: 021/2240-4944
www.mamrio.com.br
Founded in 1948, it boasts one of the most important collections of modern Brazilian art in the world, mostly from the collection of Gilberto Chateaubriand. Pieces by artists such as Andy Warhol, Picasso and Le Corbusier

complement the local art. This versatile museum also has an excellent library as well as one of the largest film archives in the country. Its stark, horizontal architecture seamlessly integrates the museum with Guanabara Bay, and has stunning gardens designed by Roberto Burle Marx.

NATIONAL FINE ARTS MUSEUM (MUSEU NACIONAL DE BELAS ARTES)

Avenida Rio Branco 199
Centro
Tel: 021/2240-0068
www.mnba.gov.br
Founded in 1937, this museum is located in the heart of Rio and occupies the building that formerly housed the National School of Fine Arts. Its neoclassical architecture is a fine example of a period of hope and aspiration, when the city was expanding and Avenida Rio Branco was being built; a time when Rio dreamt of becoming a cosmopolitan city. Its collection boasts pieces of art that range from the 18th to the 20th century as well as a wide array of Brazilian folk art.

NATIONAL HISTORY MUSEUM

Praça Marechal Âncora
Centro
Tel: 021/2550-9221
www.museuhistoriconacional.com.br
This museum was built in 1922, as part of the celebrations for the centenary of Brazil's independence. Located in Rio's historic centre, it houses a collection of almost fifty thousand pieces as well as a library, making it a major source of Brazilian cultural heritage.

MUSEU NACIONAL

Quinta da Boa Vista
São Cristóvão
Tel: 021/2568-8262
www.museunacional.ufrj.br
This palace was donated to the prince regent by the Portuguese trader Elias Antonio Lopes in 1818. It was used as a barracks, a school and the headquarters of the Constitutional Republican Congress, and eventually became a museum in 1892. The Federal University of Rio de Janeiro currently teaches a graduate social anthropology course in the museum building. It also houses major archaeological finds and skeletons of prehistoric animals from Brazil and all over the world, as well as ceramics and indigenous crafts.

MUSEU DA REPUBLICA

Rua do Catete 153
Catete
Tel: 021/2558-6350
www.museudarepublica.org.br
The Palácio do Catete was the seat of the Brazilian presidency from 1897 to 1960, and was the setting for the infamous suicide of Getúlio Vargas. Its rooms hold a collection of over twenty thousand books, seven thousand historical pieces and eighty thousand documents. Its extensive grounds are used as a public park.

CULTURAL CENTRES

BANK OF BRAZIL CULTURAL CENTRE (CCBB)

Rua Primeiro de Março 66
Centro
Tel: 021/3808-2000
This is the city's most comprehensive centre, boasting movie theatres, two theatre stages, video booths, a library of more than a hundred thousand volumes and several exhibition galleries, which are always home to excellent shows. Formerly the headquarters of the Banco do Brasil, it also houses a permanent exhibition entitled 'Brazil seen through currency'.

CASA FRANÇA-BRASIL

Rua Visconde de Itaboraí 78
Centro
Tel: 021/2253-5366
www.casafrancabrasil.rj.gov.br
This is one of the most interesting cultural centres in the city and it is housed in a neoclassical building from 1820. Of the many different exhibitions held throughout the year, one of the most renowned is the International Comics Biennale.

IMPERIAL PALACE (PAÇO IMPERIAL)

Praça XV de Novembro 48
Centro
Tel: 021/2533-4491
www.pacoimperial.com.br
Built in 1743, this palace was the residence of the viceroys of Brazil. When the colony's status was raised to that of United Kingdom of Portugal, Brazil and the Algarve, the royal family and court of Dom João VI took up residence. The palace remained the seat of government throughout monarchic and imperial times. This building is a powerful symbol of the city's history and was declared a heritage site in 1938. It holds different exhibitions throughout the year.

INSTITUTO MOREIRA SALLES

Rua Marquês de São Vicente 476
Gávea
Tel: 021/3284-7400
www.ims.com.br
This stately building currently houses a cultural centre dedicated to a wide range of projects. The permanent exhibition features the work of Marc Ferrez, among others. It is famous for its photography exhibitions and its music projects, one of which is the Projeto Villa-Lobinhos, dedicated to giving children and young people access to music lessons. Visitors can see the exhibitions, listen to music or stroll in the beautiful gardens landscaped by Burle Marx.

HISTORIC CHURCHES

NOSSA SENHORA DA CANDELÁRIA

Praça Pio X
Centro
Tel: 021/2233-2324
Open: Mon–Fri 8 am–4 pm; Sat 8 am–12 pm;
Sun 9 am–1 pm

IGREJA ANGLICANA (ANGLICAN CHURCH)

Rua Real Grandeza 99
Botafogo
Tel: 021/2226-7332
Open: information not available

CATEDRAL METROPOLITANA DE SÃO SEBASTIÃO (METROPOLITAN CATHEDRAL OF ST SEBASTIAN)

Avenida República do Chile 245
Centro
Tel: 021/2240-2669
Open: daily, 7.30 am–6 pm

IGREJA DO MOSTEIRO DE SÃO BENTO (ST BENEDICT'S MONASTERY)

Rua Dom Gerardo 68
Centro
Tel: 021/2206-8100
www.osb.org.br
Open: daily, 7 am–12 pm, 2 pm–6 pm

ARTS AND CRAFTS FAIRS

BABILÔNIA FEIRA HYPE

Jockey Club Brasileiro, Rua Jardim Botânico –
Tribuna C
Tel: 021/2236-7195
www.babiloniahype.com.br
*This fair was conceived in 1996 as part of a
project to revitalize public spaces. Held on
the grounds of the Brazilian Jockey Club, it
brings together up-and-coming designers from
the worlds of fashion, art, interior design,
food and culture. It also attracts many
prominent artists and local personalities.
Visitors can buy crafts, clothes, have a
massage, get a body-piercing or catch up
on the latest in the music scene, or simply
browse the different stands to get a feel for
the latest trends.*

IPANEMA HIPPIE FAIR

Praça General Osorio (intersection of Rua
Teixeira de Melo and Rua Visconde de Pirajá)
*This square was a hippie hangout in the sixties
and although the intensity of the market has
faded somewhat, an arts and crafts fair still
takes place every Sunday.*

FEIRA DA GÁVEA

Praça Santos Dumont, opposite the
Brazilian Jockey Club racecourse
Jardim Botânico
*The racetrack is used for several events
throughout the year. The antique and art
fair called the Feira da Gávea is open every
Sunday morning.*

FEIRA DO RIO ANTIGO

Rua do Lavradio
Lapa
Tel: 021/2224-6693
*Rua do Lavradio was one of the first
residential streets in the city. Artists,
journalists and poets soon turned Lapa into
the main bohemian district of Rio. Traditional
houses dating back to the 19th century can still
be seen around the area. The neighbourhood's
main business is the antiques trade, although
nightfall transforms the street, with bars and
music venues springing up inside the old
houses, with dancing of all kinds.*

SAARA

Rua da Alfândega (between Rua Primeiro
de Março and Campo de Santana)
www.saararioo.com.br
*This spacious area, spanning eleven streets,
boasts more than 1,200 stores. They sell all
sorts of goods, ranging from clothes to jewelry
to products of Arabic, Jewish and Portuguese
provenance. This diversity makes it the main
ethnic centre of the city.*

FEIRA DE SÃO CRISTÓVÃO: LUIZ GONZAGA NORTHEASTERN TRADITIONS CENTRE

Campo de São Cristóvão
São Cristóvão
Tel: 021/3860-9976 / 3860-9862
www.feiradesaocristovao.com.br
*Packed with kiosks and traditional stands that
sell typical food from northeastern Brazil as
well as arts and crafts, it is also a unique place
for dances, like the* forró *or for listening to
authentic music from the northeast. Artists
sometimes ad lib the lyrics to the songs, using
the nearest spectators for inspiration.*

SÃO SEBASTIÃO PRAÇA XV ANTIQUES FAIR

Praça XV
Centro
*Located in front of the Imperial Palace on one
of Rio's most historic squares, this market
features the work of all sorts of artists. Their
products range from leather to glass and
ceramic to silver. There are also many stands
that sell tourist souvenirs. This fair is open
every Saturday, from 9 am to 6 pm.*

PARKS AND GARDENS

BOTANICAL GARDENS

Rua Jardim Botânico 1008
Jardim Botânico
Tel: 021/3874-1214
www.jbrj.gov.br
*These gardens were founded almost two
hundred years ago by Emperor Dom João VI
and have grown to 137 hectares. Thousands of
rare species grace the enormous collection,
including a whole greenhouse full of tropical
carnivorous plants. People stroll down the
paths and garden trails, finding exotic
vegetation at every turn. There is also a
café and bookstore in the gardens.*

ROBERTO BURLE MARX HOUSE AND GARDENS

Estrada da Barra de Guaratiba 2019
Barra de Guaratiba
Tel: 021/2410-1412

This country house was the home of famed landscape architect Roberto Burle Marx and is currently a museum. Marx designed many of Rio's landscapes and is most famous for creating the sinuous waves of the Copacabana Beach pavements. Visitors will find an overwhelming collection of over 3,500 species of plants in the spectacular gardens that surround the house.

TIJUCA NATIONAL PARK AND MUSEU DO AÇUDE

Estrada da Cascatinha 850, Floresta da Tijuca
Alto da Boa Vista
Tel: 021/2492-2252
Estrada do Açude 764
Alto da Boa Vista
Tel: 021/2492-2119

Spanning over a hundred square kilometres, the Tijuca National Park is the largest in Rio. Interesting places to visit in the forest are the Mayrink Chapel and the Gabriela and Taunay Falls as well as the Museu do Açude with installations by Brazilian contemporary artists in its gardens. This old colonial house was formerly the residence of Raimundo Castro Maya, one of the founders of the Museum of Modern Art. Its collection includes period furniture, one of the largest collections of oriental art in Brazil, silver and glassware as well as a stunning selection of antique Portuguese tiles.

SHOPPING

BOTAFOGO PRAIA SHOPPING

Praia de Botafogo 400
Botafogo
Tel: 021/2559-9559

CASA TURUNA

(speciality shopping)
Rua Senhor dos Passos 122
Centro
Tel: 021/2224-0908

CASA SHOPPING

Avenida Ayrton Senna 2150
Barra da Tijuca
Tel: 021/2429-8000

LOJAS AMERICANAS

Rua Visconde de Pirajá 526/532
Ipanema
Tel: 021/2274-0590

NORTE SHOPPING

Avenida Dom Helder Câmara 5474
Del Castilho
Tel: 021/3089-4444

RIO DESIGN LEBLON

Avenida Ataulfo de Paiva 270
Leblon
Tel: 021/3206-9100

RIO SUL SHOPPING CENTRE

Rua Lauro Müller 116
Botafogo
Tel: 021/2545-7279

SÃO CONRADO FASHION MALL

Estrada da Gávea 899
São Conrado
Tel: 021/2322-2733

SHOPPING CASSINO ATLÂNTICO

Avenida Atlântica 4240
Copacabana
Tel: 021/2523-8709

MUSIC STORES

TOCA DO VINÍCIUS

Rua Vinícius de Moraes 129 C
Ipanema
Tel: 021/2247-5227
www.tocadovinicius.com.br

TOP SOUND

Avenida N. S. de Copacabana 1103, Loja C
Tel: 021/2267-9607

JEWELRY

AMSTERDAM SAUER

Rua Visconde de Pirajá 484
Ipanema
Tel: 021/2525-0033
Museum: Rua Garcia D'Ávila 105
Ipanema
Tel: 021/2512-1132
www.amsterdamsauer.com

H. STERN

Rua Garcia D'Ávila 113
Ipanema
Tel: 0800-227442
www.hstern.com.br

KANTER ARTE & JOIAS

Rua Vizconde de Pirajá 430 A
Ipanema
Tel: 021/2287-8299

BOOKSTORES

LIVRARIA LETRAS E EXPRESSÕES

Avenida Ataulfo de Paiva 1292
Leblon
Tel: 021/2511-5085
Rua Vizconde da Pirajá 276
Ipanema
Tel: 021/2521-6110
www.letraseexpressoes.com.br
*This bookstore has a café and a tobacconist's
and unusual business hours since it is
conveniently open until dawn.*

LIVRARIA ARGUMENTO

Rua Dias Ferreira 417
Leblon
Tel: 021/2239-5294
www.livrariaargumento.com.br
*A combination of books, music and coffee
lend a very literary atmosphere to this
bookstore. It offers a wide selection of
illustrated books on photography and art as
well as fiction, travel and cookery. There is
also a music section, specializing in jazz and
classical music. A comfortable place to browse
through books is the charming Severino café
at the back of the store.*

LIVRARIA KOSMOS

Rua do Rosário 155
Centro
Tel: 021/2224-8616
www.kosmos.com.br
*Specializing in rare books, Kosmos is one of
Rio's most traditional bookstores. Founded in
1935 by Austrian immigrants, it has managed
to keep its original location at the very heart
of the Centro. Their selection of books ranges
from art and culture to natural history,
technology and agriculture.*

LIVRARIA DA TRAVESSA

Rua Visconde de Pirajá 572
Ipanema
Tel: 021/3205-9002
www.livrariadatravessa.com.br
*This bookstore boasts a café and a knack for
organizing cultural events. It is part of a chain,*

*but the oldest and most traditional branch
is in Ipanema.*

CRAFT SHOPS

BRUMADO

Rua das Laranjeiras 486, loja B
Laranjeiras
Tel: 021/2558-2275

O SOL

Rua Corcovado 213
Jardim Botânico
Tel: 021/2294-5099

PÉ DE BOI

Rua Ipiranga 55
Laranjeiras
Tel: 021/2285-4395
www.pedeboi.com.br

THEATRES

TEATRO GLAUCE ROCHA

Avenida Rio Branco 179
Centro
Tel: 021/2220-0259

TEATRO JOÃO CAETANO

Praça Tiradentes
Centro
Tel: 021/2221-1223

CASA DE CULTURA LAURA ALVIM

Avenida Vieira Souto 176
Ipanema
Tel: 021/2267-1647

TEATRO MAISON DE FRANCE

Avenida Presidente Antônio Carlos 58
Centro
Tel: 021/2544-2533
teatromaisondefrance.com.br

MUNICIPAL THEATRE

Praça Floriano
Centro
Tel: 021/2299-1643 / 2299-1644
www.theatromunicipal.rj.gov.br

ESPAÇO CULTURAL SÉRGIO PORTO

Rua Humaitá 163
Humaitá
Tel: 021/2266-0896

RESTAURANTS

ADEGA DA VELHA

Rua Paulo Barreto 25 A e B
Botafogo
Tel: 021/2286-2176
*This small restaurant specializes in food from
northeastern Brazil. It is famous for its carne
do sol (salted meat left out in the sun to dry
and then softened in milk or water before
being barbecued); baião-de-dois (rice and
beans cooked with herbs and pork) and
macaxeira (manioc). Rather reminiscent
of a botequim, the atmosphere is light
and informal.*

AZUMI

Rua Ministro Viveiros de Castro 127
Copacabana
Tel: 021/2541-4294
*This is one of the best sushi places in Rio.
It's a typical Japanese restaurant, run by a
Japanese family that has only been in Rio for
two generations. The menu includes all kinds
of Japanese specialities as well as some
innovations created by the owner. It has
booths, tables and a balcony. Its location in
Copacabana gives it a film noir atmosphere.*

CAIS DO ORIENTE

Rua Visconde de Itaboraí 8
Centro
Tel: 021/2233-2531
www.caisdooriente.com.br
*In contrast to Siri Mole (see below), the other
seafood restaurant favoured by Cariocas has a*

luxurious and opulent atmosphere. Its dining room and mezzanine are flanked by large mirrors and peppered with antique furniture. It also has a pretty garden. The menu is eclectic and includes dishes from literally all over the world. The bar upstairs is a good place to see live music shows.

CONFEITARIA COLOMBO

Rua Gonçalves Dias 32/36
Centro
Tel: 021/2232-2300
www.confeitariacolombo.com.br
This stunning tearoom opened its doors in 1894. Not much has changed since then. The ground floor has two large deli counters and a beautiful tearoom, where teas, sandwiches and salads are served on delicate china. The upper floor is used for lunches and a worthwhile feijoada *every Saturday.*

GARCIA & RODRIGUES

Avenida Ataulfo de Paiva 1251
Leblon
Tel: 021/3206-4100 / 3206-4106
www.garciaerodrigues.com.br
Versatile and appealing, Garcia & Rodrigues is a deli, café, wine bar, bakery and ice cream parlour. It is also, unsurprisingly, a very pleasing restaurant, with an impressively stocked wine cellar and a varying eclectic menu, overseen by chef Christophe Lidy. The deli, bakery and café boast delicious sandwiches as well as a wide variety of rolls, breads, deli products and salads to enjoy at the café or take home. This busy food emporium also has areas reserved for cooking lessons and wine tasting. Very popular for breakfast and weekend brunch.

GERO

Rua Anibal de Mendonça 157
Ipanema
Tel: 021/2239-8158
Reputed to be one of Rio's finest restaurants, Gero has repeatedly won awards for the quality of its Italian cuisine and the atmosphere of its dining room. The menu varies but the famous specialities remain the same: white polenta with calamari and squid

ink or tagliatelli with Italian sausage ragout. The atmosphere is very romantic.

LE PRE-CATELAN

Avenida Atlântica 4240
Hotel Sofitel
Copacabana
Tel: 021/2525-1232
This restaurant has received its fair share of awards, thanks to its French chef, Roland Villard, who manages to create sumptuous French cuisine with a touch of Brazil. The menu is updated every two weeks and some past examples of Villard's creations are a capivara ragout, *made in coq-au-vin style with exotic Brazilian meat, and the langoustine carpaccio, served with a crab salad and avocado mousse. The desserts are also highly memorable.*

PICANHA & ETC.

Avenida Sernambetiba 2900
Barra da Tijuca
Tel: 021/2493-2021
This steakhouse specializes in picanha (a cut of steak). Located on the shores of the Barra da Tijuca beach, its large, bright spaces and excellent view of the sea make it the ideal candidate for lunch after the beach.

PORCÃO

Avenida Infante Dom Henrique
Aterro do Flamengo
Tel: 021/3389-8989
www.porcao.com.br
Porcão combines a spectacular view with an abundance of food. It is a Brazilian version of the 'all you can eat' barbecue called a rodizio *and it operates on the premise that customers who want to stop eating can place a red card on their plates for the waiters to see. But as long as the green card sits on the customer's plate, waiters will keep on coming, bearing an impressive variety of meats, including pork, beef, chicken and sausages of all kinds as well as cold antipasto dishes, hot and cold seafood and assorted salads. A place to enjoy the view and a long, long lunch.*

SATYRICON

Rua Barão da Torre 192
Ipanema
Tel: 021/2521-0627
www.satyricon.com.br
This has become one of Rio's most select hangouts, featuring gossip-hungry paparazzi and society columnists. It started out as an Italian seafood restaurant but the Italian influence slowly began to fade and it is now known simply for its seafood. A few examples of the sumptuous dishes are the oversized seafood platter and the three-fish carpaccio that features different fish every day. One of the trademark dishes is pargo, fish baked in a salt crust. It is famed for being Madonna's favourite restaurant in Rio.

SIRI MOLE & CIA

Rua Francisco Otaviano 50
Copacabana
Tel: 021/2267-0894
This restaurant is popular with seafood-lovers who like their food Bahia style. It is well known for its shrimp and fish moquecas (Bahian or Capixaba style); acarajé (bean patties); casquinhas de siri (a Brazilian version of coquilles Saint-Jacques) and fish soups. The use of peppers, dendé oil and coconut milk gives Bahian cuisine its unique flavour.

YEMANJÁ

Rua Visconde de Pirajá 128
Ipanema
Tel: 021/2247-7004
Named after a sea goddess, this restaurant is represents the very best Bahia has to offer, right at the very heart of Ipanema. Dishes from the northern region include moquecas, bobó (a stew made with shrimp), and vatapá, another stew made from ground up peanuts, fish and thickened with bread. One main course is more than enough for two.

YORUBÁ

Rua Arnaldo Quintela 94
Botafogo
Tel: 021/2541-9387
Both its decor and its menu make this a very interesting venue. It is considered one of the

most creative restaurants in Rio for its African and Bahian specialities, such as moqueca de peixe (Bahian fish stew). Plants, stones and rustic furniture complement the candomblé (Afro-Brazilian religion) motifs that adorn the restaurant. The music lends an extra African touch to the atmosphere.

BAR/RESTAURANTS

BAR D'HOTEL

Avenida Delfim Moreira 696
Marina All Suites
Leblon
Tel: 021/2540-4990
www.marinaallsuites.com.br
This bar-restaurant is located on the first floor of the Marina Hotel in Leblon. One of the hippest nightspots in town, it overlooks Leblon Beach and is also open for breakfast and lunch. Artists, football players and people from the media world flock to this mecca of cool after 10 pm, for people-watching and for modern, Italian-inspired food, such as goat's cheese ravioli. The drinks are as stylish as the patrons: the lemon kir royal and sake caipirinha come highly recommended.

ESCH CAFÉ / LA CASA DEL HABANO

Rua do Rosário 107
Centro
Tel: 021/2507-5866
Rua Dias Ferreira 78 A
Leblon
Tel: 021/2512-5651
www.eschcasadelhabano.com.br
Originally conceived by Edgar Esch to share the best tobacco with his friends, this café-bar soon became one of the best places for good cuisine, drinks and great tobacco in Rio. The penne amatriciana is a highlight.

VINÍCIUS PIANO BAR

Rua Vinícius de Moraes 39
Ipanema
Tel: 021/2523-4757
www.viniciusbar.com.br
Located on the street bearing the same musician's name, this bar is hidden away on the first floor. It is a small and quaint place, where the star is the live music played every night by a steady roster of regulars.

THE BOTEQUIM

There is no easy way to describe this type of traditional local gathering place. The closest would be to compare it to a similar hybrid in other cities, like the café in Paris and the pub in Ireland. It is neither a bar nor a café but a mixture of both where people go to drink coffee and alcohol, talk politics and art and listen to samba and bossa nova. This type of establishment can be found all over the city and is an integral part of Rio culture.

ACADEMIA DA CACHAÇA

Rua Conde Bernadotte 26 G
Leblon
Tel: 021/2239-1542
www.academiadacachaca.com.br
Its most famous branch is in Leblon, and its name immediately gives away the speciality: countless varieties of cachaça spirit from different parts of Brazil. The best known are the ones from Minas Gerais in the Salinas region.

BAR BRASIL

Avenida Mem de Sá 90
Lapa
Tel: 021/2509-5943
This botequim opened in 1907 and is renowned for its beer and German food. The specialities are Kassler (smoked pork), Eisbein (ham hock) and meatballs with potato salad and cream. It is located in the heart of Rio's Lapa neighbourhood, and is frequently patronized by local artists, journalists and other bohemians.

BAR DO MINEIRO

Rua Paschoal Carlos Magno 99
Santa Teresa
Tel: 021/2221-9227
This restaurant serves food from Minas Gerais, like tutu (mashed black beans) and cozido (a stew with vegetables). Its feijoada is particularly well known for using lean cuts of meat. An enormous balcony and rickety wooden tables make the atmosphere very cosy and rustic.

BAR LUIZ

Rua da Carioca 39
Centro
Tel: 021/2262-6900
www.barluiz.com.br
Founded in 1887, this German-style botequim has since moved to its current location on a traditionally commercial street in the centre of Rio. Its founders were two Germans who contributed to making beer popular in Rio. The atmosphere is elegant and evokes past times, making it the classic botequim.

BIP-BIP

Praça Almirante Gonçalves 50
Copacabana
Tel: 021/2267-9696
This tiny bar in Copacabana is anarchically run by its owner, Alfredinho Mello. On Sundays after 8 pm, there are samba sessions featuring great artists from all generations. There is also chorinho music on Wednesdays.

BRACARENSE

Rua José Linhares 85 B
Leblon
Tel: 021/2294-3549
This is a typical south Rio botequim, where people go after the beach for a beer and snacks called petiscos. Customers crowd the sidewalks with their folding beach chairs and lounge in their swimwear all afternoon. According to a survey, Bracarense was chosen the best bar in the city, five times running.

JOBI

Avenida Ataulfo de Paiva 1166
Leblon
Tel: 021/2274-0547
This small botequim in Leblon is famous for its food, beer, waiters and staying open until dawn.

MERCADO COBAL DO HUMAITÁ

Rua Voluntários da Pátria 448
Humaitá, Botafogo
Tel: 021/2266-0194
This market is filled with bars, sushi places, Portuguese restaurants, pizzerias and churrascarias (steakhouses). The youth of the city swarm to this place, where there is chorinho music on Sunday afternoons in the Espírito de Chope bar. All sorts of kiosks sell merchandise ranging from fine wines to tobacco and deli products. In the morning, it turns back into a fruit, vegetable and meat market.

PALADINO

Rua Uruguaiana 226
Centro
Tel: 021/2263-2094
A typical example of the classic downtown Rio botequim, Paladino is a hundred years old. An antique deli counter adorns the front of the room and the bar stands at the back. The specialities are a variety of sandwiches and omelettes.

NIGHTLIFE IN RIO

People lucky enough to visit Rio between September and the carnival season can attend one of the escola de samba *rehearsals on Saturdays. The rest of the year round, samba can be enjoyed at hip places in Lapa like the Rio Scenarium or the Centro Cultural Carioca, and there is invariably dancing going on at Rio's traditional dance halls on Fridays. The Gafieiras are traditional old ballroom dance halls, once the centre of the city's nightlife. Although people rarely dress up any more, it is still worth visiting these older venues, where couples float across the floor to the rhythm of a samba, a* pagode, *a foxtrot or a* forró.

One of the many things that make Rio a unique city are random street parties, called points and pronounced poin-chee in Portuguese. These generally spring up outside a crowded bar or nightclub while people are waiting to get in.

CENTRO CULTURAL CARIOCA

Rua do Teatro 37, Praça Tiradentes
Centro
Tel: 021/2252-6468
www.centroculturalcarioca.com.br
This restored building from the twenties was used as a dance hall during the thirties. It now hosts live bands that specialize in samba, choro, gafieira and other styles of Brazilian music. The atmosphere of the shows is relaxed and intimate.

LAGOA KIOSKS

These began as concession stands scattered around the Lagoa Rodrigo de Freitas but they soon became an essential part of Rio's nightlife. People stroll around the Lagoa, stopping at the kiosks to have a bite, listen to some live music or have dinner at a Middle Eastern, Italian or Brazilian restaurant.

RIO SCENARIUM

Rua do Lavradio 20
Lapa
Tel: 021/3147-9005
www.rioscenarium.com.br
Another example of an antique store turned bar, Scenarium is known as the most beautiful bar in Rio. Inside an old renovated warehouse, the bar is decorated with leftovers from the antique store as well as props from old movies and the entire inventory of a vintage pharmacy. Tables are crowded around the stage so that clients can fully appreciate the choro and samba shows, while enjoying a caipirinha and some local snacks.

Text
PAULO THIAGO DE MELLO

Photographs
RETO GUNTLI & AGI SIMOES

Project coordination
DUDU VON THIELMANN

Design
ESTUDIO LO BIANCO

Translation
EDWARD SHAW

Color separation
AUSTRAL PREPRESS

First published in the United States in 2006 by
The Vendome Press
1334 York Avenue
New York, N.Y. 10021

Originally published by
Ediciones Larivière as *Vivir Rio*

Text and compilation © 2006 Ediciones Larivière
Photographs © Reto Guntli & Agi Simoes
Except:
p. 16: Augusto César Malta de Campos,
collection Álvaro de Frontin Werneck
pp. 52, 130 (above): Dudu von Thielmann
p. 67: Rio Scenarium
p. 159: Ernani D'Almeida

ISBN-10: 0-86565-178-7
ISBN-13: 978-0-86565-178-4

First edition

Printed in Spain by Artes Graficas Toledo

Library of Congress Cataloging-in-Publication Data

Mello, Paulo Thiago de.
 [Viver de Rio. English]
 At home in Rio / photographs by Reto Guntli ; text by Paulo Thiago de Mello.
 p. cm.
 ISBN-13: 978-0-86565-178-4 (hardcover : alk. paper)
 ISBN-10: 0-86565-178-7 (hardcover : alk. paper)
 1. Rio de Janeiro (Brazil)--Pictorial works. 2. Rio de Janeiro (Brazil)--
 Description and travel--Pictorial works. I. Guntli, Reto. II. Title.
 F2646.1.M45 2007
 981'.5300222--dc22
 2006018417